DRAWING LESSONS

FROM THE

GREAT MASTERS

ROBERT BEVERLY HALE

Curator of American Painting and Sculpture,
The Metropolitan Museum of Art
Instructor of Drawing and Lecturer on Anatomy,
the Art Students League of New York
Adjunct Professor of Drawing,
Columbia University

WATSON-GUPTILL PUBLICATIONS
New York

Paperback Edition
First Printing 1989

Copyright © 1964 by Watson-Guptill Publications

First published in 1964 in the United States and Canada by Watson-Guptill Publications, a division of Billboard Publications, Inc., 1515 Broadway, New York, N.Y. 10036

Library of Congress Catalog Card Number: 62-24246

ISBN 0-8230-1400-2
ISBN 0-8230-1401-0 pbk.

Distributed in the United Kingdom by Phaidon Press Ltd., Musterlin House, Jordan Hill Road, Oxford OX2 8DP

Manufactured in U.S.A.

1 2 3 4 5 6/93 92 91 90 89

PREFACE

IT HAS ALWAYS SEEMED to me that if you really wanted to excel in drawing the figure, you should go and study with the greatest living master of figure drawing. But the trouble is that there is no one alive today who can draw the figure very well; there is, perhaps, no one alive today who can draw the figure even as well as the worst artist represented in this book. The explanation for this state of affairs is somewhat complex, but I suspect that any sophisticated student knows the esthetic and historical factors that have brought about the situation. But things are not as bad as they seem, because in these days of unlimited reproductions you can study with any of the old masters you wish.

You see, your instructor in art can do little more than help you solve your technical problems; the rest is very much up to you. And even a cursory examination of the pictures in this book should expose a multitude of technical problems, and the artists' brilliant solutions.

Since the studio practices I am attempting to explain were apparently shared by all the artists herein, the pictures are neither placed chronologically, nor grouped by styles: they simply are arranged to give clarity to the text. The pictures also have been chosen to reveal all parts of the body from differing points of view, and to include many studies of heads, hands, and feet. All drawings are reproduced as large as the page size permits and many are actually reproduced larger than the original for detailed study.

ACKNOWLEDGMENTS

I should like to thank Stewart Klonis, Director of the Art Students League, Jacob Bean, Curator of Drawings, Metropolitan Museum of Art and A. Hyatt Mayor, Curator of Prints, Metropolitan Museum of Art for their very kind assistance in the preparation of this book. I should like especially to thank my wife, Niké Mylomas Hale, for all the work she has done. And I am most grateful to my editor, Donald Holden, for his sustaining encouragement and for the many valuable suggestions he has given me. All photos have been supplied by the museums credited in the captions and by Alinari — Art Reference Bureau.

CONTENTS

Preface, 5

List of Illustrations, 9

Introduction, 11

ONE

LEARNING TO DRAW 13
*Ideas Are Communicated by Symbols • Forms: Their Shape,
Lighting, and Position • Practicing Lines • Basic Geometric
Forms • Context and Juxtaposition • Learning to Think in
Many-Shaped Boxes*
ILLUSTRATIONS, 17

TWO

LINE 33
*Outer Edges • Plane Meets Plane • Color Meets Color • Value
Meets Value • Line Explains Shape • Contour Lines • Lines
Suggest Changing Values • Line Has Many Functions*
ILLUSTRATIONS, 37

THREE

LIGHT AND PLANES 57
*Importance of Light • Light on Planes • Color and Values •
Light and Three Dimensional Form • Gray to Highlight to
Dark to Reflected Light • Interrelationship of Basic Forms •
Values on Interior Planes and Interior Curved Surfaces •
Learning Values • Cast Shadows • Inventing Your Own
Sources of Light • How Light Can Destroy Form • Jumping
Light • Violation of Light and Dark Planes • Reversal of
Values • Violation of Highlights • Line Carries Light and
Shade • One Form in Front of Another • Reflected Light •
Light and Direction • The Artist Controls Light • Decisions
You Must Make*
ILLUSTRATIONS, 67

FOUR

MASS 87

*Massing and General Shape Mass and Proportion Mass and
Values Line and Mass Mass and Subordination of Detail
Inventing Mass Conceptions*

ILLUSTRATIONS, 93

FIVE

POSITION, THRUST, OR DIRECTION 109

*Determining Thrust Problems in Determining Thrust Forms
in Motion The Model is Always Moving Values and
Direction of Form Thrust and Line Position and True
Shape Thrust and Drapery*

ILLUSTRATIONS, 115

SIX

ARTISTIC ANATOMY 141

*Drawing Without the Model Learning Anatomy Bones
Determine Bodily Forms Please Buy Some Bones Origin and
Insertion of Muscles The Evolutionary Approach Gravity
and the Four-Footed Animal Gravity and Man Further
Results of Standing Erect The Importance of Function
Functional Groups Lines Divide Functional Groups
Anatomical Sins*

ILLUSTRATIONS, 149

SEVEN

DRIVING ALL THE HORSES AT ONCE 209

*The Elements of Drawing Are Interrelated Composition and
Perspective Study the History of Art Your Future Growth
as an Artist*

ILLUSTRATIONS, 213

Index, 269

LIST OF ILLUSTRATIONS

John Henry Fuseli	THE DEAD ACHILLES MOURNED BY THETIS	18
Annibale Carracci	STANDING FIGURE OF A NUDE WOMAN	20
Luca Cambiaso	GROUP OF FIGURES	22
Luca Cambiaso	CHRIST LEADING THE CALVARY	24
Nicolas Poussin	HOLY FAMILY	26
Honoré Daumier	DON QUIXOTE AND SANCHO PANZA	28
Leonardo da Vinci	MADONNA AND CHILD AND OTHER STUDIES	30
Jacopo da Pontormo	NUDE BOY SEATED	38
Pupil of Leonardo da Vinci	HEAD	40
Raphael Sanzio	FIGHT BETWEEN MAN ON A HORSE AND TWO NUDE SOLDIERS	42
Albrecht Dürer	HEAD OF A MAN	44
Rembrandt van Rijn	WOMAN WITH CLASPED HANDS	46
John Henry Fuseli	MAN EMBRACING A WOMAN	48
Tintoretto (Jacopo Robusti)	DESIGN FOR ARCHER	50
Pieter Bruegel	THE PAINTER AND THE CONNOISSEUR	52
Antoine Watteau	WOMAN SEATED ON THE GROUND	54
Albrecht Dürer	FEMALE NUDE	68
Gentile Bellini	PORTRAIT OF A YOUTH	70
Albrecht Dürer	HEAD OF A NEGRO	72
Peter Paul Rubens	PORTRAIT OF ISABELLA BRANT	74
Jacopo da Pontormo	HEAD OF A WOMAN	76
François Boucher	STUDY FOR THE JUDGMENT OF PARIS	78
Raphael Sanzio	COMBAT OF NAKED MEN	80
Albrecht Dürer	FIVE NUDES, STUDY FOR A RESURRECTION	82
Tintoretto (Jacopo Robosti)	DESIGN FOR VENUS AND VULCAN	84
Leonardo da Vinci	CANON OF PROPORTIONS	94
Albrecht Dürer	STANDING FEMALE NUDE	96
Leonardo da Vinci	HEAD OF AN OLD MAN	98
Michelangelo Buonarroti	STUDIES FOR THE LIBYAN SIBYL	100
Annibale Carracci	POLIFEMO	102
Annibale Carracci	POLIFEMO	104
Leonardo da Vinci	CARTOON FOR THE VIRGIN WITH SAINT ANNE	106
Titian (Tiziano Vecelli)	RIDER AND FALLEN FOE	116
Peter Paul Rubens	STUDY FOR MERCURY DESCENDING	118
Rembrandt van Rijn	TWO BUTCHERS AT WORK	120
Peter Paul Rubens	STUDIES OF HEADS AND HANDS	122
Copy of Albrecht Dürer	STUDY OF HANDS	124
Edgar Degas	DANCER ADJUSTING HER SLIPPER	126
Leonardo da Vinci	SURFACE ANATOMY OF THE SHOULDER REGION AND HEAD	128
Antoine Watteau	NINE STUDIES OF HEADS	130
Tintoretto (Jacopo Robusti)	DRAPED STANDING FIGURE	132
Pieter Bruegel	SUMMER	134
Jacopo da Pontormo	VIRGIN ANNUNCIATE	136
Sandro Botticelli	STUDY FOR THE ALLEGORICAL FIGURE OF ABUNDANCE	138
Bernard Siegfried Albinus	*Tabulae sceleti et musculorum corporis humani,* plate 1	150
Bernard Siegfried Albinus	*Tabulae sceleti et musculorum corporis humani,* plate 2	152
Bernard Siegfried Albinus	*Tabulae sceleti et musculorum corporis humani,* plate 3	154
Andreas Vesalius	*De Humani Corporis Fabrica,* plate 21	156

Andreas Vesalius	*De Humani Corporis Fabrica*, plate 22	158
Andreas Vesalius	*De Humani Corporis Fabrica*, plate 23	160
Bernard Siegfried Albinus	*Tabulae sceleti et musculorum corporis humani,* plate 1	162
Andreas Vesalius	*De Humani Corporis Fabrica*, plate 26	164
Bernard Siegfried Albinus	*Tabulae sceleti et musculorum corporis humani,* plate 7	166
Andreas Vesalius	*De Humani Corporis Fabrica*, plate 32	168
Andreas Vesalius	*De Humani Corporis Fabrica*, plate 33	170
Andreas Vesalius	*De Humani Corporis Fabrica*, plate 35	172
Bernard Siegfried Albinus	*Tabulae sceleti et musculorum corporis humani,* plate 4	174
Raphael Sanzio	A COMBAT OF NUDE MEN	176
Baccio Bandinelli	MALE NUDE FROM SISTINE CEILING	178
Leonardo da Vinci	NUDE ON HORSEBACK	180
Luca Signorelli	NUDE MAN FROM REAR	182
Jacques Callot	ANATOMY STUDIES	184
Jacques Callot	STANDING MALE NUDE	186
Andrea del Sarto	STUDIES OF HANDS	188
Raphael Sanzio	STUDY FOR THE TRANSFIGURATION	190
Leonardo da Vinci	HANDS	192
Peter Paul Rubens	STUDIES OF ARMS AND LEGS	194
Michelangelo Buonarroti	STUDY FOR CHRIST	196
Filippino Lippi	ATHLETIC YOUTH	198
Antonio Pollaiuolo	FIGURE OF ADAM	200
Andrea del Sarto	STUDY OF FEET AND HANDS	202
Michelangelo Buonarroti	STUDY OF THE BACK AND LEGS OF A MAN	204
Michelangelo Buonarroti	FIGURE OF A MALE NUDE	206
Jean Auguste Dominique Ingres	PORTRAIT OF PAGANINI	214
Giovanni Battista Tiepolo	ANGEL	216
Rembrandt van Rijn	GIRL SLEEPING	218
Andrea Mantegna	JUDITH AND HER SERVANT	220
Raphael Sanzio	STUDY OF DAVID AFTER MICHELANGELO	222
Peter Paul Rubens	NUDE WOMAN	224
Andrea del Sarto	HEAD OF AN ELDERLY MAN	226
Andrea del Sarto	HEAD OF AN APOSTLE	228
Michelangelo Buonarroti	HEAD IN PROFILE	230
Antonio Pisanello	MULE	232
Albrecht Dürer	CHRIST ON A CROSS	234
Raphael Sanzio	HERCULES AND THE CENTAUR	236
Michelangelo Buonarroti	STUDY OF A NUDE	238
Jacopo da Pontormo	MALE NUDE	240
Peter Paul Rubens	STUDY FOR ABRAHAM AND MELCHIZEDEK	242
Edgar Degas	STUDY FOR LES MALHEURS	244
Correggio	BOY WITH A FLUTE	246
Andrea del Sarto	TWO JOINED HANDS	248
Peter Paul Rubens	PORTRAIT OF A LITTLE BOY	250
Rembrandt van Rijn	SASKIA CARRYING RUMBARTUS DOWNSTAIRS	252
Giulio Romano	TWO FIGURES	254
Francisco Goya	THREE MEN DIGGING	256
Rembrandt van Rijn	FEMALE NUDE	258
Francisco Goya	WAKING FROM THE SLEEP IN THE OPEN	260
Auguste Rodin	FIGURE DISROBING	262
Michelangelo Buonarroti	NUDE YOUTH	264
Winslow Homer	A FISHER GIRL ON THE BEACH	266

INTRODUCTION

I AM DELIGHTED to be permitted to write this preface. I have admired
Robert Beverly Hale's work and his abilities as a teacher for some time.
He has taught drawing and artistic anatomy at the Art Students League
for the past twenty years. Countless artists have benefited from his
insights.

This is a book for professional artists, for those who intend to make
art their profession, and for amateurs who take art seriously. Its publica-
tion is well timed.

We are witnessing today a resurgence of interest in realistic and
representational draftsmanship. A few years ago, good figure drawing
seemed doomed to extinction. A kind of fever had attacked even the best
known art schools. In many places where art was taught, drawing was
slighted and even neglected completely. (I am glad to say this was never
true of the Art Students League). But this fever now seems to have run
its course. Once again, good drawing is being understood as a foundation
for painting — no matter what style or direction. It is surely no accident
that the great masters of the modern movement were, without exception,
well schooled in draftsmanship!

Robert Beverly Hale's book contains one hundred drawings by acknowledged masters, beginning with the Renaissance. They embody, or synthesize, the fundamental expression of the tradition of Western art.

No one can have sat in on his deservedly famous lectures at the Art Students League without being impressed by the profundity of his knowledge and the sophistication of his presentation. He is the foremost artistic anatomist of his time — the best I have known. He is perceptive and knowledgeable. His approach is fresh and never stereotyped. He avoids inflexible and dogmatic assertions. He takes into consideration the variations of individual perceptions. He is aware of the constant changes in art.

In this book, Mr. Hale analyzes the master drawings he has selected to accompany his text from the standpoint of good draftsmanship. He demonstrates that the teacher of figure drawing must be aware of the deceitfulness of individual appearance; he must be aware of artistic structure, light and shade, pattern, movement and rhythm.

In his analyses, Mr. Hale takes care to point out the knowledge of artistic anatomy displayed by the artist, as well as the artist's control of light, his use of planes, his feelings, and his personal point-of-view. In other words, the author stresses those qualities which make a drawing both a masterpiece and a personal statement.

Most books on drawing — at least those available to the serious student today — oversimplify. There can be no harm in presenting complicated problems in a simplified fashion, but oversimplification must lead to shallowness. *Drawing Lessons From The Great Masters* presents the essentials of good drawing *simply*, but without *over*simplification. This is the great virtue of Mr. Hale's book.

One of the great things Robert Beverly Hale is able to perform in his book is to explain how a great *drawing* can become a great *teacher*. He opens the eyes of his readers to those profound qualities which lie beyond the threshold of immediate awareness.

Stewart Klonis,
Executive Director
THE ART STUDENTS LEAGUE OF NEW YORK

ONE

LEARNING

TO DRAW

DRAWING, LIKE SO MANY other skills, is a matter of being able to think of several things at once. Since the conscious mind seems to be able to think about only one thing at a time, the subconscious mind must take care of a good deal when we draw. So the process of learning to draw demands that we acquaint the subconscious mind with a certain amount of material, so that the subconscious can largely take over the control of our hand.

Actually, I am inclined to think that *no* artist can be called an accomplished craftsman until all matters of technique are so well learnt that they are part of his subconscious equipment. I know it is very difficult for an artist to express himself adequately unless this has been done.

Students and laymen, of course, are apt to confuse the technique with the art. As you read these pages, remember that technique is but a means to an end, and should never be confused with the end itself.

IDEAS ARE COMMUNICA-
TED BY SYMBOLS

Now all types of drawing — whether by people of long ago, by people in distant places, by children, or by the most advanced artists of the 20th century — represent an artist's effort to communicate to the observer.

In this book, we are studying a traditional type of drawing: the ways and means of creating the illusion of what is popularly called reality. A fundamental characteristic of this type of drawing is that ideas are communicated by means of symbols that give the illusion of three dimensional form. In short, the artist conceives a form, draws it, and other people, who look at his drawing, receive the idea he wishes to communicate.

FORMS: THEIR SHAPE,
LIGHTING, AND POSITION

But first of all, in order to draw a specific form, you must be aware that this form exists. This is one of the reasons that figure drawing is so difficult for the beginner: in the human body, there are many forms which the beginner has neither heard of nor thought about. For him, these forms literally do not exist. For instance, many beginners are not conscious of the rib cage, the largest form in the body; very few are aware of the tensor of the fascia lata, though it is impossible to represent the pelvic region faithfully without a knowledge of this form. Indeed, this muscle takes six or more inches of the outline of the figure in certain poses; so you can imagine how important it is.

Once you are aware of the existence of a form, you must then come to an exact conclusion as to its shape. Unless you have decided on the exact shape of a form, how in the world can you communicate its exact shape to others?

Furthermore, you must light the form in such a way that it is recognized for what you have in mind and not for something else. A woman's breast may be lit in such a way that it looks like a flat, white poker chip, or almost anything but its true, somewhat spherical form.

Finally, you must come to a decision about the position of the form in space. Certainly you will not wish to draw it in two or more places at once. Nor will you wish to draw a form in a position that does not reveal its true shape.

PRACTICING LINES

Naturally, it is difficult for the beginner to carry all these matters in his mind at once. What is more, his unaccustomed hand will be unable to draw with precision the shapes he wishes to present. And his hand will be too heavy to render the necessary values (light and shade).

You must realize that there is no royal road to drawing. It is practice, practice all the way.

So get your pad of paper and start drawing simple lines. You will

find it very hard to make a really straight line, and harder to make a vertical line than a horizontal. Try drawing a perfect circle. Draw a few thousand and they will get perceptibly better. Above all, don't get discouraged. It is said that only the divine Raphael reached circular perfection.

<table>
<tr><td>BASIC GEOMETRIC
FORMS</td><td>You should practice drawing cubes, cylinders, and spheres. These are the simple, basic forms; the artist feels that all other forms are composed of these forms, or parts of them.</td></tr>
</table>

BASIC GEOMETRIC
FORMS

You should practice drawing cubes, cylinders, and spheres. These are the simple, basic forms; the artist feels that all other forms are composed of these forms, or parts of them.

Soon you will discover that there are many forms that lie between the cube and the cylinder, between the cylinder and the sphere. An egg, for instance, is neither a cylinder nor a sphere; its shape lies somewhere between the two. In your mind, whittle away the vertical edges of the cube until it becomes a cylinder. Close up the top and bottom of the cylinder and imagine it as a sphere. In this way, you will begin to feel the relationship between these forms, which becomes so important in the study of values.

Soon you will find you can give the symbol — the illusion — of any simple form you wish. After quite a while, you will realize that you can give the illusion of any complex form by combining the simple forms — or parts of the simple forms — of which the complex form is composed.

CONTEXT AND JUXTA-
POSITION

As soon as you are able to produce the symbols of the simple forms we have been discussing, you will realize that you have learnt the most important "words" of the visual language. Draw a cube and you have a cubical box; draw a cylinder and you have a column; draw a sphere and you have a tennis ball. With these simple symbols you can represent thousands of things. And by combining these forms, you can create an infinite variety of objects.

As in a language, the symbols are often identified through context or juxtaposition. Draw a spoon near your cube; the cube will promptly become a lump of sugar. Place the cube on top of a house and the cube will become a chimney. A wisp of smoke and your cylinder becomes a cigarette. Placed beneath a head, the cylinder becomes a neck. As for the sphere, add a stem and a leaf and it becomes an apple. Placed in the hand of Aphrodite, the sphere becomes the apple of discord, a golden apple of the Hesperides.

When you are learning to draw, it is most important to cultivate the habit of forcing everything you see into its simplest geometric form. Do this sort of thing continually. It enables you to feel a form in its entirety, disregarding details which are so loved by the beginner. Above all, it promotes the ability to think in mass, which must become an instinctive habit, the most important habit the student can acquire.

You will find it helpful to think in terms of many-shaped boxes: block-like, cylindrical, and spherical. When you draw an object, you can imagine the object as in the box; thus, you can feel the simplest geometric quality of your subject. Your book, your chair, your room, your house will all fit into block-like boxes. Create some cylindrical boxes and pack your lamp shade, the trunk of a tree, and the neighboring gas tank. Take a spherical box. You will need quite a large one for the moon, but a small one will contain your eyeball very nicely.

Perhaps the wilder the ideas, the better. You soon realize that there are very few basic shapes in the universe and that there is a geometric relationship between the most diverse objects. The sea is but the skin of a sphere and is related to the spherical head of a pin.

Next, imagine yourself inside the boxes. Contemplate the flat and curved surfaces around you. This exercise familiarizes you with the interior planes, with how these planes meet, and with the movement of concave surfaces. Inside a cube-like box, you are in a room; inside a cylindrical box, you are in a curl of hair; inside a cylindrical box with half a spherical box on top, you are in the Pantheon in Rome.

Later we will visualize values of light and shade on our many-sized boxes: on their exteriors, on their interiors, and on parts of them. Thus, we will begin to understand the artist's approach to diverse subjects like the rounded hills, the interiors of breaking waves, and above all, the human figure.

ILLUSTRATIONS

John Henry Fuseli (1741-1825)

THE DEAD ACHILLES MOURNED BY THETIS

watercolor over black chalk

15¾" x 19⅞" (40 x 50.5 cm)

Art Institute of Chicago

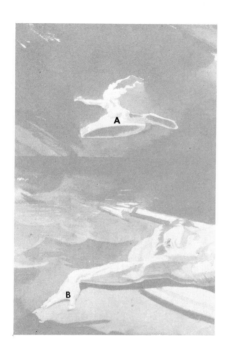

Here Fuseli conceived the form (A) as a cylinder. He knew how to draw cylinders and how tone moves on form. So he put the cylinder in a position that revealed its true shape; decided where the cylinder was and in what direction it was going; and lit the form so that it looked even more like a cylinder.

But let us move on to something more subtle. On Achilles' hand, Fuseli decided that the muscle called the abductor of the index (B) was egg shaped. On this egg, the artist threw the same light that he had thrown on the rest of the body, and thus filled up a rather dull space on the hand.

Note that Fuseli also decided on the individual shapes of all those rocks. He broke the rocks into planes and threw the same light on them that he had thrown on the figure of Thetis.

18

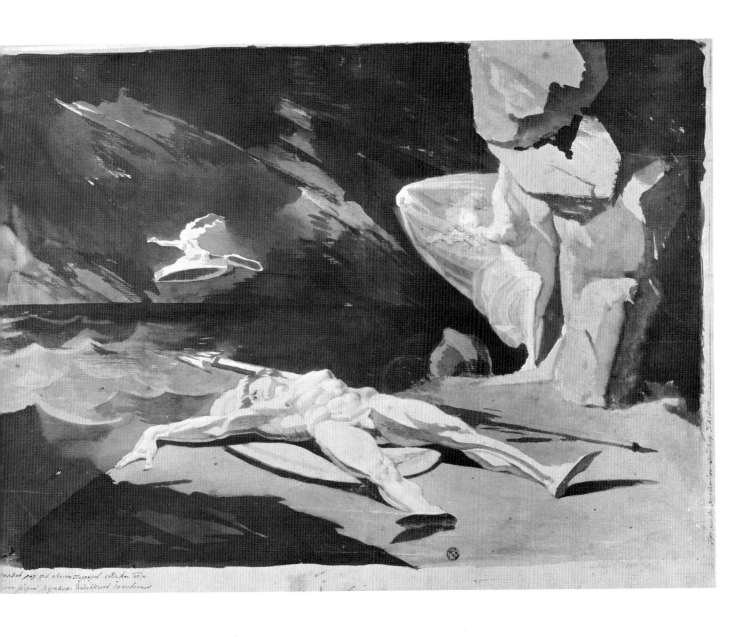

Annibale Carracci (1560-1609)

STANDING FIGURE OF A NUDE WOMAN

red chalk

14⅞" x 9" (37.5 x 22.8 cm)

*Reproduced by gracious permission of
Her Majesty the Queen*

Royal Library, Windsor

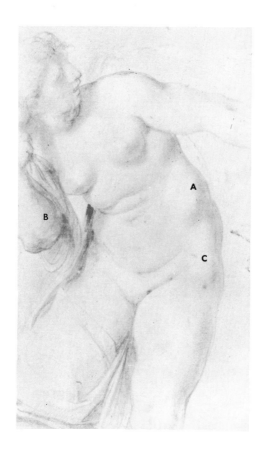

This drawing is composed largely of simple symbols of three dimensional form. The breasts are pure spheres; the external oblique (A) is a simple egg; the thighs are eggs; the flexor group (B) of the arm on the left is an egg. Observe the tensor of the fascia lata (C); the artist has thought of it as a double egg symbol; artists often think of it this way when the model bends slightly forward.

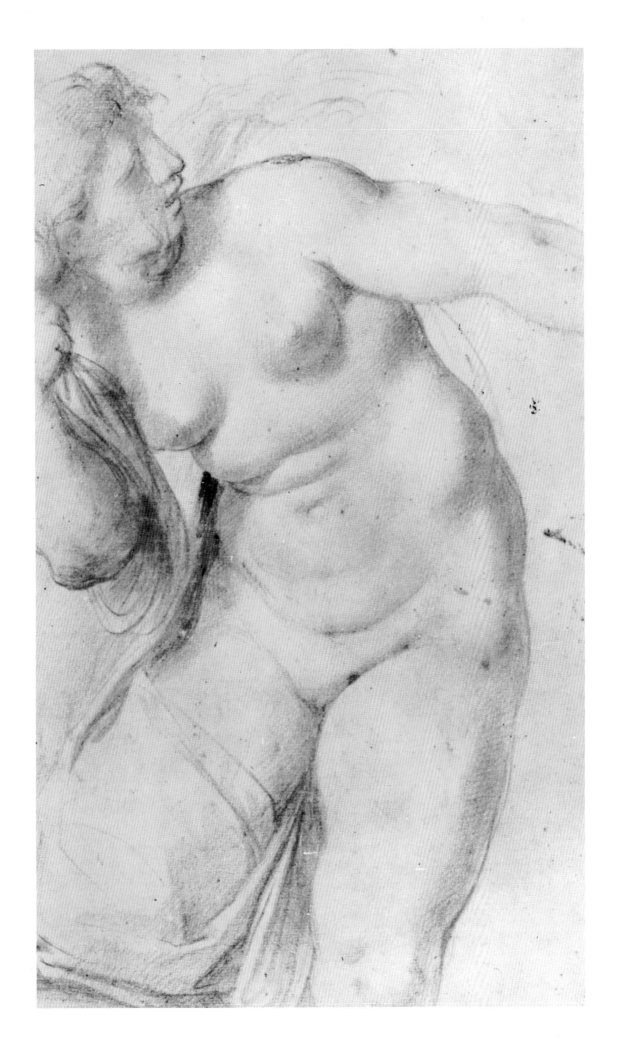

Luca Cambiaso (1527-1585)

GROUP OF FIGURES

pen and bistre

13⅜″ x 9⁷⁄₁₆″ (34 x 24 cm)

Uffizi, Florence

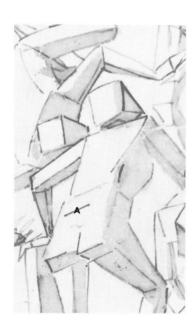

In this drawing, Cambiaso shows you how an artist thinks of the figure in terms of simple masses. He used blocks to clarify the front and side planes and the up and down planes. He then threw a light from the left and from above. Thus, it was very easy for him to put shade on the side and down planes. If he had drawn perfectly life-like figures and put the same light and shade on them, they would have looked very ~~well~~. *good*.

Even in these block-like figures, Cambiaso still shows his anatomical training. The line (A) designates the top of the sacrum.

There is another principle nicely illustrated here. As the artist turns his attention from one block-like form to another, he varies the direction of each form. In other words, adjacent forms vary in direction, each to each.

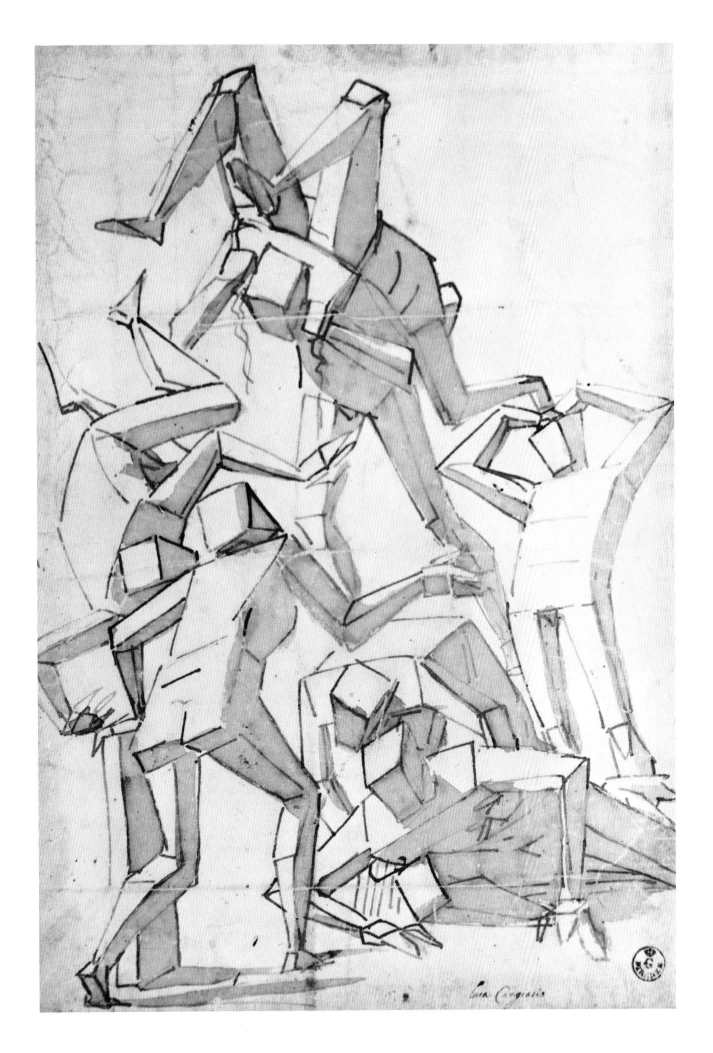

Luca Cangiasi

Luca Cambiaso (1527-1585)

CHRIST LEADING THE CALVARY

pen and bistre

7⅞″ x 11″ (20 x 28 cm)

Uffizi, Florence

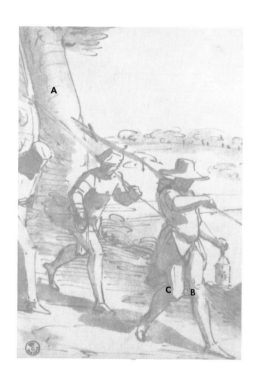

This is a Cambiaso drawing carried just a bit further. Now the light source is on the right. Everything is blocked out in much the same way. However, notice the tree (A); this is a cylinder symbol. You will find lots of arms and legs in this book, done in much the same way. Cambiaso even throws a line or so around the tree (A) as Leonardo does around the arm (see page 31), and for the same reasons; that is, to intensify form and direction. As for precise anatomy, look at the exact indication of the inner hamstring (B) and the outer hamstring (C).

24

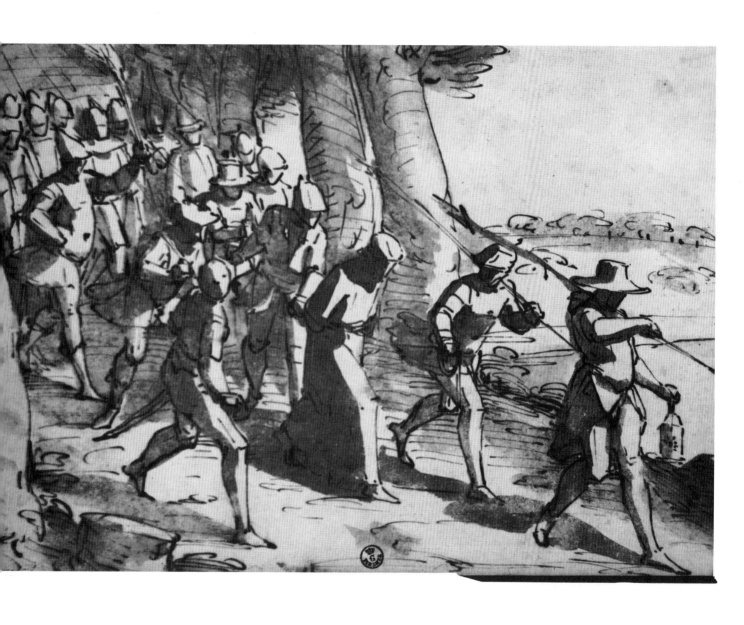

Nicolas Poussin (1594-1665)

HOLY FAMILY

pen and bistre wash

7¼" x 10" (18.4 x 25.3 cm)

Pierpont Morgan Library, New York

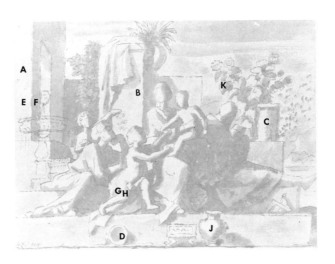

Here is a sketch by Poussin, with much the same underlying simplicity as the drawings of Cambiaso. The house (A) is a block. The wall (B) is a block. The column (C) is a cylinder. The bowl (D) is the inside of a spherical box. Notice how the planes meet at E and F, exactly the same way as they do at G and H. For the moment, perhaps, the artist forgets that he is dealing with stone and flesh; he thinks of them both as pure form.

Notice the ball-like body of the vase at J; this is closely related to a sphere. And note the two planes on the leaf at K.

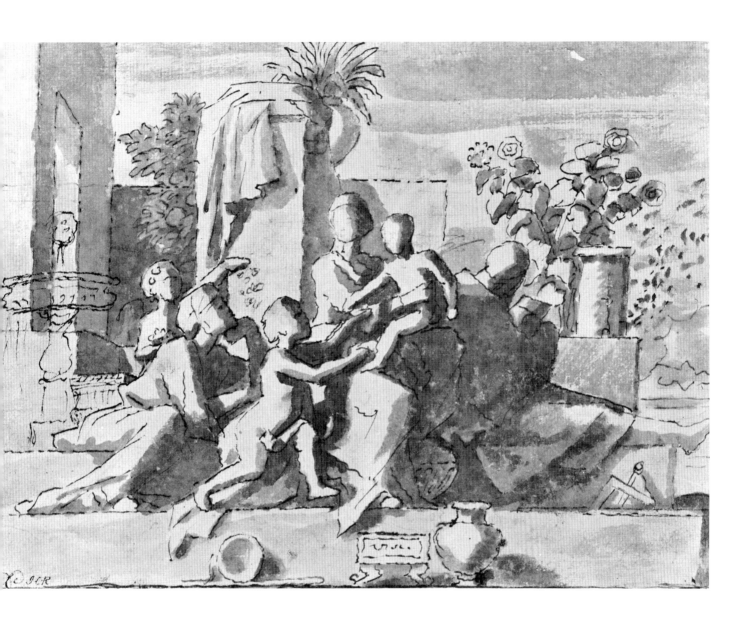

27

Honoré Daumier (1808-1879)

DON QUIXOTE AND SANCHO PANZA

charcoal washed with india ink

7⅜" x 12⅛" (18.7 x 30.8 cm)

Metropolitan Museum of Art, New York

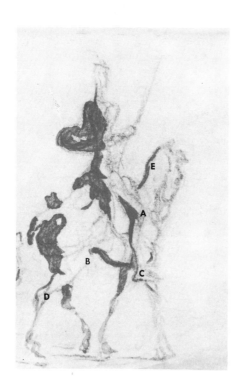

Try re-drawing this Daumier, giving it the simple, block-like shapes of Cambiaso. Throw the light from the right and you will understand why Daumier put his shade where it is.

Incidentally, this drawing shows that Daumier was altogether intimate with the bones of horses. (Have you got a friend in the country who will send you some horse bones so that you can learn to draw horses?) Compare the horse with his rider and start to think of the basic similarities between men and animals. Don Quixote's knee is at A; his horse's knee is at B. Don Quixote's ankle is at C; his horse's ankle is at D. From here down, the horse's leg is all foot.

Notice the S curve on the back of the horse's neck (E). This is the basic movement of the cervical or neck vertebrae of animals, but not of man.

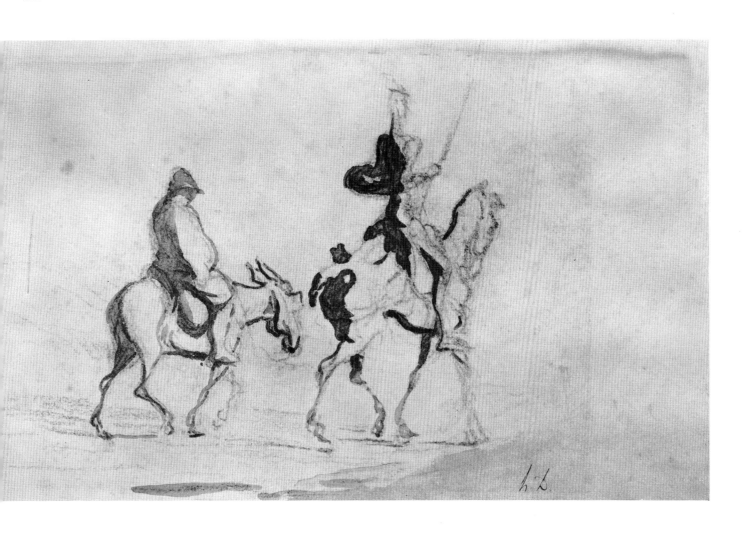

Leonardo da Vinci (1452-1519)

MADONNA AND CHILD AND OTHER STUDIES

pen and ink

16" x 11⅜" (40.5 x 29 cm)

Reproduced by gracious permission of Her Majesty the Queen

Royal Library, Windsor

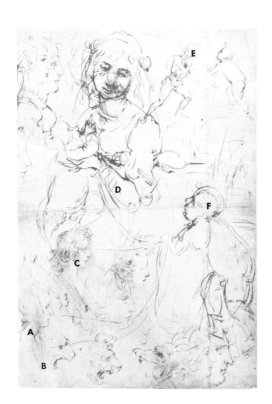

Every artist will tell you how to learn to draw: keep a sketchbook and just draw and draw. This is a page from Leonardo's sketchbook.

There are fascinating lines at A and B. The artist is trying his hand at shade lines. They have no relation to the drawing under them. Each individual line runs from light to dark to light.

Such lines are very hard to draw. Together, they give the effect of a curved plane. Leonardo has used these lines to show the gentle curve of the flesh over the bottom of the jawbone in the little head above (C).

Notice the circular lines on the arm (D). They give the arm a sure feeling of direction.

Observe Leonardo's preoccupation with the basic forms of the head in E and F.

30

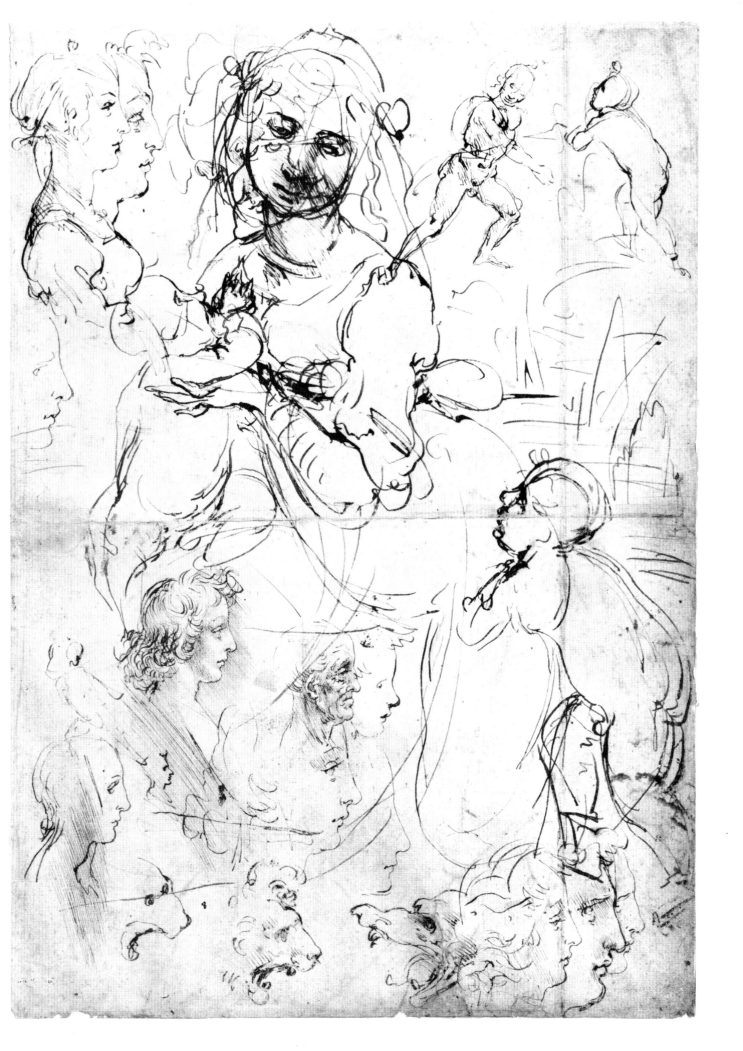

TWO

LINE

BY SIMPLY DRAWING A CUBE, you can understand some of the significance of line in creating the illusion of reality. It seems evident at once that the *outer* lines symbolize the edges of the cube and the *inner* lines symbolize the place where planes meet upon the cube. Now if you wish to indicate a spot of colored ink upon the cube, you will find yourself drawing a line around the edges of the spot to symbolize its presence. In other words, it will be seen at once that lines may be used to symbolize the outer edges of an object, the meeting of planes, and the meeting of one color and another. And, of course, a line may be used to symbolize a line!

OUTER EDGES

Let us take these things up one by one. If you decide to make a line drawing of an object without any interior details, you might say that the line symbolizes the place where the background stops and the object begins. If you draw a profile of a head against a wall, the line differentiates head from wall, and incidentally creates the illusion that the head is in front of the wall — even though your paper is absolutely flat! I think this is well understood by everybody, so let us move on to a much more subtle matter: the use of line to indicate the meeting of planes.

33

PLANE MEETS PLANE

In drawing a cube, you automatically put a line where the various faces of the cube meet. This shows how well a line symbolizes the place where plane meets plane. You can understand, then, why an artist who draws a building makes a line where one wall meets another wall. He also draws a line where the top of a table meets the side of the table. Thus, he draws lines to show the meeting of exterior planes.

Now, if you can visualize yourself *inside* a cube, you can understand why the artist puts a line where a ceiling meets a wall, where a floor meets a wall, or where wall meets wall. This is the meeting of *interior* planes.

If you draw a cylinder with a flat top, you will find yourself drawing a line where a curved plane meets a flat plane. Someday you will realize that you are drawing a line where a curved plane meets a curved plane when you draw the breast meeting the rib cage, for instance, or the buttock meeting the back of the thigh.

COLOR MEETS COLOR

When one color abruptly meets another color, a line may be drawn to symbolize this meeting. If you wished to make a line drawing of the flag, you would draw a line around the blue area, a line around each red area, and a line around each white area. For the eye, you might well draw a circle where the colored iris meets the white, plus a smaller circle where the dark pupil meets the iris.

TONE MEETS TONE

You must remember that an artist thinks of shade and shadow as color, so when a dark area abruptly meets a light area, a line is often used to symbolize this meeting. If you put a white block (or cube) near a window, you will see that each plane of the block has a different degree of lightness or darkness — a different tone. When you draw the block you will use a line to indicate the meeting of these light and dark planes.

LINE EXPLAINS SHAPE

A further use of line is to explain more fully the shape of the form over which the line moves. If drapery is striped, for instance, a careful rendering of the stripes more fully explains the form of the drapery. Instructors are forever recommending that the student throw a piece of drapery over a chair and draw it. This is wonderful practice. The more stripes, the better; a Scottish plaid is ideal.

It is also very good practice to draw a cake of ice and then draw lines over it; since ice is transparent, you will have to draw the lines on the *back* of the ice too. Draw a transparent cylinder, and draw a spiral line around the front and back. Draw a transparent globe, and run lines of latitude and longitude around it.

Not only is the shape of the object more fully explained by this process, but the practice increases your feeling for form. Eventually the surface of your paper seems to become transparent: your lines seem to recede from you and approach you as you draw.

CONTOUR LINES

In figure drawing, in order to clarify the shape of the form, the artist is forever seeking lines that move across the skin. It is too bad that human beings are not striped like zebras, because then it would be very easy to explain the shape of the nude. But since they are not, the artist is forever seeking and even *inventing* such lines in his search for the illusion of form. He invents all kinds of lines he cannot see at all. This, I assure you, takes a thorough knowledge of the elements of drawing. The accomplished artist, for instance, will run an imaginary ribbon around the neck; furrow the placid forehead; invent the meeting of planes, and draw lines where these planes meet. If he is shading with lines, he will be altogether conscious that the direction of these lines may be used to accentuate the shape and direction of the form over which they travel. The study of artistic anatomy is of great value in determining which lines to accentuate on the human body and which to subordinate or leave out. Muscles, for instance, are often in groups related by function; lines are used to separate the *groups* rather than the individual muscles.

As I have suggested, it is a great help to run lines over simple geometrical forms. Running lines over the nude is much more difficult, but a marvelous aid in helping you to understand the shape of the body. These lines are called *contour* lines. One way to think of a contour line is to imagine the track left by a very small insect with ink on his feet crawling over the nude. It is said that as soon as you can run contour lines perfectly in any direction over any part of the body, you have really learnt how to draw. Many difficult problems in drawing are readily solved by a full understanding of the contour line: the exact placement of the eyes on a three quarter view of the head, for example, and the transference of a likeness from profile to the three quarter head.

Line is further used to suggest the changing tones of light and shade that lie upon an object. A line of varying strength can be run across an object: where the line is heavy, it will suggest deep shade on the object; where it is light, the line will suggest light shade; if the line is very light or absent, it will suggest a highlight.

Naturally, we will have more to say about line, especially in relation to planes, light and shade, and direction. But enough has been said already for you to realize that line has many functions, and that sometimes a simple line may indicate not one, but *many* of the conditions I have just described.

When you are drawing a head, think for a moment of the line that designates the top limit of the upper lip. This line symbolizes not only the change in planes where the lip meets the skin above. It also shows the color change where the red of the lip meets the skin; the shape of the form over which the line moves; the abrupt change of dark to light where the down plane of the lip meets the up plane above; and finally, the movement of light and shade upon the head as a whole.

ILLUSTRATIONS

LINE

Jacopo da Pontormo (1494-1556)

NUDE BOY SEATED

red chalk

16⅛" x 10⁷/₁₆" (41 x 26.5 cm)

Uffizi, Florence

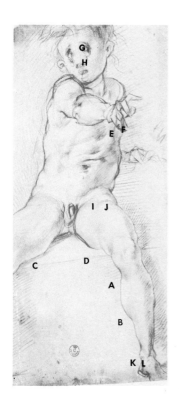

It should be clear that the line A-B is the outer edge of the calf. This line helps to give the illusion that the model's leg is in front of the curious block-like form on which he is sitting. The line C-D on the block symbolizes the place where the top plane of the block meets the down plane. This line is similar to the thick, short line E-F on the model's little finger, where the up plane of the first phalange meets the down plane of the second. It is also similar to the very faint line G-H on the nose, where the front plane of the nose meets the side plane.

These lines all suggest the meetings of exterior planes. Look at the outside of a cubical box; you will see the exterior planes meeting. On the other hand, look inside the box; you will see the *interior* planes meeting.

Let us look at the lines of a few interior planes. Line I-J symbolizes the place where the front plane of the body meets the top plane of the leg. The little, heavy, curved line K-L shows where the front of the leg meets the top of the foot. A similar line is suggested on the other foot. How many other interior plane lines can you find?

38

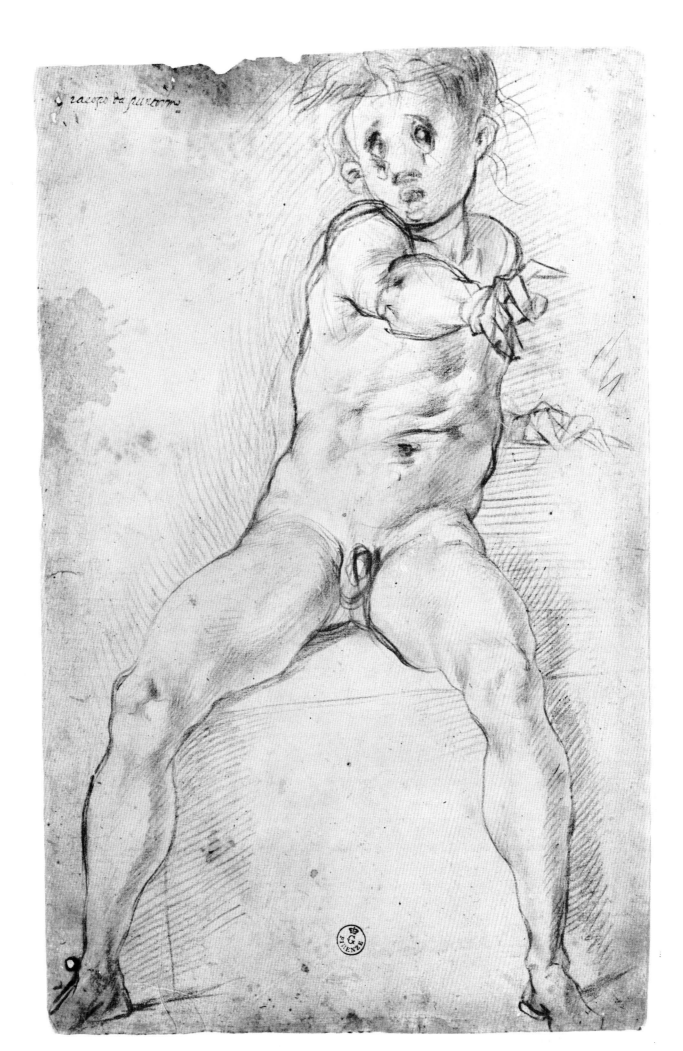

Pupil of Leonardo da Vinci

HEAD

silverpoint heightened with white

8¹³⁄₁₆″ x 6¼″ (22.4 x 15.8 cm)

Reproduced by gracious permission of Her Majesty the Queen

Royal Library, Windsor

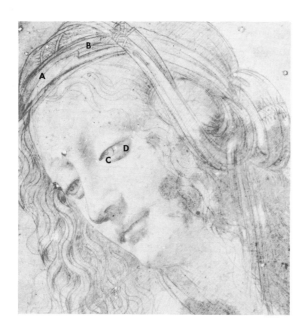

The circular lines drawn on the eyeballs designate, of course, the places where the black of the pupil meets the iris, and where the color of the iris meets the white of the eye. Line A-B and its companions play their parts in explaining the shape of the head. Line C-D tells of the shape of the eyeball.

In this picture, no eyelashes have been drawn. Eyelashes have always troubled artists and sculptors because the lashes have no mass. In this case, the artist has left out the lashes entirely and simply indicated their presence by throwing their shadow on the eyeballs.

It is almost impossible to study *extreme* subtlety of values in any reproduction; the student must take every opportunity to study the originals.

40

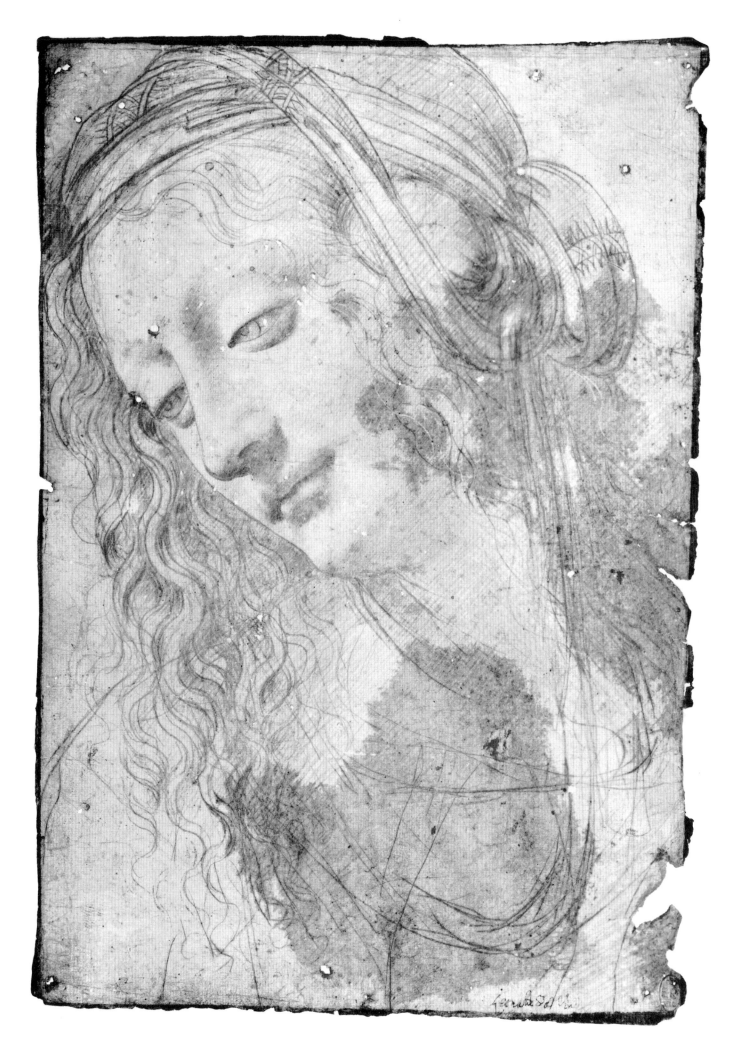

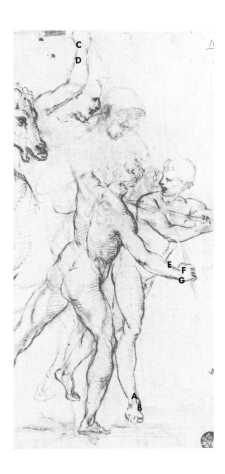

Raphael Sanzio (1483-1520)

FIGHT BETWEEN MAN ON A HORSE AND TWO NUDE SOLDIERS

pen

10⅛" x 8¼" (25.8 x 20.9 cm)

Academy, Venice

Do not imagine for a moment that the artist posed these models and then copied them. Most people naturally believe that all the figures in this book were simply copied from models. But I assure you that most of these drawings were just made up by the artist out of his head. Do you suppose that Fuseli persuaded that girl to sit on the flying saucer (a few pages back) or that Raphael persuaded the horse here to take this rearing pose and hold it for this picture? Raphael could draw a horse or a human figure in any position he wanted.

Just to hint at Raphael's mastery of artistic anatomy, note that the short line A-B indicates the tendon of tibialis anticus. You may never have heard of tibialis anticus, but its tendon, when the foot is flexed, creates a form larger than your nose! Lines C-D and E-F show that he is aware of the function, origin, insertion, and course of extensor carpi radialis brevior. He also realized the exact shape and position of the end of the ulna (G) and indicated the straining of the little tendon of extensor carpi ulnaris to get around the tuberosity in order to reach its insertion in the proximal end of the metatarsal of the little finger.

Raphael and all the other artists in this book were able to construct figures out of their imagination because they were all masters of artistic anatomy.

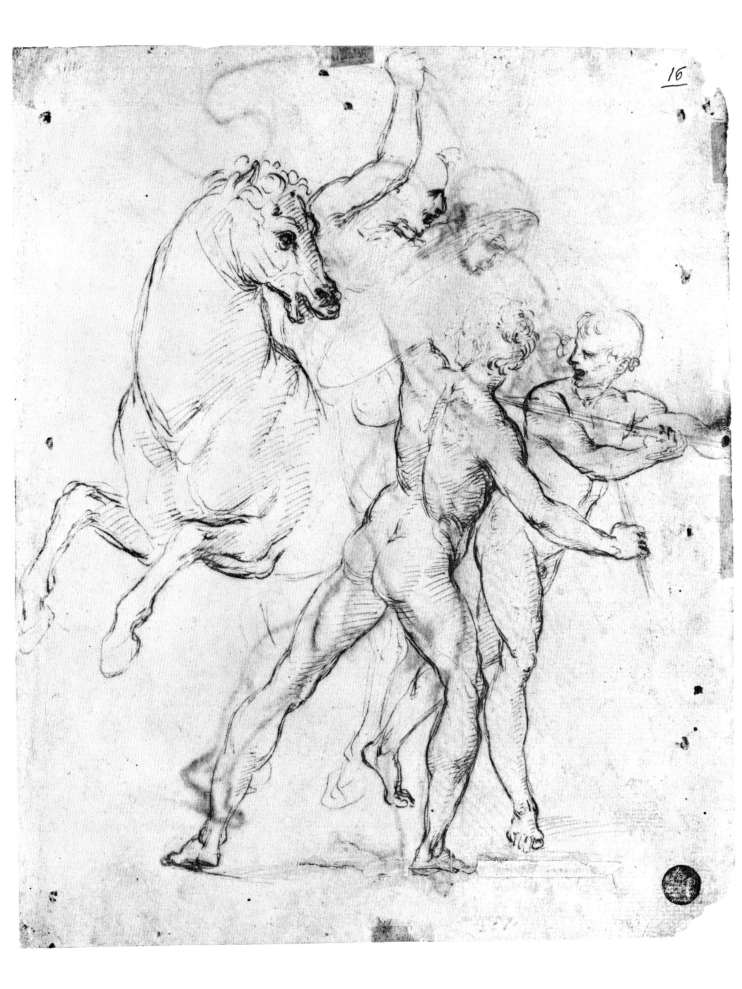

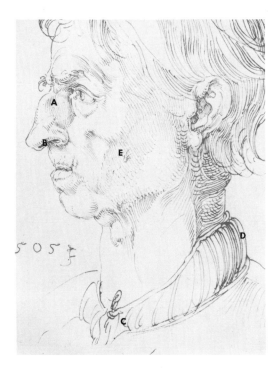

Albrecht Dürer (1471-1528)

HEAD OF A MAN

pen

8¾₁₆" x 5¹³⁄₁₆" (20.8 x 14.8 cm)

British Museum, London

The line that indicates where the color of the iris meets the white of the eyeball is fascinating. This line does not follow a true circle, showing that Dürer had considered what would happen to a circle drawn on a sphere near the *profile* of the sphere.

The lines at A show the side plane of the nose. They indicate the changing values that Dürer felt on this plane. They are contour lines; as such, they explain the shape of the plane. They start where the front plane of the nose ends and they stop where the front plane of the cheek begins. The lines at B indicate an important little down plane on the nose, often neglected.

The lines from C to D carry the form of the collar, and also vary in strength to indicate the varying values on the collar. Properly, they almost die at the highlight. They are generally light at their tops and dark at their bottoms to indicate the shade on the down plane at the base of the collar.

The ear is well drawn. Get a medical anatomy book; study the helix and the antihelix, the tragus and the antitragus; and you will be able to draw ears for the rest of your life.

Students will often shade the side plane of the nose and leave out the shade on the side plane of the head itself. Naturally, Dürer did not neglect the head; there is shade at E. You see how first things come first. Heads are more important than noses. Hands are more important than fingers. Rib cages are more important than breasts.

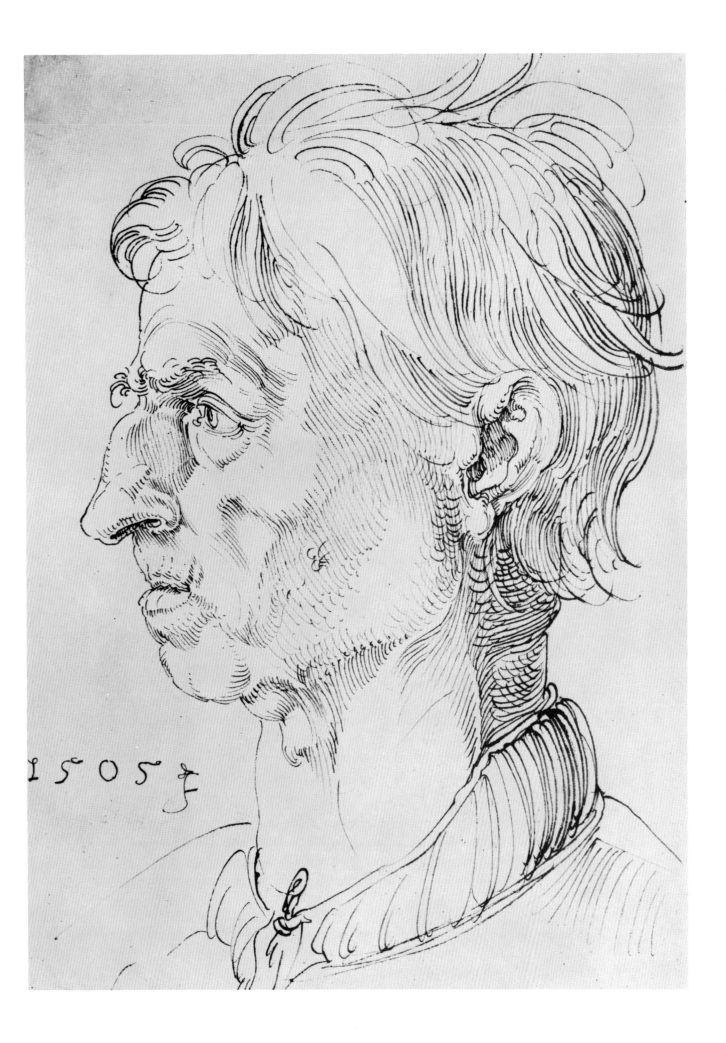

Rembrandt van Rijn (1607-1669)

WOMAN WITH CLASPED HANDS

pen and bistre

6½" x 5⅜" (16.6 x 13.7 cm)

Albertina, Vienna

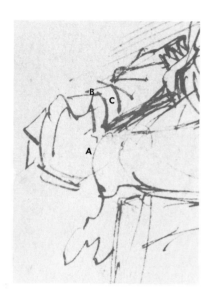

This picture, I believe, was drawn from the model. But the reason it is so good is that Rembrandt could draw with equal ease from his imagination.

Actually, he saw hardly any lines at all when he drew this picture. He saw plane meeting plane; color meeting color; tone meeting tone; tones changing; outer edges; basic geometric forms and their direction, etc. He was extraordinarily versed in anatomy and he knew his perspective. He was thoroughly aware of what light, coming from varied directions, did to individual forms; he knew which light increased the illusion of form, and which destroyed it. In short, before he sat down to draw this picture, he had absorbed the technical knowledge which should be expected of any competent artist.

For instance, the line A shows that he was thinking of the wrist (at that moment) as a *cylinder*. This line gives the direction he wanted for the wrist. And the changing strength of the line reveals the tones he imagined to be on the cylinder. Of course he could not imagine the tones on this imaginary cylinder, unless he also imagined the exact position of an imaginary light source, and the exact position of his imaginary cylinder.

The line B-C shows that (for the moment) he was thinking of the other wrist as a *block*. The line is light on top and dark on the side because he threw his imaginary light on the top plane of his imaginary block. Do not think for a moment that Rembrandt saw the ends of either sleeve the way he drew them. Mass conceptions change readily in the artist's mind in order to solve particular problems.

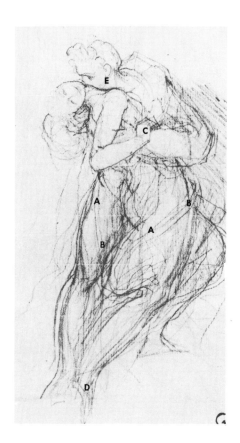

John Henry Fuseli (1741-1825)

MAN EMBRACING A WOMAN

black chalk

8⅛" x 5¾" (20.6 x 14.7 cm)

Kupferstichkabinett, Basel

This picture by Fuseli is exciting and appealing, of course, but perhaps I should warn beginners that it really is not half as good as the Rembrandt on the previous page. The reasons are somewhat outside the province of this book. Just remember that every artist has to walk a tightrope. There is always a danger of his losing his balance and falling off into overstatement, oversentimentality, or just plain vulgarity. It is always hard for an artist to keep his balance.

But technically, Fuseli was very good and we can learn much from him. (Besides, he was the teacher of William Blake.) For instance, Fuseli conceived the young girl's head as a simple egg; the lines of the upper lip are simply run over the egg. The lines of the drapery (A and B) give form to Fuseli's egg-like conceptions of the thighs. He has visualized the young lady's hand as a block, and drawn the line C where the two planes of the block meet.

The line D is where the plane of the side of the foot meets the plane of the sole.

The line E on the man's head is where the side plane of the cheek meets the plane of the flesh beneath the jaw. Compare it to the same line on the Rembrandt you have just seen. Rembrandt had evidently studied human jawbones with more intensity than Fuseli and was therefore able to give more character to his line.

48

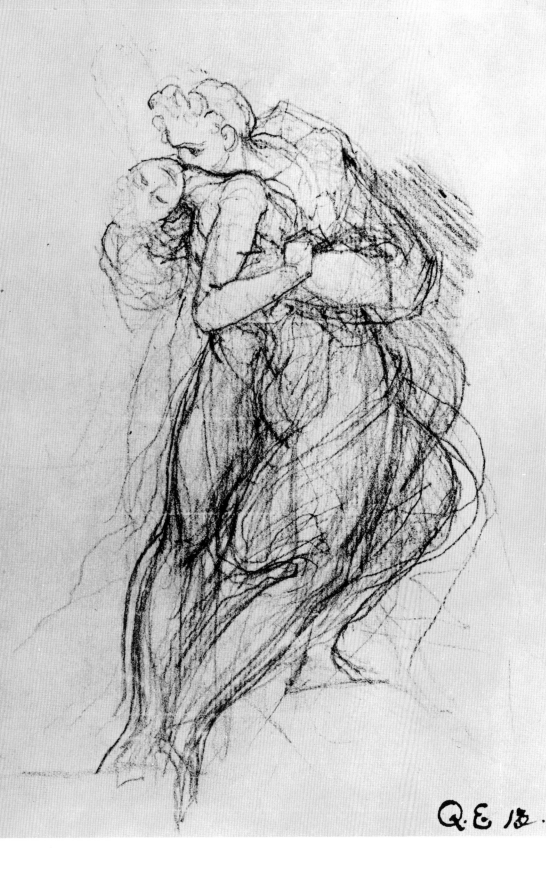

Q.E.13.

Tintoretto (Jacopo Robusti) (1512-1594)

DESIGN FOR ARCHER

charcoal

12⅝″ x 8⅛″ (32.2 x 20.7 cm)

Uffizi, Florence

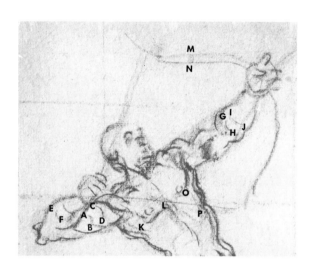

In this rapid sketch, the upper arm on the left was momentarily thought of as a cylinder. The lines A-B and C-D were put on the cylinders to accentuate the direction of the form, particularly as the foreshortening problem is quite difficult here.

The direction of the lower arm is given by the line E-F and its companion. Lines G-H and I-J were drawn for a similar reason. The rib cage was conceived as a cylinder, and line K-L was drawn at the base of the great pectoralis muscle to accentuate the direction of the rib cage. The little line M-N gives form and direction to the bow. Line O-P indicates the meeting of the front and side planes of the body. This makes the side plane very narrow, but it often is.

Pieter Bruegel (1525-1569)

THE PAINTER AND THE CONNOISSEUR

pen and brown ink

10" x 8½" (25.5 x 21.5 cm)

Albertina, Vienna

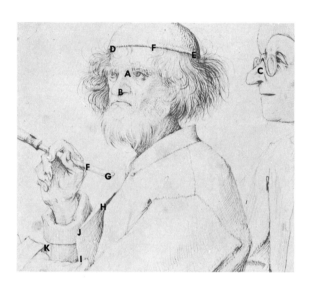

Here is an artist at work with a non-artist looking over his shoulder.

In this picture, Bruegel has several times used a series of dots to indicate a line. On the nose, the dots indicate a line (A-B) which serves to separate the front plane of the nose from the side plane. The same device is apparent on the other nose (C). Dots are also used for the top line of the artist's upper lip. Dots are also used to reinforce the line D-E. They disappear at the highlight (F) and also serve to designate the minute down plane of the cap. The line F-G separates the top plane of the brush handle from the side plane.

The lines of the belt show that the artist's mass conception of the body (at the moment) was a cylinder. The line H-I is bent at J, where the up plane of the great pectoralis stops and the down plane begins even though this line is well outside the body! The cuff (K) suggests a block-like conception of the wrist beneath.

52

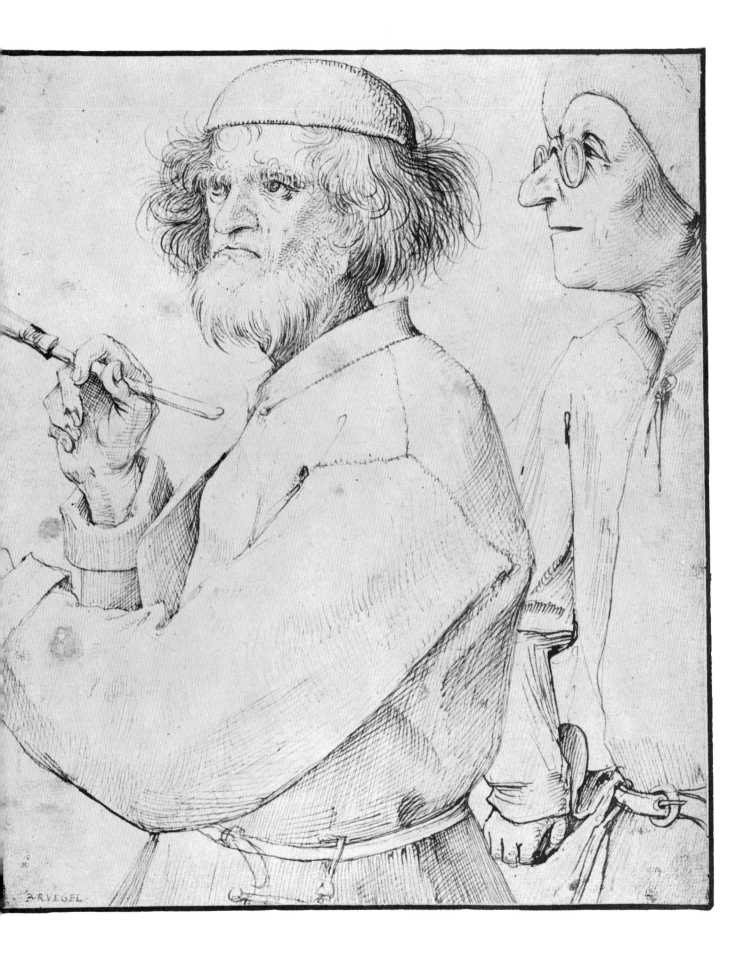

Antoine Watteau (1684-1721)

WOMAN SEATED ON THE GROUND

red and black chalk

5¾" x 6⁵⁄₁₆" (14.6 x 16.1 cm)

British Museum, London

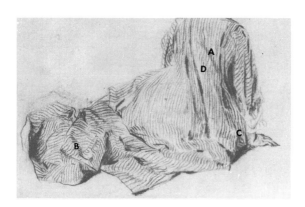

Here is a marvelous example of line running over drapery. Watteau could not have run his lines so nicely over the drapery unless he had practiced doing it many times before. He also understood the nature of contour lines.

Running lines over drapery is a matter of running lines over a form that you have *conceived*. At the same time, you must be very conscious of the exact direction of the light, as well as the direction of the reflected light if you are using it.

The light is thrown at the bottom of form A; therefore, the lines on the top of the form are darker than those at the bottom. The light is thrown from the left of form B; the lines on the right are darker than those on the left. The artist has created a highlight on the top of this form; therefore, the lines coming from the left grow lighter as they approach the highlight. Very often an artist kills lines altogether when he hits a highlight, as Watteau has done at many places in this drawing, such as C and D.

As soon as you create your source of light, you create your highlight. Sometimes you may accept the highlight you see on the model; but if you do not approve of its placement, you create another. Of course, if you are making a drawing out of your head, there is no model and no highlight, so naturally you must create your own highlight.

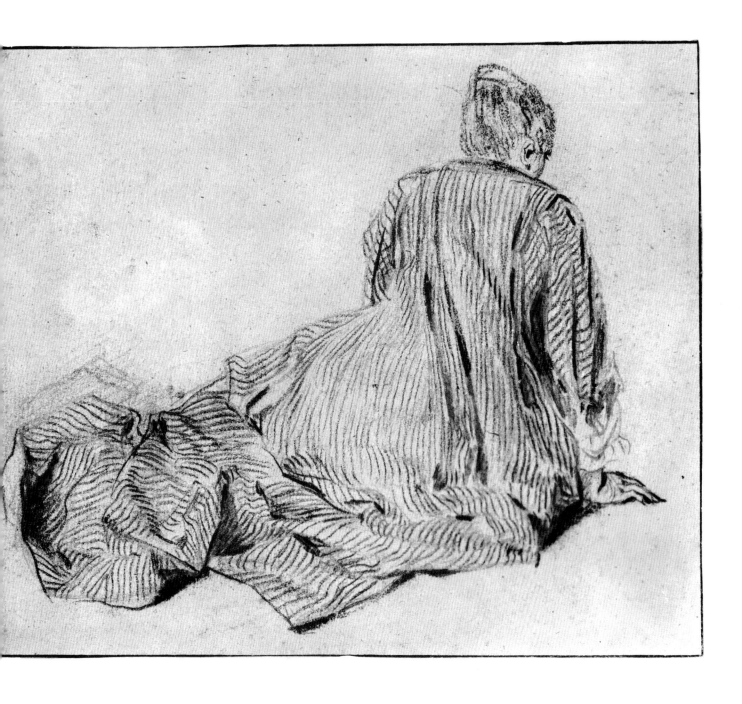

THREE

LIGHT

AND PLANES

YOU CAN CREATE an excellent illusion of three dimensional form on a surface by using line alone. However, this illusion may be greatly strengthened through the use of shade and shadow, which the artist calls *tones*. Ordinarily, the layman does not pay much attention to shade and shadow; but I assure you that a large part of the training of an art student is to make him supremely conscious of these two important elements in drawing.

IMPORTANCE OF LIGHT

Of course, if there were no light, there would be no shade or shadow: nothing for us to see, nothing to draw. It is only when light plays upon an object that we can see the form emerging. So the artist becomes incredibly sensitive to the play of light on form. Beginners usually see only about three tones when light plays on a white object: black, white, and gray. But the accomplished artist sees thousands. In fact, it is in this field — the field of light and shade — where a great difference exists between the beginner and the accomplished artist.

LIGHT ON PLANES Shade and shadow, obviously, are caused by light; so it is only through a thorough understanding of light that we can understand shade and shadow. A practical approach to the study of light may be initiated with a simple piece of white paper. Crease the paper into two planes and hold it up to the light from a window. The light should not be bright sunlight, which is too bright and dulls the sensitivity of the eye. Preferably, there should be only one window in the room.

Notice the extreme contrast of light and dark where the planes meet. The *lightest* area of the plane — adjacent to where the planes meet — is the highlight. In the beginning, the lightest plane will probably look just plain white to you; but study it carefully and you will see a subtle movement of tone from the far edge towards the brilliant highlight. Study the dark plane until you can see that the *darkest* part is adjacent to the place where the planes meet and that the tones will get perceptibly *lighter* (due to light reflected from the room) as they move towards the opposite edge of this plane.

COLOR, LIGHT AND SHADE Now place your creased white paper over the top and edge of a colored table. You will then see the pure tones of light and shade as they would be on the table if the table had no color. It is highly possible that these are the tones you would give your table if you decided to draw it in black and white.

Do you begin to see how an artist differentiates between colors and tone? Colors may be paint, dust, skin, sunburn, even lipstick. Suppose you put the creased paper over your somewhat block-like wrist; you will then see the pure tones; the color of the skin will no longer interfere with them. You can understand how easy it would be to see the pure tones on a nude if the model were made of white paper! This was one of the reasons why figure drawing was taught from white plaster casts in the old days.

You might try wrapping a piece of white paper around the leg of the next nude you draw, if there is no objection. (Be careful: models vary, but many of them are easily irritated!)

LIGHT AND THREE The separation of color and tone in the artist's mind is very important
DIMENSIONAL FORM indeed. But once you can think of everything as white, you have the knack. When it comes to highlights, it is sometimes valuable to think of

58

the material you are drawing as made of highly polished aluminum. Then you can understand how an artist can put a brilliant white highlight on a dark blue serge suit or on a nun's black habit.

Put a table near your window, cover it with a white cloth, and put a white cube, a white cylinder, and a white sphere upon it. The cube can be a lump of sugar, the cylinder a cigarette, the sphere a tennis ball. The light from your window should be somewhat above, somewhat to one side, and somewhat in front of your objects. This is the traditional light that artists have used through the centuries. If you can fully understand its effect on form, you will soon become familiar with all other lighting conditions the artist requires.

Perhaps what you have already learnt from the two planes of your paper will help you to understand the movement of light and shade on the cube. Take three pieces of sugar; place them one on top of the other, so that you have a sort of tall block. Now stand the cigarette on end next to this block. Study the tones on each object and see if you can feel the relationship between them. The highlight, you will find, runs down the full length of the cigarette as it does on the tall block. But the highlight on the cylinder does not meet abruptly with the full dark, as it does on the block; it merges, as you will see, slowly into the dark.

If you cannot see this, make a larger cylinder out of white paper and a larger block.

On the side away from the window, you will also see reflected light on both the cylinder and the block. Study the light side of the block and the cylinder; you will notice the almost imperceptible movement from very light gray at the far edge towards the highlight.

Though this sort of thing may seem rather dull to you, any artist will tell you it is of the greatest importance. If you are going to give your life to art, you should certainly spend at least a day performing the experiments I am describing.

GRAY TO HIGHLIGHT TO DARK TO REFLECTED LIGHT

Begin to make sketches of the movement of tones on the cube, and the cylinder and the sphere. Study particularly the tones on the cylinder. Tones in many natural objects move as they do upon the cylinder or upon parts of the cylinder. The movement you will discover is this. The edge towards the window is slightly gray; this moves imperceptibly from dark to light towards the highlight. There is then a subtle light-to-dark movement from the highlight to the extreme dark. This is a movement

most characteristic of a curved surface, a movement which does not exist on the two planes of your paper or your tall block. The movement is then dark to light, from the extreme dark to the far edge of the cylinder, which receives reflected light. Notice that no matter in what position you place the cylinder, the highlight will run the full length of the form.

Make a few hundred sketches of such movements, particularly that of the cylinder, until these movements of light and dark become part of your subconscious equipment.

INTERRELATIONSHIP OF
BASIC FORMS

Now take an egg and hold it in the same position as the cylinder. Realize that if you closed the two ends of the cylinder, you would have something like an egg; the shade on the egg would be much like that on the cylinder. And with a little visualization, you can press the ends of your egg and it will become a sphere, perhaps a tennis ball; you will then understand that the shade on your tennis ball is much like that on the egg. Of course, if you close just *one* end of your cylinder, you will have a cone; naturally, the shade upon the cone will be related to that on the cylinder.

In considering the sphere, it may be valuable to think of the sphere as a soap bubble, because then you will realize that the highlight is nothing but a mirror reflection of the light source. In fact, if you blow a soap bubble in your room, you will see a little window on the spherical form. On the tennis ball, of course, you will not see the window because of the texture of the ball.

LIGHT AND SHADE ON
INTERIOR PLANES AND
INTERIOR CURVED
SURFACES

We must also memorize the progression of tones on the inside of the cube, cylinder, and sphere. If you are unable to imagine what these tones should be, two pieces of creased paper, put together like the walls of a cube, will help you to understand the tones on the inside of a box; hold them in different positions. And you can curve another piece of paper so that it is like the inside of a cylinder. As for the sphere, you can easily study the inside of a white bowl.

LEARNING
LIGHT AND SHADE

The few objects we have been discussing are the basic forms of nature. The light and shade that appear upon each form are directly related to the light and shade that fall upon the other forms.

I have asked you to memorize the movement of tone on the interior and exterior of the forms we have been discussing because every accomplished artist has memorized these movements. He knows them instinctively and by heart. He is able to anticipate them when he draws and thus he can present them with sureness and authority.

CAST SHADOWS

Let us return to our white table by the window, with the cube, cylinder, and sphere upon the surface. You will notice that each object casts a shadow on the table top. If you made a drawing of the table top with these objects upon it, and then you rubbed out the objects, leaving only the cast shadows, your table top would have three dark blotches upon it. These would tend to give the illusion of holes in the table top. This is why artists complain that cast shadows tend to destroy the form on which these cast shadows fall.

It may come as a great shock for the average student to learn that accomplished artists radically change — or even eliminate — the cast shadows they see in nature or on the model. It is almost impossible for an instructor to persuade beginning students to eliminate cast shadows. Beginners seem to be attached to cast shadows with blind passion. The best cure for this is to make a number of drawings that illustrate the absurdity of retaining cast shadows in your drawing.

These drawings also present another stunning surprise to the beginner: the discovery that the artist does *not* draw what he sees. When one of Whistler's students said, "I like to draw what I see!" the artist answered, "Wait 'til you see what you draw!"

The first illustration is a very simple one. Draw a cylinder, rendering the light and shade very carefully; then draw another, but throw a cast shadow over the highlight. You will see that in the second drawing the illusion of roundness of the cylinder is partially destroyed. Think how often such a condition must arise, as when the cast shadow of one arm falls upon the highlight of the other, or upon the highlight of the body.

Now let us consider the cast shadow beneath the nose. The shadow is there, of course, but if you draw it as you see it, you will probably give the illusion that the model (male or female) has a mustache. The next time you see a portrait by a skillful artist, notice how he has eliminated or subordinated the shadow under the nose.

The head, of course, throws a cast shadow on the neck. Not only

does this destroy the highlight on the neck and thus the neck's column-like form, but this shadow may make the model look as if she had a beard.

I once had a student who carefully copied, as he drew the model's chest, the cast shadow of a cat asleep on the skylight.

We could continue down the body, examining the cast shadows, one by one, but I imagine you get the point.




INVENTING YOUR OWN
SOURCES OF LIGHT




Where there is no light, there is no visible form. When light plays upon the form, tones appear and the form emerges. But naturally there are certain conditions of light under which an object will give the clearest presentation of its shape. Skilled artists can create these light conditions *even though they do not exist*. An accomplished artist is able to create his own light source or sources, disregarding, if he wishes, those which *do* exist. Actually, an artist can not only create new sources of light, but he can decide on their position, color, size, and intensity. He can therefore create his own highlights, darks, and halftones.

You can grasp the importance of *inventing* light sources if you think of certain problems confronting the landscape painter. In the morning, he starts to paint a tree; if the sun is on his right, the shade and cast shadows of the tree will be on his left. After lunch, however, when he is completing his picture, he will find the shade and cast shadow on the *other* side of the tree. You can see that this would be troublesome unless an artist had the power of Joshua, which indeed he has, for he can command the sun to stand still! The artist realizes that just as he cannot draw a moving object, but must seize upon a phase of the motion, so he cannot draw an object under a moving light source, unless he imagines the source as fixed.







HOW LIGHT CAN
DESTROY FORM




But there is a much more important reason why an artist must have the power to create his own sources of light: the light that plays upon a form frequently — almost invariably — does not reveal the true shape of the form. I assure you that it is possible to arrange your sources of light so that a cylinder looks like the window of a prison cell and a sphere like a soiled white poker chip. You can see what complications might arise if the cylinder happened to be your model's neck, and the sphere her breast. This may sound exaggerated, but almost all beginners manage to make the egg-like form of the model's thigh look like a roller coaster or a large piece of cheese which the mice have taken over.




62

The best way to demonstrate the power of light to reveal or destroy the true shape of a form is to make a few experiments. We have already shaded a cylinder in a traditional light. Now let us throw *three* lights of equal intensity on the cylinder. Three highlights will run the length of the cylinder; there will be dark bars in between, and thus we have the window of our cell.

Or take your tennis ball into the bushes when there is brilliant sunlight and let the cast shadows of the leaves fall upon the sphere. Copy it carefully and show it to the man in the street, who probably knows nothing about art, but who instinctively understands the accepted symbols used in our civilization to explain the shape of a form. He will say your drawing looks like a dirty old poker chip to him, or maybe a mince pie.

JUMPING LIGHT

The ways in which light may destroy the illusion of shape are manifold. We have already covered such matters as the moving source of light, cast shadows, and the danger of too many sources. Now let us take up what is called *jumping the light*. Often when you draw the model, you discover that the light is coming first from the right, then from the left, then from the right again, and so on. Put the cylinder on the cube, and the sphere on the cylinder, and arrange the lights so that they come alternately from right and left. Make a drawing. You will find that the illusion of form has been partially destroyed.

Now build a simplified human figure: stand two cylinders on the table, the cube on top of the two cylinders, a small cylinder on the cube, and another cube on top. Now jump the light from side to side and see what a poor picture you have: imagine how disastrously such lighting conditions might affect the nude.

As you acquire skill and understanding, you realize that you can occasionally jump a light and improve the shape. But this takes skill and understanding. Don't be too anxious to try in the beginning.

VIOLATION OF LIGHT
AND DARK PLANES

Place your cube on the table. The side *toward* the light is called the front plane; the dark side *away* from the light is called the side plane. Now suppose you take a tiny but powerful flashlight and shine it on the dark side plane. The impression will be that there is a hole in the form. If you shine the flashlight on the dark side plane where it meets the bright front plane, it will seem as if a mouse has been nibbling at the corner of our

cube. Similarly, if you create little patches of dark on the bright front plane — and even under studio conditions, you will find these patches, due to accidents of light — you will tend to destroy the form of the front plane. Think what damage this sort of thing can cause to the illusion of shape in your drawing.

REVERSAL OF LIGHT
AND SHADE

A very common fault among beginners might be called the reversal of tones. When they are shading the side plane, they properly move from dark to reflected light, as they move away from the highlight; but as they move down the plane, they reverse these tones and then move from light to dark. Sometimes they will reverse themselves two or three times, even on a small plane. As usual, the illusion of shape suffers.

Naturally, the same applies to the front plane. A professional is most consistent in the movement of his tones, and will most likely maintain the same movement all the way down the figure.

VIOLATION OF
HIGHLIGHTS

Every form must have a highlight. In art school, the violation of a highlight is a grievous sin. If you are drawing a detail that exists in the highlight, draw very lightly, or omit the detail altogether.

This is because the contrast of light and dark is one of the most important devices we have for creating the illusion of shape; such contrast is usually reserved for the meeting of planes. Be careful not to put a black line or blotch in the highlight. Your line or blotch usually represents an unimportant detail; but it will be in extreme contrast with the highlight and will *seem* like one of the most important elements in the picture.

LINE CARRIES LIGHT
AND SHADE

When a line travels over a form, it carries the characteristics of the shade on the form. In other words, the line is dark where the shade is dark, light where the shade is light, non-existent or very light in the highlights.

It takes much practice and a delicate touch to accomplish this, but, as usual, practice makes perfect. Draw a number of forms and shade them; then run lines over them, making your line light where the form is light and dark where it is dark. And practice running lines in any direction over the human figure, letting each line vary in value as the values vary upon the body. Do the same with drapery placed in a good light. Do all this so many times that the practice becomes utterly instinctive.

ONE FORM IN FRONT
OF ANOTHER

When one form comes in front of another, beginners usually darken or blacken the *rear* form to make the form in *front* stand out. Beginners do this not only because they see the cast shadow on the rear form, but also because they erroneously believe that the black rear form will push the front form forward. The professional realizes, on the other hand, that the way to bring the front form forward is to intensify the contrast between the planes of the front form. The cast shadow *is* used at times on the rear forms, but it tends to kill the planes and destroys the illusions of true shape when it is misused.

You meet this particular problem constantly in figure drawing: when one arm is in front of the other; when the arms are in front of the body; when one leg is in front of the other, etc.

REFLECTED LIGHT

Reflected light is one of the most powerful devices we have for presenting the illusion of three dimensional form. It can be regarded as simply another independent light source, less intense than the source which causes the highlight. The traditional reflected light usually comes from somewhat behind the model, somewhat to one side. But whether it comes from above or below the model depends upon the artist. As we have seen, the artist controls his light sources; the decision as to whether reflected light comes from above or below depends upon his will.

Reflected light may destroy the illusion of form in several ways. One very common problem is too intense a source of reflected light. If we throw an intense reflected light on our cylinder, we must not make our cylinder *pure white* on the edge where the reflected light falls. This will give the confusing impression that this part of the cylinder is facing in the same direction as the highlight.

If a reflected light is thrown on *each side* of the form, the illusion of the true shape is also weakened. To prove this, simply draw a cylinder and throw reflected light on each side; you will see how the illusion of shape is marred.

LIGHT AND DIRECTION

There is a related principle at work here. If the movement of light and shade clearly indicate that a form faces in a certain direction, then the same tones on another part of the form will give the illusion of facing in the *same* direction.

For instance, let us say that we draw a figure and begin with the head. We make the forehead generally light and the side of the head dark. Thus, we have already made a strong statement that light areas are facing in one direction and dark areas are facing another. The observer's mind seems to grasp this readily; he thereafter *expects* the other front planes of the body to be generally light, and the side planes generally dark, as we drew them on the head. He expects all front areas to face the light and side areas to face the dark.

This is another strong reason why artists cannot draw what they see. If the *actual* light does not behave properly — if lights and darks are inconsistent — he must be able to create, alter, or quench sources of light. And this is another argument, of course, for not jumping your light.

THE ARTIST CONTROLS
LIGHT

The professional artist is acutely aware of the existence of light and its effect on form. He understands that light can create *or* destroy form: thus, he must be the creator and destroyer of light. He is instantly aware of light sources that play upon form: their color, position, size, and intensity. He can change the position of these sources; regulate their color, size, intensity; quench them; or create new sources.

He decides the number of lights to throw upon the form and knows the danger of throwing more than two. He decides with exactitude on the progression of tones. He is a dedicated hunter of cast shadows; he can spot one at a hundred yards and annihilate or tame it at a glance.

DECISIONS YOU MUST
MAKE

You see now that one problem of drawing has to do with deciding on what forms you wish to draw, deciding on their exact shape, then presenting them under the lighting conditions that best bring out this shape. If you do not like the lighting conditions as they exist, you must invent better ones. This means that in figure drawing you must analyze the body until you can break it into the forms you wish to draw; you must decide on the shapes of these forms; and then you must decide on the lighting conditions that will best bring out these shapes.

In figure drawing, it is a good idea to take a piece of paper, cut a small hole in it, and hold it before your eye to isolate the separate parts of the drawing. Then you can ask: "Does this form really have the shape I had in mind?" In this process, you think of the shape of the form itself, alone and unconnected with the rest of the body.

66

ILLUSTRATIONS

LIGHT AND PLANES

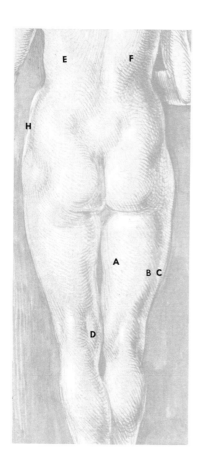

Albrecht Dürer (1471-1528)

FEMALE NUDE

silverpoint

11⅛" x 8¹³⁄₁₆" (28.3 x 22.4 cm)

Kupferstichkabinett, Berlin

Assuming that you know by heart the movement of tones on a column lit by direct and reflected light, you should have no trouble analyzing the tones on the model's legs. A is the highlight, B the dark, and C the reflected light. A theoretical line through the darkest part of the dark is the *edge* where the planes meet. The proper placement of this theoretical line greatly increases the illusion of form. Dürer has actually placed a small part of this slightly curving vertical line on the inner hamstring of the leg (D). Each buttock is shaded much like a sphere. In the back, E and F are conceived as columns. But E is unable to move into reflected light, because that part of the column E which would receive the reflected light is covered by F.

Cast shadows are used, but they are used by a master and *sparingly*. Where, for instance, is the cast shadow that should be on the calf? Where is the cast shadow that might be under the buttocks? Dürer *does* use a cast shadow on the arm (H), but the shadow's course obeys the contour and improves the form.

You *can* use a cast shadow if it helps the form. But you have to draw for quite a while before you are a good enough critic of your own work to make such a decision.

68

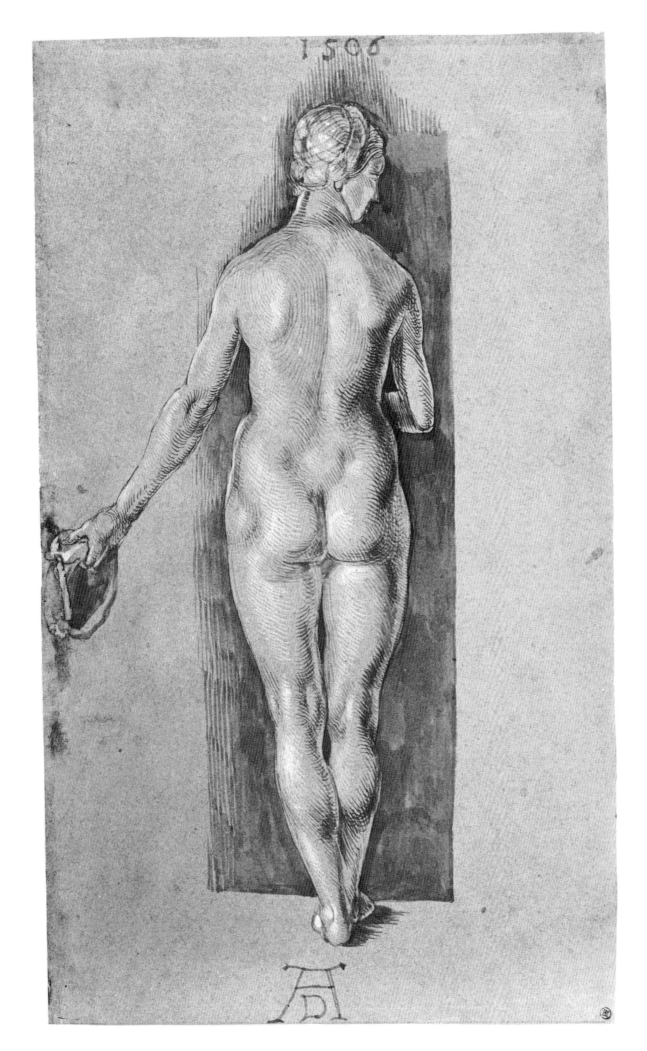

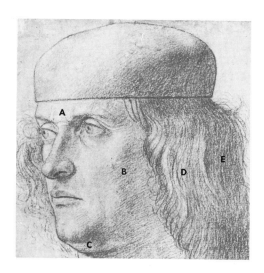

For purpose of tones, the head was thought of as a block, with a front plane (A) — the whole front of the face — a side plane (B), and a down plane (C). The artist has forced the tones to move as they would move on a box with a direct light from the left and a weaker reflected light from the right. As usual, when the head is conceived as a block, the nose also becomes a block. The hair was also thought of as a block, with front and side planes, D and E.

As on a block under these lighting conditions, the shade on the side plane (B) moves from dark to light, left to right; and the shade on the down plane (C) from dark to light, front to back. The hat has column and sphere qualities, and is shaded as such, with the same lights that fall upon the face.

Artists do not like to change the direction of their lights from form to form, unless there are really good reasons. Even under studio conditions, light directions frequently shift on the model; but artists refuse to accept such shifts.

The neck is thought of as a column, around which sweeps the line of the collar. The cast shadow of the head on the neck is subordinated, as is the cast shadow of the nose on the skin above the upper lip. A big black cast shadow under the nose destroys any possibility of carrying out the delicate modeling of the upper lip.

70

Albrecht Dürer (1471-1528)

HEAD OF A NEGRO

charcoal

12⅝" x 8⁹⁄₁₆" (32 x 21.8 cm)

Albertina, Vienna

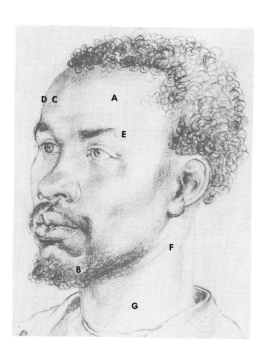

Here the artist has thought of the head as a sort of a column, rounded on top. His principal light comes from one side, in this case, the right, above, and in front (most artists' favorite light). Reflected light comes from the left. The highlight moves down the head rather widely and loosely from A to B. As the head is thought of as a column, so is the nose. The dark on the head is seen clearly at C and reflected light at D. Notice how the highlight on the head completely smothers the dark of the eyebrow at E. Remember, highlights should not be violated by darks.

The neck is a column. Its highlight runs from F to G. Notice how the lines of the collar, going around this column, follow the shade that should properly be on the column. They fade at the highlight, darken at the dark, and fade perceptibly under the influence of the reflected light.

One lesson to be learned here is that artists change their mass conceptions of a form (head, rib cage, thigh, or *anything*) in order to solve the problem at hand. This Dürer head and the Bellini head on the previous page are both looking in roughly the same direction. But Bellini's principal light comes from the left, Dürer's from the right. Bellini realized that — for *his* light — a block conception would solve his tone problems. Dürer knew that a block would be unsuitable for *his* light. So he created a kind of cylinder, rounded on top, to solve his tone problems in this particular drawing. To solve a different problem, he might have used a block.

Peter Paul Rubens (1577-1640)

PORTRAIT OF ISABELLA BRANT

black, red, and white chalk

15" x 11½" (38.1 x 29.2 cm)

British Museum, London

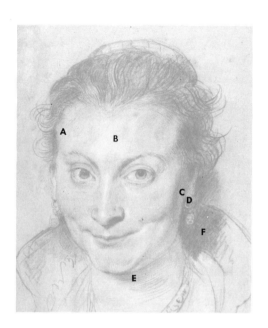

This head is thought of as a block, the front plane somewhat rounded. The light is from the left, above, and in front. The nose as usual is thought of in much the same way. (It is a very good thing to visualize heads *without* noses because noses disturb the front plane.)

The tones run in the usual way: (A) to highlight (B) to dark (C) to reflected light (D). As usual, the tonal scheme on the nose is the same as that on the block of the head.

The side plane of the face curves into a down plane, but this down plane is not dark because the reflected light is from below. The rule, *up plane light, down plane dark*, is based on the fact that the light almost always comes from above, as from the sun, skylights, and lamps. Naturally, if the artist chooses to light his model from below, the rule is reversed.

It is very good practice for students to draw the model as if the direct light were coming from below.

The cast shadow under the nose is subordinated. The cast shadow of the head on the neck (E) is drawn with nicely curving lines, which accentuate the cylindrical mass conception of the neck. The cast shadow of the head is used on the collar (F) because a patch of dark there is a nice foil to the head. Notice the movement of values on the jewel of the earring: the same movement as on the head itself.

Jacopo da Pontormo (1494-1557)

HEAD OF A WOMAN

sanguine

9" x 6¾" (22.8 x 17.2 cm)

Uffizi, Florence

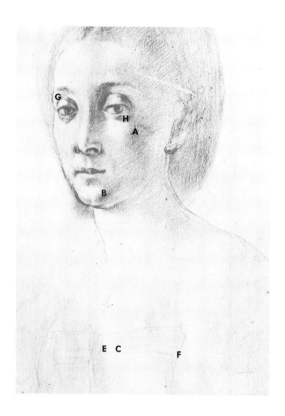

This head is thought of as an egg, the direct light from the left and above, the reflected light from the right and below. There are a number of sphere symbols used here: the eyes, the cheek bone (A); the chin (B); and the breast (C). The lines moving from E to F run over the sphere symbol of the breast. Notice how they fade when they cross the highlight at C.

Notice the form (G) above the eye. It is what the artists call the sausage and is egg-like. It is often strongly lighted as it is on page 75.

Note very carefully the little white up plane of the lower lid of the eye on the right. Notice how strongly it is contrasted with its down plane at H. Then look at the upper lid and note the violent contrast of the front and side planes. Pontormo wanted his eye to dominate the picture and he knew that strong contrasts of light and dark would be sure to attract the observer's attention.

François Boucher (1703-1770)

STUDY FOR THE JUDGMENT OF PARIS

charcoal

13¾" x 7½" (34.9 x 19 cm)

Collis P. Huntington Memorial Collection

*California Palace of the
Legion of Honor, San Francisco*

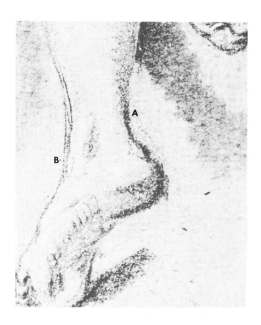

There are hardly any concave planes in the human body. In this drawing by Boucher, I really do not think there are any concavities at all. Nor are there any concave lines. Beginners are forever taking great bites out of the body with concave lines. But a study of the masters will show that they do not use concave lines to outline their forms, except under the rarest circumstances.

On close examination, what appears to be a concave line will often turn out to be a convex line, or a series of convex lines, like the curve of the ankle (A). The front of the ankle (B) is interesting because there *are* two concave lines there. Whenever you draw a concave line, be on the alert. After Boucher drew two concave lines at B, he evidently remembered the rule and put a faint *convex* line to the left of the upper concave line and two convexes to the right of the lower concave line.

Remember, Boucher did not copy the actual tones he saw running across the back of this model. He created a mass form in his mind, something like a column with convex fluting. He then invented a direct and reflected light, observed the resulting imaginary tones on his imaginary column, then transferred these tones to the drawing he was making of his model.

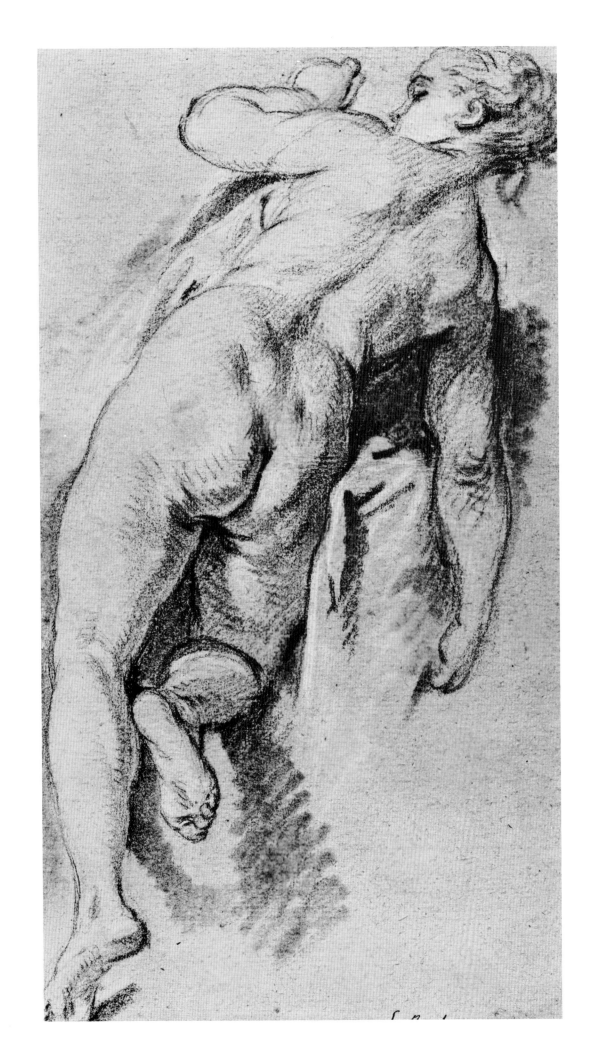

Raphael Sanzio (1483-1520)

COMBAT OF NAKED MEN

pen and brown ink

10⅞" x 16½" (27.5 x 42 cm)

Ashmolean Museum, Oxford

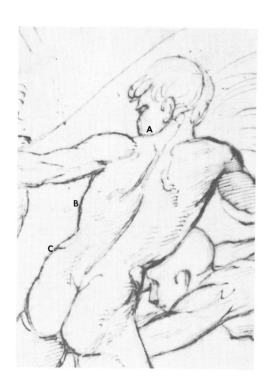

Speaking of concave lines, how many can you find in this drawing by Raphael? The trapezius line (A), apparently concave, is actually three convex lines. The apparently concave line B-C is actually three convexes.

Beginners invariably make these two lines — the trapezius line (A) and the rib cage-external oblique line (B-C) — concave. In fact, beginners adore putting concave lines all over and all around the body. But the body is something like an inflated balloon: no matter where you poke it with a stick, the surfaces are always convex.

This is an imaginary drawing, unlike the preceding drawing by Boucher. Now, I am *not* telling you to avoid drawing from models; you *must*, and frequently. I am trying to impress upon you the fact that you can never draw the model with real skill — with anything approaching the skill of the artists in this book — unless you can create figure drawings out of your imagination.

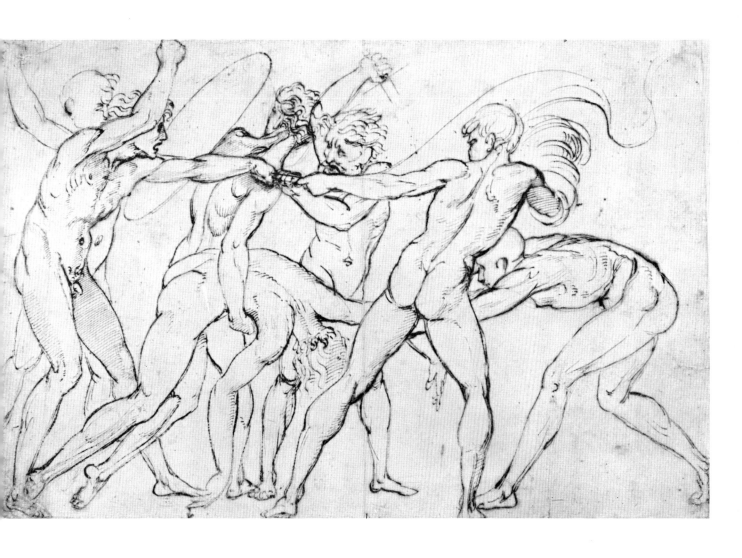

Albrecht Dürer (1471-1528)

FIVE NUDES, STUDY FOR A RESURRECTION

pen

7⅜" x 8⅛" (18.8 x 20.6 cm)

Kupferstichkabinett, Berlin

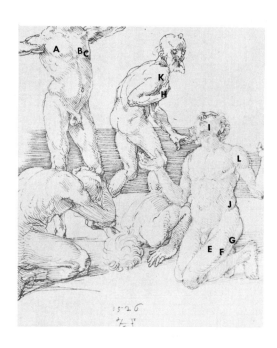

In this drawing, lines have been used to indicate the shade; but the same basic tone systems are still in operation. Students must understand that every drawing principle is related to every other principle. You cannot make a good line drawing unless you understand light and shade as well as all the other elements.

Here, A is the light front plane, B is the dark, and C is the reflected light. On the kneeling figure, E is the light front plane, F is the dark, and G is the reflected light. The hand (H) is thought of as a block.

Notice the simple blocking of the head (I) and the external oblique mass (J).

The external oblique is another example of how mass conceptions change. On front views, it is usually thought of as a teardrop. As the front view approaches the three-quarter, it is often thought of as a combination of teardrop and wedge. The deltoids (K and L) are close to sphere symbols.

Cast shadows on the figure are used very sparingly. Cast shadows are liberally employed on the ground at the feet to give the model a firm stance on the ground plane.

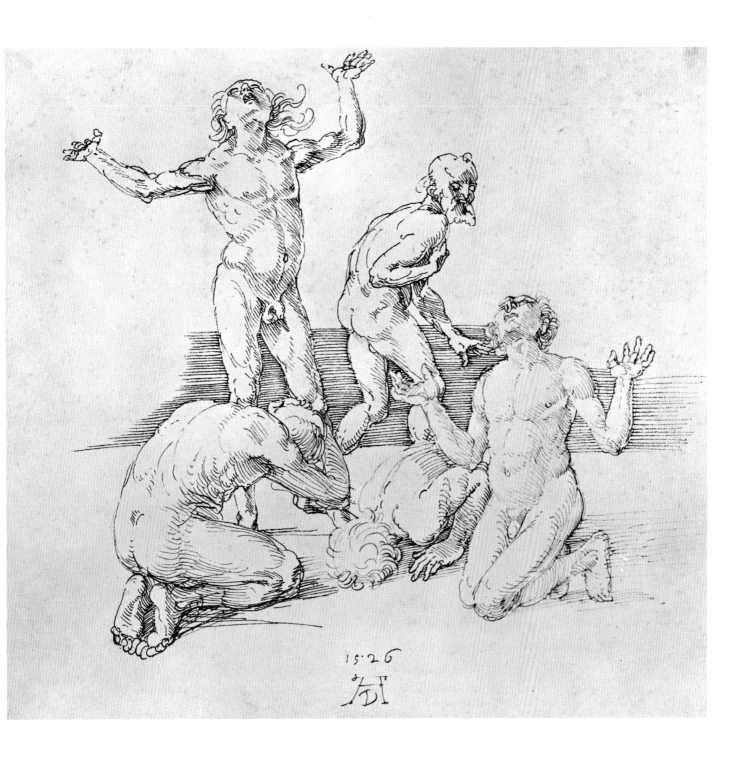

15·2·6

83

Tintoretto (Jacopo Robusti) (1512-1594)

DESIGN FOR VENUS AND VULCAN

pen and wash

8" x 10¾" (20.4 x 27.3 cm)

Kupferstichkabinett, Berlin

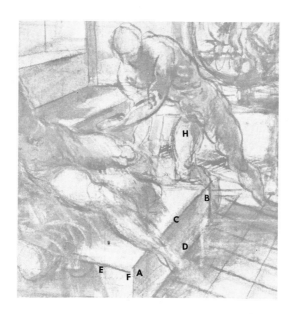

Here we can see the value of studying the inside and outside of cubical boxes. The inside of the room is the inside of a box; so are the recessed windows. The bench is a box; so are the table and the bed.

Please get some white block-like boxes and study the shade movements on them. Study tones on white things first. Tones on colored things confuse a beginner.

Notice that the shade movement from A to B is dark to light, as are C to D, E to F. Notice how the egg-like massing predominates in the figures: in the upper legs, the lower legs, and particularly the lower arm. Get a white egg out of the refrigerator and shine a light on it as in H.

This picture is a very nice exercise in perspective. All the artists in this book knew their perspective well. Get a book on perspective and study it. Do you know any young architects well? I am sure they would be delighted to give you the rudiments.

84

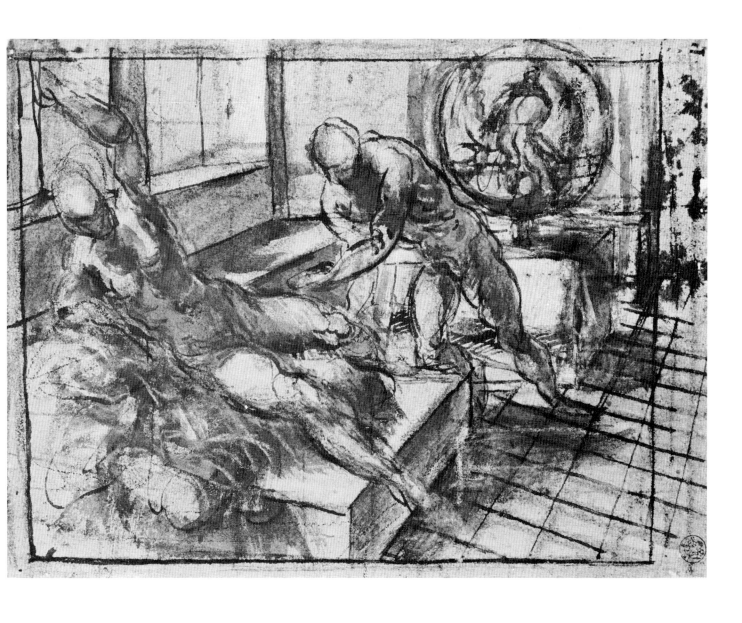

FOUR

MASS

AN ACCOMPLISHED ARTIST is extraordinarily skilled in visualizing forms in terms of very simple mass. The masses he uses are the simple geometric forms we have been discussing: the block; the cylinder; the sphere; occasionally the cone; as well as simple combinations and modifications of these forms, principally the egg. He does this not for the fun of it, but because he knows through experience that by thinking in simple geometric forms, he will easily solve all sorts of problems that seem insurmountable to the beginner.

When we wish to create the illusion of reality on the surface of a piece of paper or canvas, nothing is more helpful than the ability to visualize in terms of simple mass. Troublesome problems connected with general shape, proportion, direction, planes, detail, light and shade, and line can all be solved by thinking in simple geometrical masses.

MASSING AND GENERAL SHAPE

If you draw objects with your mind on one detail after another, the results will be poor; the large shape of the object, in which resides much of the object's impact and personality, will be lost. Artists therefore think

of the mass first of all. Many of them actually sketch it on the paper, even after many years of drawing experience. Certainly, beginners should always do this. Later on, they may not have to do this unless they wish. By then, they will have the habit of visualizing the mass whether they sketch it in or not.

A good example of how general shape is preserved through the use of mass occurs in the drawing of the profile of a skull. Beginners, enraptured with detail, will create a most distorted illusion. But if you first think of the skull as an egg in front and a ball behind, the details will become subordinate to the general shape and the drawing will be much stronger.

A side view of the body is most easily massed by using the egg and ball idea for the head; a cylinder for the neck; and various egg shapes for the rib cage, the abdomen and buttocks, the thighs and lower legs. The detail may then be very readily sketched in and should fall into place very naturally.

It is well to know that as different problems arise, the artist may use different masses for their solution. On a side view of the body, for purposes of general shape and proportion, he may well use two eggs: one for the rib cage; one for the hips. But if, on the side view, the top of the rib cage is directed towards the artist, and the hips have an opposite direction, he may visualize cylinders to accentuate these directions.

MASS AND PROPORTION

Beginners always feel that somehow, somewhere, someone has laid down for all time the proportions of the human body. They are convinced that all they have to do is to memorize these mythical statistics and everything will be all right. Beginners unconsciously feel that the anthropologists have measured all the people of all the races in the world, past and present, and have come up with something called the "normal" or "ideal man," whose proportions the artist should draw.

Proper proportions lie, however, not in pages of statistics, nor in the dogma of scientists, but in the mind of the individual artist. Proportions are entirely his responsibility, his decision.

In the beginning, however, the student is confused by the problems of proportion as a whole; he is unable to decide on the proportions he prefers, nor has he the skill to *draw* them even if he could decide. So perhaps it is wise for the instructor to offer the student a few simple

observations on the mythical "average figure." If they do nothing else, these observations will make the student feel happier and more secure. Later on, when he learns to draw, he can observe when the model adheres to these proportions or departs from them. He can accept these proportions or reject them as he sees fit.

In the beginning, all students have a tendency to make one of two errors: when they draw the figure, it gets progressively larger as they work down the paper, or the figure gets progressively smaller and more squat. These students can be helped if they are told that the symphysis pubis (the place where the pelvis comes together in front, between the thighs) can be taken as a point halfway between the top of the head and the soles of the feet. Then, at least, the student who makes his figures progressively larger as he works down will be able to get the feet in before he reaches the bottom of the paper.

It is helpful, too, to say that the nipples are about one head below the chin; the navel another head below the nipples; and the symphysis pubis about three fourths of a head below the navel. The knees may then be said to come halfway between the symphysis pubis and the floor.

Of course, the trouble with this good advice is that these remarks work well when the model is standing straight, but the whole system collapses when the model poses in any other position.

It is better, therefore, to realize that proportions are largely a matter of relating masses in a manner suitable to the *artist* himself. In drawing the figure, you should constantly practice breaking the body down into simple masses: the head as an egg and a ball or perhaps a block, for instance; the neck as a cylinder; the rib cage as an egg; right down to the fingers, which may be thought of as cylinders or long blocks.

Practice will promote your ability to visualize the figure in terms of mass. At the same time, practice will greatly refine your feeling for proportion.

Start right away on a front figure. Mass up the head and the neck. Then visualize the egg of the rib cage in a proportion that pleases you when you relate this egg to the masses of the head and neck. Throw in the ball of the abdomen underneath. How big do you want to make it? This depends entirely on your expressive intent.

You are an artist now, you must make your own decisions. Do you prefer the proportions of Rubens or Michelangelo? Or would you like to leave the ball of the abdomen out altogether, like Henry Moore?

Beginners have more trouble with light and shade than with anything else in drawing. The reason is that the accomplished artist depends much more upon his mind than upon his eyes. He seldom draws exactly what he sees. He draws what he knows will promote the *illusion* of reality. The professional artist largely determines his tones of light and shade *not* by copying from the model, but by visualizing his model in terms of simple masses, and by lighting these masses in his mind. The tones he sees in his *mind's eye* greatly influence the tones in his drawing.

This seemingly involved process naturally stupefies the beginner, who almost always starts to draw with the conviction that he must copy exactly what he sees. Even though he may understand the process intellectually, the effort of visualizing mass, and creating light, quickly exhausts the poor beginner. After a short time, he invariably returns to his old method of exact copying, as a tired traveler returns to his fireside.

Every instructor knows that drawing can be taught in the classroom only by constant repetition of a small number of basic principles. So let us repeat. When the accomplished artist shades a form, his drawing will be strongly influenced by the tones he *conceives* to be on the controlling mass or masses. I might even say that he frequently *transfers* these tones to his drawing, blinding himself to the tones he sees upon the model.

For instance, if he wishes to draw the model's lower arm and hand, he may visualize the lower arm as a long, narrow egg; the wrist as a block; and the hand as the wedge-shaped mass. He has now visualized the general shape, proportion, and direction. Now for his light. Thinking of the wrist as a box, he may reason that a light from the left (slightly above and to the front) and a reflected light from below (but to the right) will reveal this form at its best. He will then light the other masses with the same lights, knowing that jumping the light is destructive. He also knows that it is constructive to have the highlight run the full length of a complex form like the arm and hand, without interruption. And he knows that the same is true of the intense darks.

In figure drawing, all lines should travel over preconceived form. But if the form is complex, this seems a difficult rule to obey. However, if the form is thought of in terms of simple mass, drawing lines is not so difficult for the beginner after all.

If you think first of the simple mass, you can easily draw lines that give the illusion of traveling in three dimensional space. For instance, it

is very difficult for the beginner to draw the ribs of a skeleton from the front view. To him, each rib poses an individual problem each seems an independent object; each presents its own extremely subtle curve as it moves downhill towards the front of the body. But when the student is told that the rib cage may be thought of as an egg — that the ribs are but lines to be drawn over this imaginary egg — the problem is solved. If he then thinks of the tones that might be on the egg under decent lighting conditions, he can shade his egg first, draw the ribs, then rub out everything between the ribs, and the ribs will be beautifully shaded.

Similarly, if he wishes to draw an eye, he will simply run lines over a sphere, and eyelids will appear. The shade on the sphere, of course, will influence the shade on the lids.

Many lines that are extremely valuable in figure drawing may be attacked in this way and their full spatial significance easily understood. The center lines of the torso, front and back, must always be present in the student's mind. They may be constructed in this manner. The front line may go over the egg of the rib cage and then over the ball of the abdomen. The back line may again travel over the egg, and then perhaps over a cylinder representing the buttocks.

MASS AND SUBORDINATION OF DETAIL

Beginners always feel that all details are created equal and that it is thoroughly undemocratic to put details in their proper place. But this liberal belief leads to disaster. Of course a drawing must have details. But the student must realize that their impact must be subordinated or intensified at times. And sometimes they are selected, invented, or even eliminated altogether. These procedures require the deepest resources of the artist.

It is in the realms of mass and tone that students most frequently mishandle details. This mishandling may be easily corrected and explained. Remember that details must never be allowed to attract the attention that rightfully belongs to the mass itself.

Let us consider a line around a shaded cylinder. The cylinder is the mass and the line is the detail. If the line is allowed to circle the cylinder in full strength, the line will draw too much attention to itself as it crosses the highlight and the delicate grays. The solution to this problem is to vary the strength of the line so that the line is very light (or even absent) in the highlight, dark in the darks, and hardly seen in the grays. Naturally, segments of any other line, on any other part of the cylinder, must be

so treated. From this, we draw the conclusion that the tones of lines on any mass must vary according to the tones on the mass. A crease in the skin or a line indicating a satin ribbon around the neck will naturally vary in strength, according to the tones on the controlling mass.

INVENTING MASS
CONCEPTIONS

Mass conceptions, as I have pointed out, are used to solve figure drawing problems. Students of the figure soon become familiar with those masses that help them solve problems of light and shade. Naturally, there are certain mass conceptions that are so apparent and so useful that they are used by almost everyone: the head is again and again thought of as a block or an egg, or an egg and a ball, the neck as a cylinder, etc.

An artist necessarily *borrows* these conceptions, but he also *invents* many others spontaneously as problems confront him. In fact, some of the most personal qualities of an artist's style stem from his preference for certain mass conceptions. As you study the master drawings in this book, notice how different masters choose different mass conceptions for the *same* form. Perhaps you can now make up some mass conceptions of your own. If you are to become an artist, the things I tell you are not half so important as the things you create for yourself or discover through your own investigations of the human form.

ILLUSTRATIONS

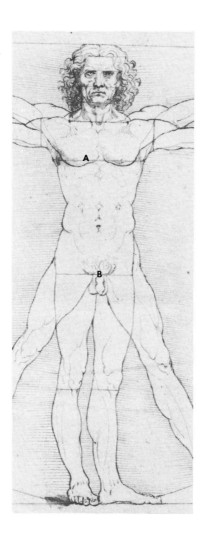

Leonardo da Vinci (1452-1519)

CANON OF PROPORTIONS

pen and ink

13½" x 9⅝" (34.3 x 24.5 cm)

Academy, Venice

Here Leonardo experiments with proportions. Of course, he settled on certain ideas of proportion that appealed to him as a man living in fifteenth century Italy. Now a Japanese and an Aztec of the same period (endowed with similar genius) would have found Leonardo's proportions unsuitable and would have thought up proportions that appealed to *them*.

For your convenience, there *are* proportional ideas in this drawing that are still used by many Western artists. The nipple line (A) is one head below the chin. The symphysis pubis (B) is halfway down the figure. (Artists are aware that the top of the great trochanter and the tip of the sacrum are on about the same level; they too may be thought of as halfway down the figure.)

Notice that Leonardo has divided the head into three equal parts from the hair line down. The upper leg is two heads high. The lower leg is two heads high. The pelvis is one head high.

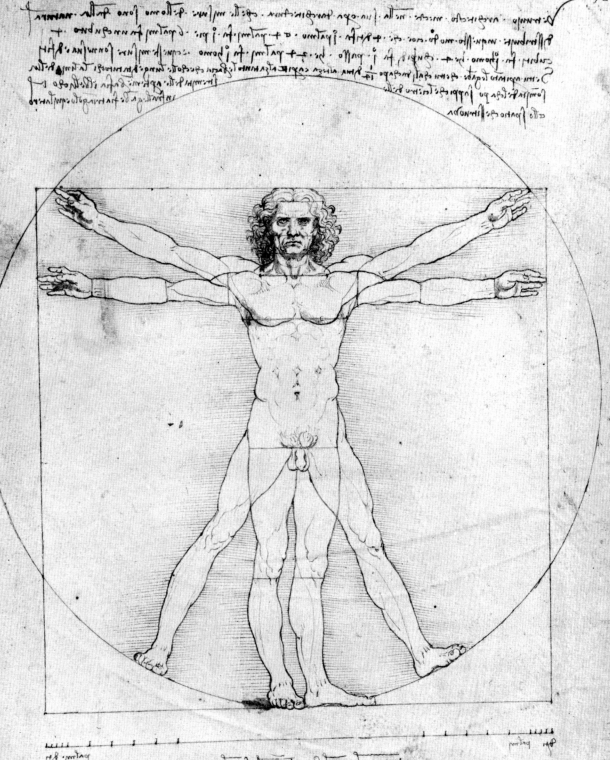

Albrecht Dürer (1471-1528)

STANDING FEMALE NUDE

pen

12⅞" x 8⁹⁄₁₆" (32.6 x 21.8 cm)

British Museum, London

Dürer is experimenting with a system of proportions. As you can see, they are very different from Leonardo's. The upper and lower legs are two heads each as in Leonardo. But otherwise there are very few proportions similar to Leonardo's figure. The symphysis pubis (A) is not halfway down. The center of the body is on line B-C. The nipples are not one head below the head. The pelvis is well over a head high.

This plate and the Leonardo should convince you that proportions vary in the hands of different artists. As an artist, you can use whatever proportions you choose.

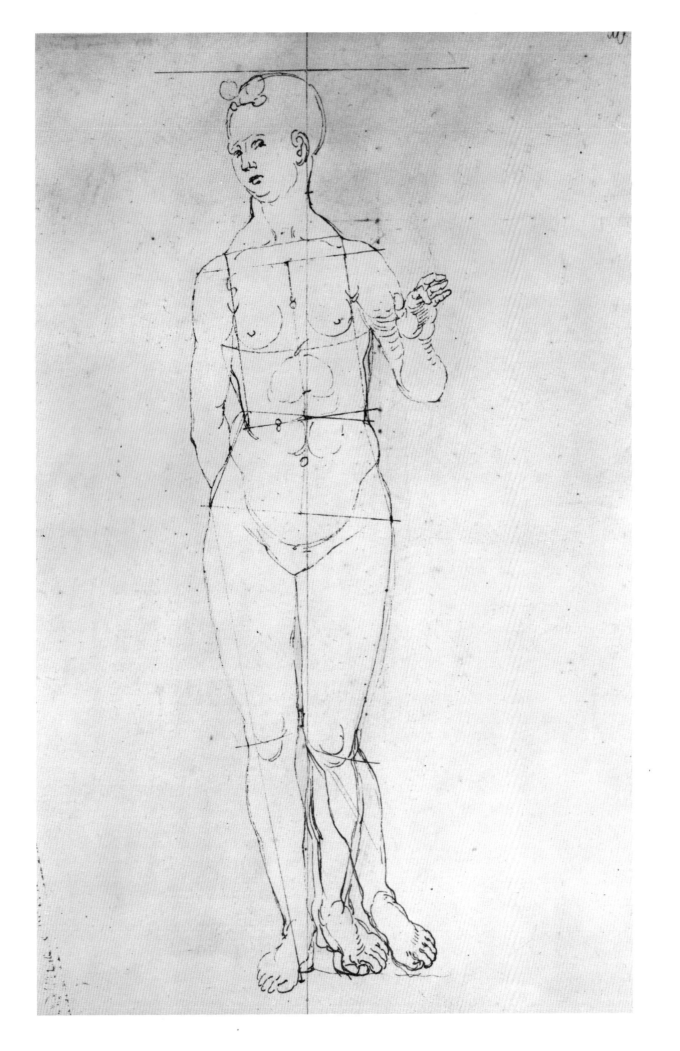

Leonardo da Vinci (1452-1519)

HEAD OF AN OLD MAN

pen and ink and red chalk

11" x 8¾" (27.9 x 22.3 cm)

Academy, Venice

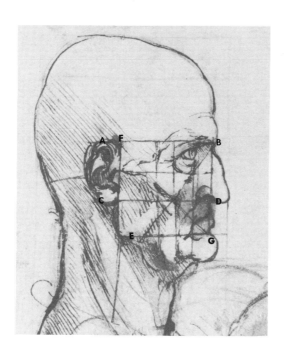

Leonardo in the large head is concerned with the proportions and placement of the features each to each.

For the student, the most important lines are A-B and C-D. Ears are usually placed between the eyebrows and the base of the nose. When a head is in an unusual position, the proper placement of the ear is difficult. Think of your head as a block. Try throwing the block into a three-quarter view, tipping slightly forward. Now run two lines (A-B and C-D) around the block at the level of the eyebrows and the base of the nose. The ear will naturally fall between these lines. If you must draw a head in any strange position, draw a block in the same position, and you will be able to place the ear correctly by using these lines. If you prefer, you can use a cylinder or an egg.

Leonardo gives you all sorts of valuable suggestions here. He shows you that the front of the eyeball, on the side view, may be as far back as the end of the mouth; that the outer corner of the eye may be as far back as the point of the cheek bone. He thinks up two other lines — the diagonals he has put on the face — B-E and F-G — to reinforce the placement of the tips of the cheek bones. He introduces you to one of the most important construction lines (B-G), the famous center line of the face.

98

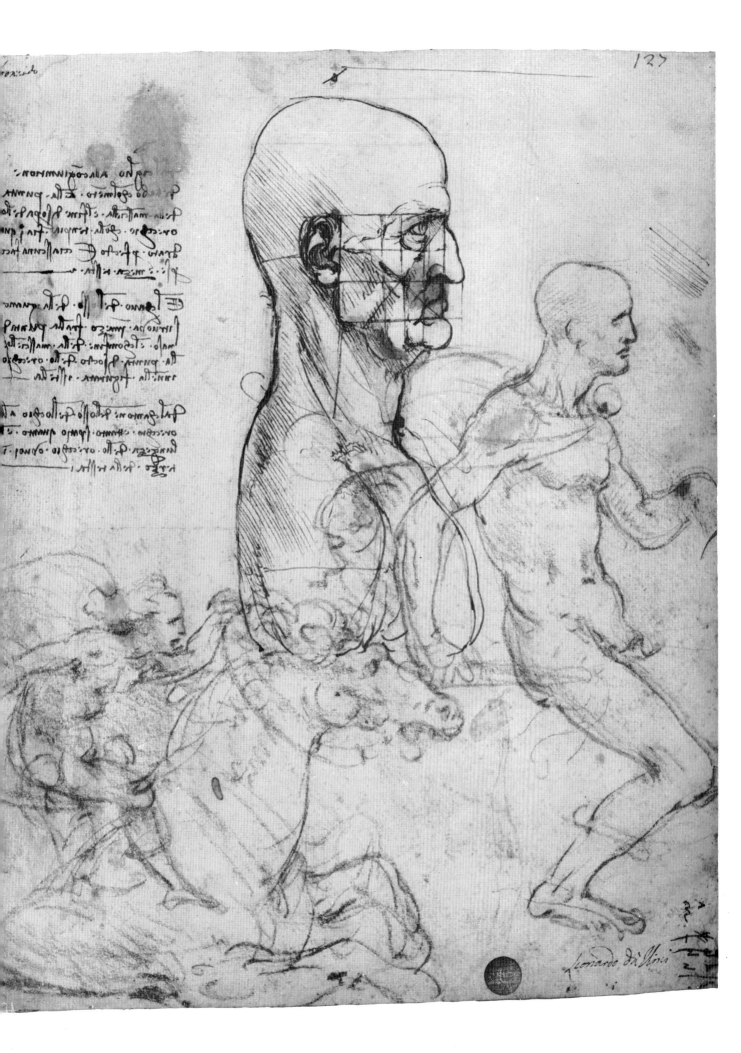

Michelangelo Buonarroti (1475-1564)

STUDIES FOR THE LIBYAN SIBYL

red chalk

11⁵⁄₁₆" x 8⅜" (28.8 x 21.3 cm)

Joseph Pulitzer Bequest

Metropolitan Museum of Art, New York

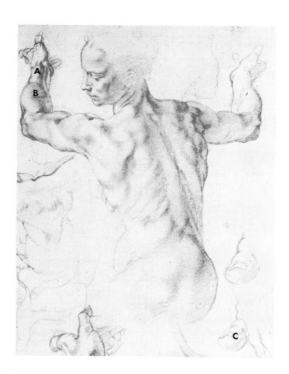

In this figure by Michelangelo, it is clear that the wrist (A) is thought of as a block and the forearm (B) is thought of as an egg. Another very evident mass conception is the toe (C) which is essentially a sphere symbol. The drawing is littered with egg symbols. The head, I believe, is thought of as a block with a rounded front; and so is the nose, though the wing of the nose is a sphere.

Small mass symbols are frequently placed on large mass symbols, as the spherical wing of the nose placed upon the larger block of the head. When small mass symbols are placed on large mass symbols, the small ones are often partially buried in the large mass. Let us illustrate this point by examining the model's back. Many little egg-like forms are buried in the large controlling mass. In all cases, Michelangelo is forcing the values on his little forms to conform with the important tones of the large controlling mass.

100

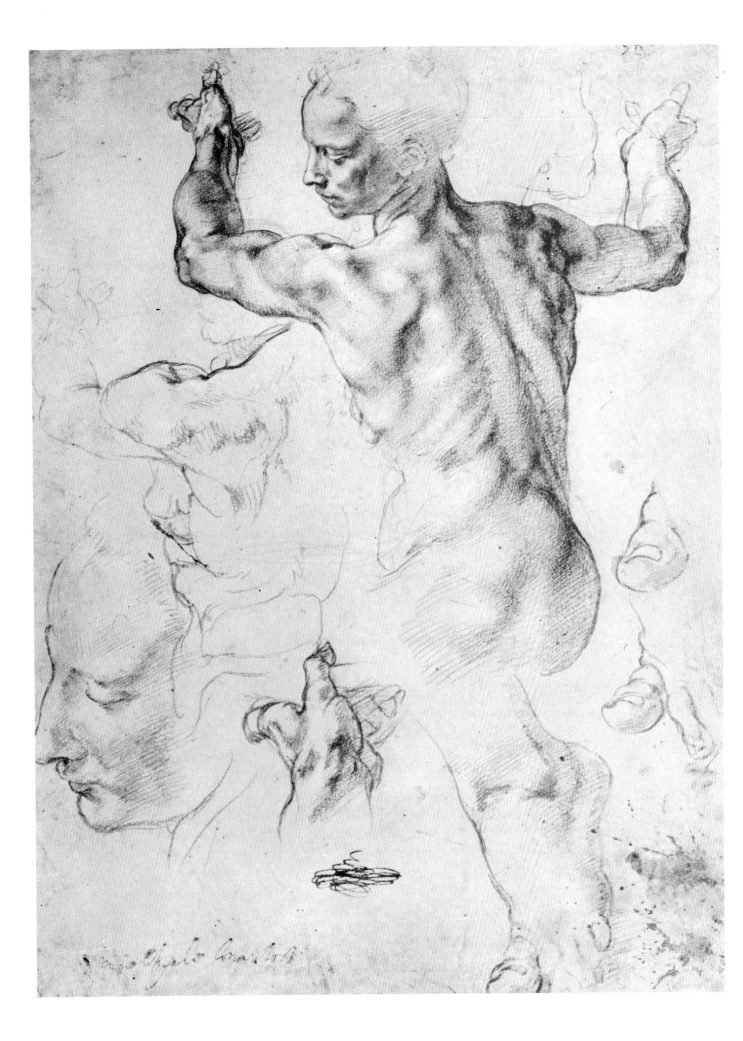

Annibale Carracci (1560-1609)

POLIFEMO

pen

10⅛″ x 7¼″ (25.8 x 18.5 cm)

Louvre, Paris

This drawing and the following are interesting because they show how an artist — in this case Carracci — can throw his principal light at will; first from the left, as in this example; then from the right, as in the example on the following page.

The thigh is thought of as a block with front plane (A) and side plane (B). The lower leg is a sort of cylindrical mass, with front plane (C) and side plane (D).

Carracci has not put any shade on the side plane of the body (E), though he has put it on a detail on the front plane (F) (the side of the rectus abdominis). I think this is bad, like putting shade on the side of a nose, then not putting any on the side of the head. I also feel that the patch of dark (G) on the chest is a crude violation of the front plane. In the next picture you will notice that he corrects these conditions.

Carracci's instinctive feel for the relationship of mass to mass is in no way as highly studied as Michelangelo's.

Line H follows Poupart's ligament, a feature much considered by artists as it separates the torso from the thigh. Here the line symbolizes the interior plane break where the torso meets the thigh. Line I also symbolizes the interior plane break where the deltoid meets the chest. Line J symbolizes the interior plane break where the calf group meets the tibia.

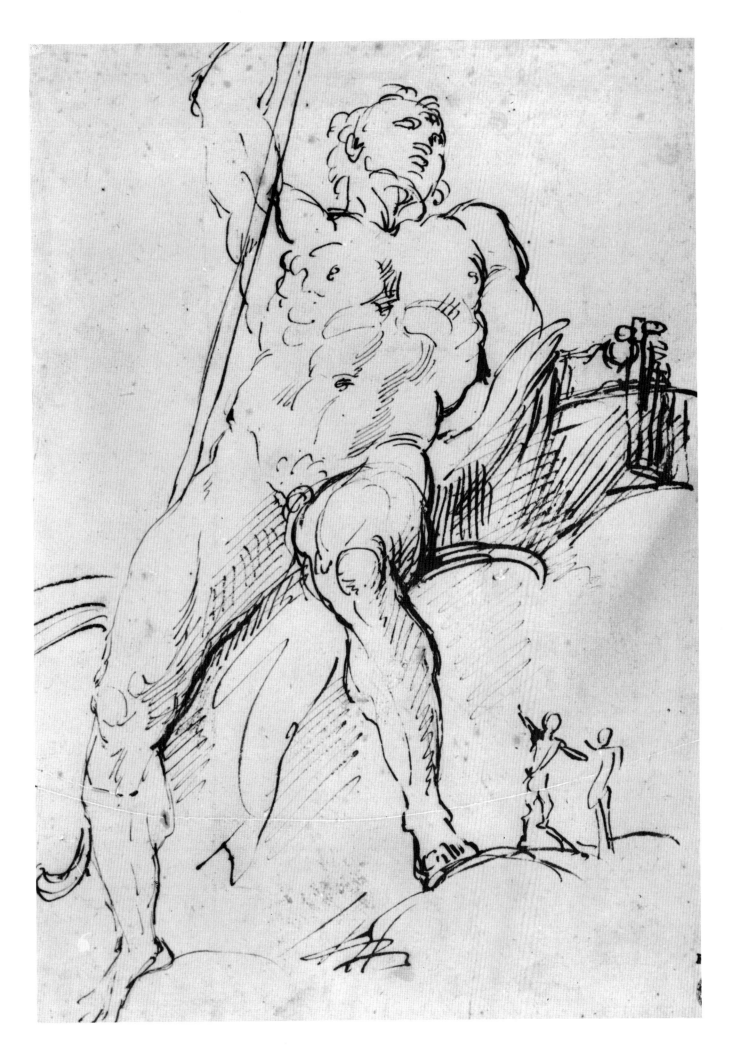

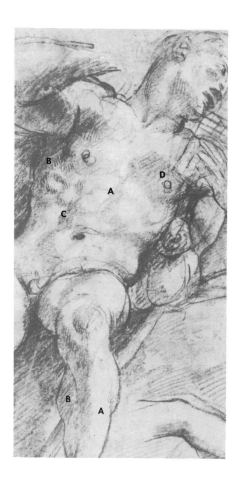

Annibale Carracci (1560–1609)

POLIFEMO

black chalk

20½" x 15⅛" (52.1 x 38.5 cm)

Louvre, Paris

This is much the same as the preceding drawing. The arms are placed differently, of course. The head is directed down and a little more to the right. The lower leg on the right is more vertical, and so forth.

Here the principal light was thrown from the right; in the preceding picture, it was thrown from the left. The front plane is now A; the side plane is B.

The first picture was mostly in line. This one is developed in shade. By comparing the two, perhaps you will learn something of the relationship between line and shade. I said earlier that lines are used to indicate where one tone abruptly meets another. A dark tone abruptly meets a light tone at C, as it would whether the principal light came from right or left. This meeting of tones is indicated by a line in the preceding drawing. Look for other places where tones meet abruptly in this picture; see if you can find lines that indicate these meetings in the preceding picture.

There are very few cast shadows. D appears to be the cast shadow of the hand on the chest; but this shadow is most transparent and does not interfere with the modeling. There is the usual shadow of the foot on the floor.

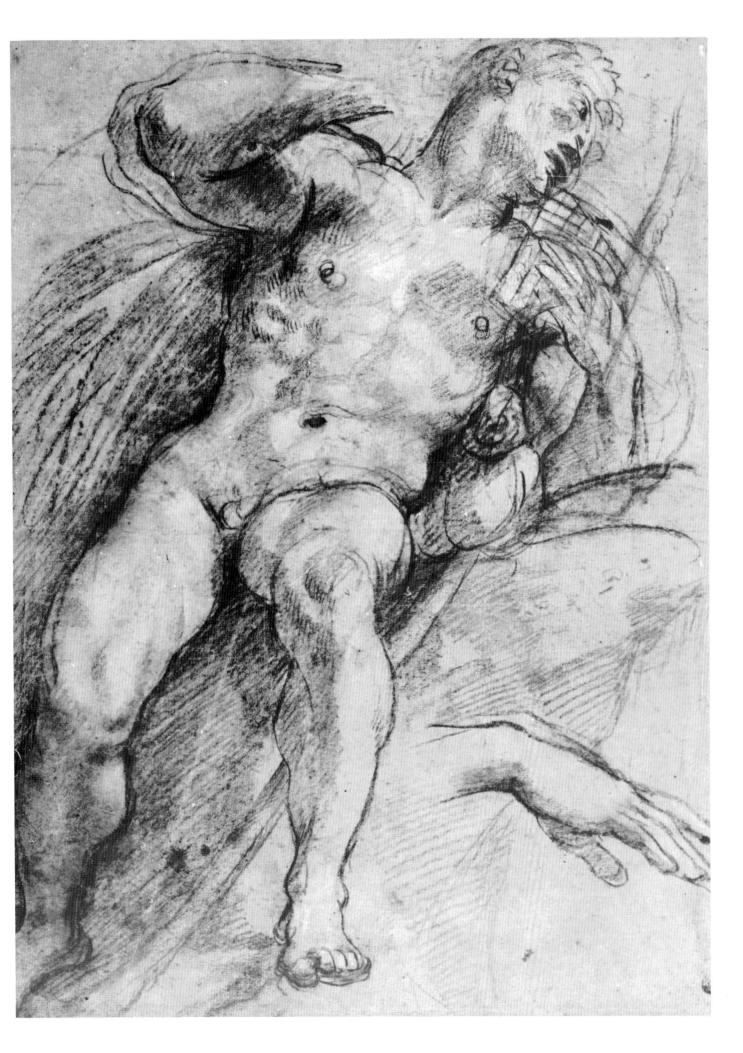

Leonardo da Vinci (1452-1519)

CARTOON FOR THE VIRGIN WITH SAINT ANNE

charcoal heightened with white

54¾" x 39¾" (139 x 101 cm)

Royal Academy of Art, London

Head A is beautifully rendered. It is conceived as a block, with the principal light from the right. The shade on the block of the nose has been properly subordinated to conform with the darker shade on the side of the larger, more important block of the head. The eyeballs are sphere symbols buried in the head, the heavy lids welded to the spherical surfaces, following the form and partaking of the shade of the spheres.

Head B is conceived as a more cylindrical mass, rounded on top. As the direction of the head changes, the artist changes his mass conceptions to accommodate the light direction which is constant here.

The breasts are sphere symbols, well buried in the chest so that the dark side plane is not apparent. The upper arm (C) is a cylinder, growing larger at the bottom: almost a truncated cone. The knee (D) is a sphere-like form with drapery hanging from it, though the upper leg is cylindrical, as the drapery upon it suggests. But the principal light here has suddenly been shifted somewhat to the left, which is always permissible for purposes of composition, form, or any reason you consider really important. But the principal light is generally from the right.

The half finished hand (E) seems to me too big for the perspective conditions implied. The mass conception of the body of the hand is most clearly stated: a block with a curving plane on the back of the hand.

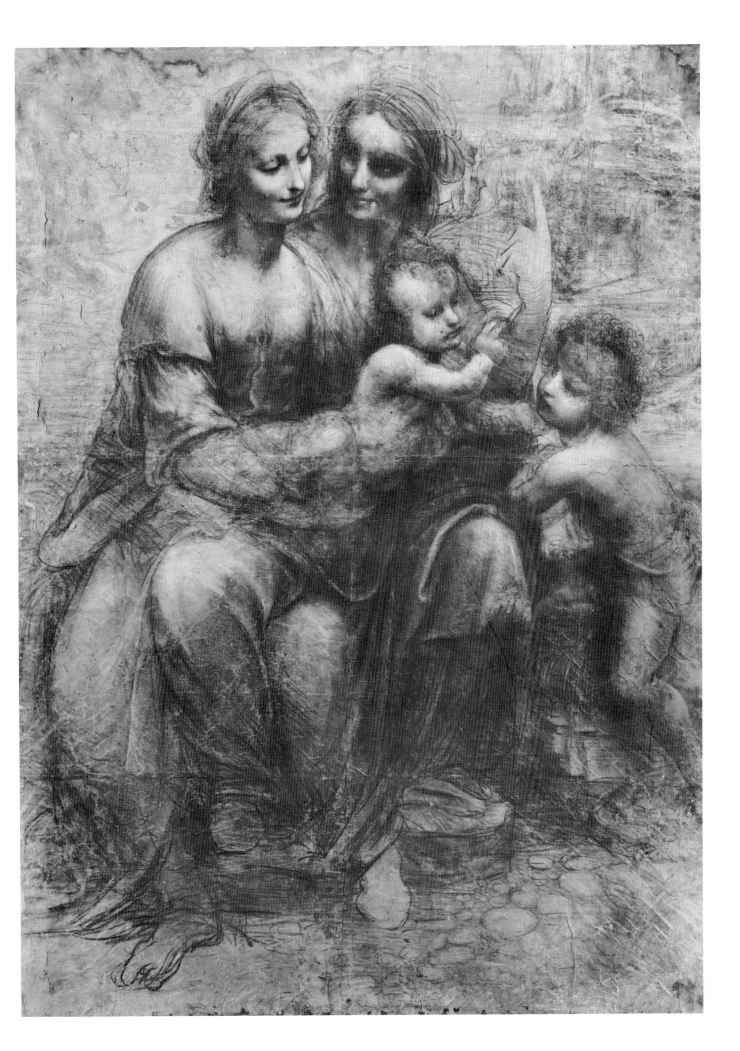

FIVE

POSITION, THRUST, OR DIRECTION

ONCE THE FORM HAS BEEN IDENTIFIED, its shape decided upon, its controlling mass determined and properly lit, the student must come to a further decision concerning the exact position of this form in space. There is a further complication: the artist must also decide on the position he himself occupies or wishes to occupy in relation to the form. Though he stands upon the floor of his studio, he may, if he wishes, observe the model as if he were in the cellar or hanging from the chandelier. In other words, he may draw the form *in* any position, or *from* any position he chooses to fulfill his expressive intent.

The student must learn to decide on the exact position of the form in relation to himself, as well as its direction, or "thrust" as the artist likes to say. A form can occupy only one position at a time, and can be pointing in only one direction. An aircraft, for instance, is naturally in a certain position at a certain time. At the same time, it is headed in a certain direction; or as the artist would say, it has a certain thrust.

DETERMINING THRUST In drawing, it is not too difficult to decide on the position of an object; but to remain consistent in this decision seems most difficult for the be-

ginner. The student will often draw a head facing one way, with the nose and mouth facing in totally different directions. Again and again, when he draws the upper torso, the direction of the front will not be consistent with the direction of the sides. In drawing hands, the problem of thrust or direction is all-important: with all the wrist, there can actually be *sixteen* individual problems of thrust or direction that must be solved in drawing a hand. You know how hard hands are to draw.

Now the head and the upper part of the torso are complex forms, full of details which are most distracting to the student. Determining the thrust of these forms is difficult, but this can be readily solved if the complex form is visualized in terms of simple mass. The head has eyes, a mouth, a nose, ears, eyebrows, etc. But these may be forgotten if the head is thought of as a simple block, and it is very easy to determine the direction of a block.

If you think of the head as a block and run a line down the center of the front plane of the block, you will have determined the direction of the head, to a certain extent. If you then think of the head as a cylinder and run a circle around this cylinder, you will have determined the full direction of the head. Both these construction lines have been used by artists for generations.

Think of the rib cage as an egg, and run a line down the center of the egg, from the pit of the neck through the point between the nipples. Then think of the rib cage as a cylinder and run a circle around it through the nipples. Thus, you will have determined the direction of the rib cage.

Arms and legs may be thought of as cylinders: the moment a circle is thrown about them, their direction is established.

Through these conceptions of mass and direction, the really difficult problem of drawing hands is simplified. Straight fingers may be thought of as long blocks or cylinders. If a finger is bent, it forms itself into three blocks or three cylinders, each with a different direction. Having visualized the form and thrust of the fingers, you must then try to form a mass conception for the body of the hand. It is not wise to include the metacarpal of the thumb in this conception.

PROBLEMS IN
DETERMINING THRUST

In coming to a decision as to the position and thrust of a form in space, the student will face many problems. If a form is in motion, he must decide on the one phase of that motion which he wishes to draw. Tones often depend upon the direction of the form, and the direction may have

to be altered to improve these values. Lines that move over a form vary as the direction of the form varies; therefore, the direction of the form must be decided before the lines are drawn. Frequently, forms do not reveal their true shape unless their position or direction is altered. The student must decide on the thrust of forms over which drapery falls, in order to give character to the folds. Finally, the student must decide upon the positions and directions which will be acceptable to his composition as a whole, and which will be compatible with the final effect he wishes to produce.

FORMS IN MOTION

Let us first examine the problem of forms in motion. Traditionally, a form cannot be drawn in two or more places at once; therefore, a student must decide upon and seize a single phase of the motion. Luckily, most action has a repetitive quality and there is a moment of rest at the beginning and end of the action. These moments of rest are the phases that are drawn, as they are usually most suggestive of the action. The woodsman is rendered with his axe raised or buried in the wood.

The problem of representing continuous or unrepetitive action has never been satisfactorily solved. Usually, the artist seizes a random phase of the action, accompanied by such obvious symbols as wind-blown drapery or trailing hair.

THE MODEL IS
ALWAYS MOVING

When drawing the nude, beginners invariably complain about any visible movement of the model. At times, they suddenly discover that the model is breathing and demand that the instructor put a stop to it. To the advanced student, a movement of the model makes little difference; he has already come to a decision as to the direction of the forms.

But beginners seldom complain about the slower movements of the model, which are far more insidious and are liable to last throughout the duration of the pose. Often through fatigue, the model's shoulders slowly drop; the weight shifts; head, rib cage, and pelvis slowly rotate. It soon becomes apparent to the sophisticated student that if he wishes to express the vitality and well-being of the model, he must decide to seize the bodily thrusts existing at the *beginning* of the pose. If he wishes to express fatigue he must seize upon the thrusts he anticipates at the *end* of the pose. If he wishes to express other emotions, he must be prepared to create the thrusts these emotions might involve.

TONE AND
DIRECTION OF FORM

If the sources of light are fixed, the tones upon a form will vary as the direction of the form changes. If a door is closed, for instance, it will retain the tones of the wall upon which it is hinged; if it is opened, the wall side of the door will become lighter or darker than the wall, depending upon how the light falls. Similarly, if two skyscrapers have equal tones on their front planes, and if one of the skyscrapers should suddenly lean forward a bit, the front plane of the leaning skyscraper would be darker than the front plane of the other, assuming that the light comes from above. Thus, if the model stands with her legs together, her legs will have equal tones on the front planes. But if the model poses with one leg forward and one leg back, the forward leg may well be lighter in tone than the other.

Such considerations of thrust may well be the most decisive factors in suggesting the tones to be placed on head, torso, arms, and legs, as these forms change direction, each to each.

THRUST AND LINE

The student soon discovers that he cannot draw a line over a form until he has decided on the form's exact thrust or direction, for as the thrust varies, so does the line. Since one function of line is to explain the shape of the form over which the line moves, the thrust of the form must be determined exactly so that the line will be exact.

As the thrust of a cylinder varies, circles about the cylinder will also vary. Since we can think of a straight finger as a cylinder, this means that the lines at the joints will vary as the thrust of the finger varies. On the palm side, the body of the hand is crossed by two lines of great importance: the head line and the heart line, which are of particular value in giving the illusion of the shape of the palm. Usually, these delicate lines are too far away to be seen distinctly; they cannot be copied, so they must be created. The artist must decide exactly on the thrust of the body of the hand before he creates these lines.

Actually, *all* the lines on the human body have a direct relationship to the thrust of the form over which they move. A consideration of thrust must always be in the mind of the artist when he draws.

POSITION AND
TRUE SHAPE

In order to present the true shape of a form, its position or direction must be altered at times. A cube copied head-on gives the illusion of a square plane; it must be moved so that its two sides are brought into view. A

cylinder copied head-on gives the illusion of a circle. An egg copied head-on gives the illusion of a sphere. They must be moved a bit to reveal their identity.

Thus, an artist seldom attempts to render a finger pointed directly at him, he moves it a little this way or that. He also avoids direct front and back views of the figure, as sides are subordinated and there is little movement of the center line to reveal the shape.

At times the position of a form must be altered when the form is partially hidden by other forms which prevent the hidden form from explaining its identity and shape. Sometimes the head is turned so that only a mere sliver of the ear remains. It is better to leave out the ear entirely; otherwise the ear may look like a strange growth on the far side of the head. Or one can turn the head a bit to show more ear. Sometimes one breast will almost completely hide the other breast. Or one buttock will almost hide the other. Don't be afraid to leave out the hidden breast or buttock, or to turn the figure in your mind a bit until these shapes reveal their true character.

THRUST AND DRAPERY Folds of drapery must have strong character and to a certain extent they may nicely reveal the action of the figure. Changing positions and changing thrusts of shoulders, arms, legs, and other parts of the body will strongly affect folds. It should now occur to the student that since he has the power to change the position and thrust of bodily forms at will, he also has a good deal of control over the character and rhythm of folds.

ILLUSTRATIONS

POSITION, THRUST, OR DIRECTION

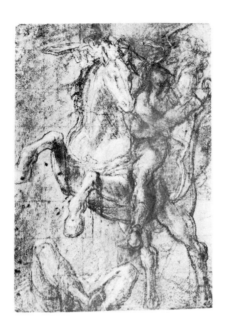

Do you think that Titian persuaded this horse to take this rearing pose, then asked the rider to climb on the animal's back, and finally persuaded them both to hold their poses for three hours while the artist lay on the studio floor and drew this picture? Titian drew the whole thing out of his head, of course. He just *imagined* he was on the floor and that the horse was rearing above him.

Furthermore, if Titian had wished, he could have imagined himself in any other location, at any distance from the horse and rider, with his models in any conceivable pose. And he still could have produced a picture.

In the life class, students ruin drawing after drawing because they insist on trying to draw the model exactly as they see it from exactly where they are sitting. When my classes are crowded, students sometimes have to sit three or four feet from the model; they proceed to draw the model exactly as they see it from close up, and the results are very funny indeed. The near shoulder assumes enormous proportions. Or the foot, if it is the nearest thing to them, becomes six times as big as the head. Even when students sit further back, they copy exactly what they see, with lamentable results. The most common fault is that forms at the students' eye level seem larger than things above or below eye level. As the model's buttocks are usually at eye level, these are forever enlarged to gigantic size.

The cure for these faults includes a large dose of perspective, ability to draw from the imagination, and esthetic understanding of what a picture really is.

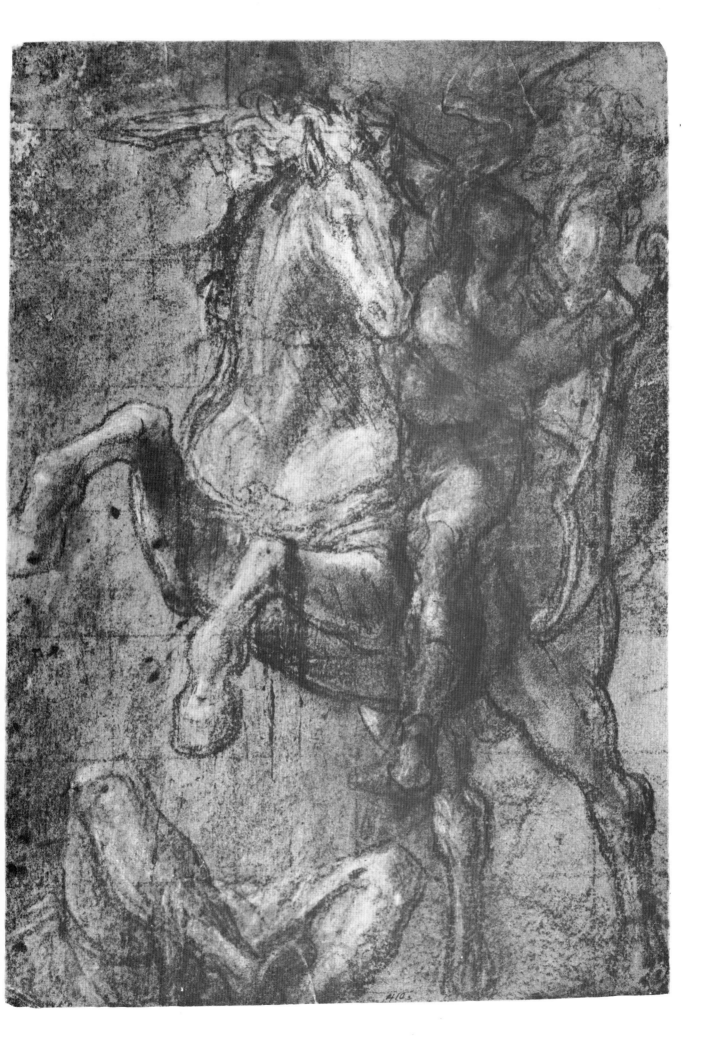

Peter Paul Rubens (1577-1640)

STUDY FOR MERCURY DESCENDING

black and white chalk

18⅞" x 15½" (48 x 39.5 cm)

Victoria and Albert Museum, London

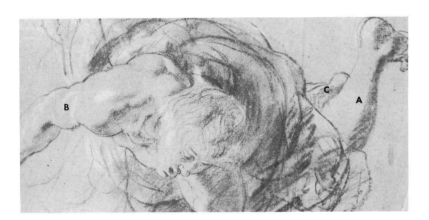

This is another imaginary drawing. I hope I have not given the impression that students should always draw without a model. You *should* draw from the model as often as you can; but you should also draw the figure out of your head as often as you can. When you draw figures from imagination, questions continually arise; if you cannot answer these questions, you put them aside and try to find the answers when you next draw the model. Drawings made from a model can be very good indeed. A model is invaluable in suggesting detail and striking unusual turns of pose.

In this drawing, Rubens had a hard time making up his mind about the thrust or direction of the legs. I think he finally preferred the leg at A, because he took the trouble to shade it carefully.

The highlight lines which circle the form (B) are interesting because they give direction and form to the upper arm. Cover these lines with your little finger and you will notice how weak the direction and the form are without them. The torso appears to have been conceived as a large cylinder, around which flow the circular lines of the drapery. These lines certainly impart a direction to the torso.

The foot (C) is an example of a form which is not sufficiently revealed to proclaim its identity. This form, within the context of this drawing, might well be a piece of drapery.

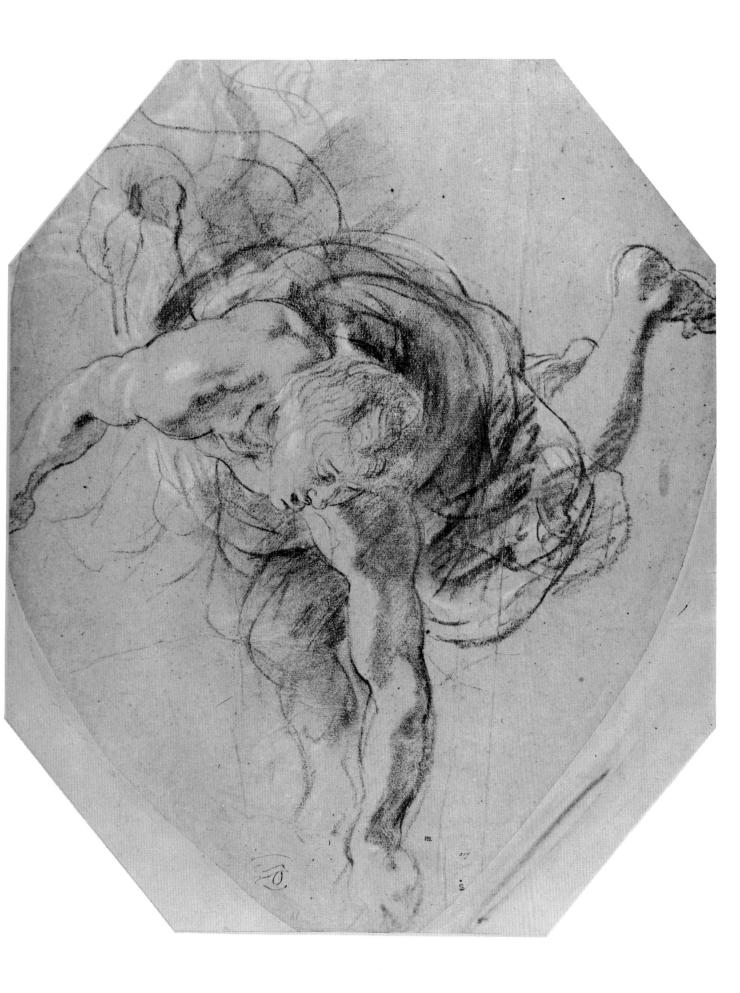

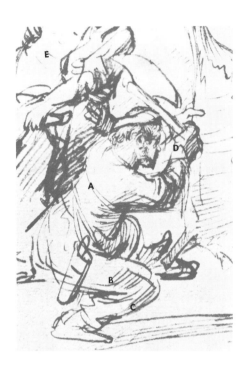

Rembrandt van Rijn (1606-1669)

TWO BUTCHERS AT WORK

pen and bistre

5⅞" x 7⅞" (14.9 x 20 cm)

Kunstinstitut, Frankfort

Here is a drawing of one man cutting a piece of meat, while another man walks away with a piece of meat. Cutting is a repetitive action. Walking is both repetitive and continuous. The man with the ax is drawn with his ax raised; he might also have been drawn with the ax buried in the meat. Either pose would have suggested the action which Rembrandt had in mind. But if the ax had been drawn halfway between the man's head and the meat, the action would not have been suggested as effectively. The walking man is shown at the beginning of the stride of the far leg. An action is best drawn at its beginning or its end, not at the midpoint.

The line (A) suggests the direction of the rib cage. The upper and lower legs (B and C) are visualized as if cut out of one simple block. The lines at B and C are drawn to give proper direction to the side plane of this block. The hand holding the ax is blocked and the wrist is blocked; the line D not only confirms this fact, but gives direction to the wrist. The lines at E show the direction in which the pig is going; if the pig were going in another direction, these lines would be going in another direction.

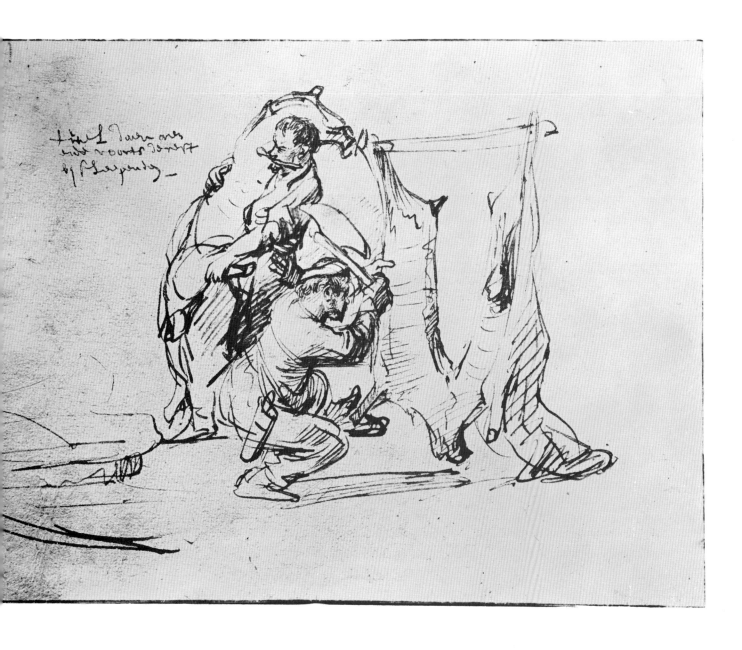

121

Peter Paul Rubens (1577-1640)

STUDIES OF HEADS AND HANDS

black and white chalk

15⁷⁄₁₆″ x 10 ⁹⁄₁₆″ (39.2 x 26.9 cm)

Albertina, Vienna

Hands are very hard to draw, but they will ultimately yield to study. Perhaps the first problem to tackle is mass and the direction of mass. Unfortunately, there are sixteen separate masses to consider: the body of the hand; each phalange of each finger; the two phalanges of the thumb, and its metacarpal. The student must create mass conceptions for each separate form and decide on the thrust or direction of each. No wonder the poor beginner can never draw hands!

The mass conception of the body of the hand presents many difficulties because the shape is not at all constant. For instance, the hand is normally rounded on the back; but press the palm down on the table, and the body of the hand becomes very flat. Or spread your fingers and see how flat it becomes. Furthermore, the back of the body of the hand becomes very long in flexion and very short in extension. Because of the webbing between the fingers, the palm of the hand seems much longer than the back. All these factors — and others, such as the direction of the chosen light — must be kept in mind by the student.

In this drawing, the body of the hand is thought of as a block, with front plane A and side plane B. Each phalange of each finger seems to be thought of as a block; where plane meets plane, there is a contrast of tones. This is most clearly seen where plane C meets plane D. Notice the cast shadow (E) on the front plane; realize this shadow is not continued on the side plane. Shadows cast by the principal light *never* fall on side planes. Shadows cast by *reflected* light may' fall on side planes, but they are seldom permitted to do so.

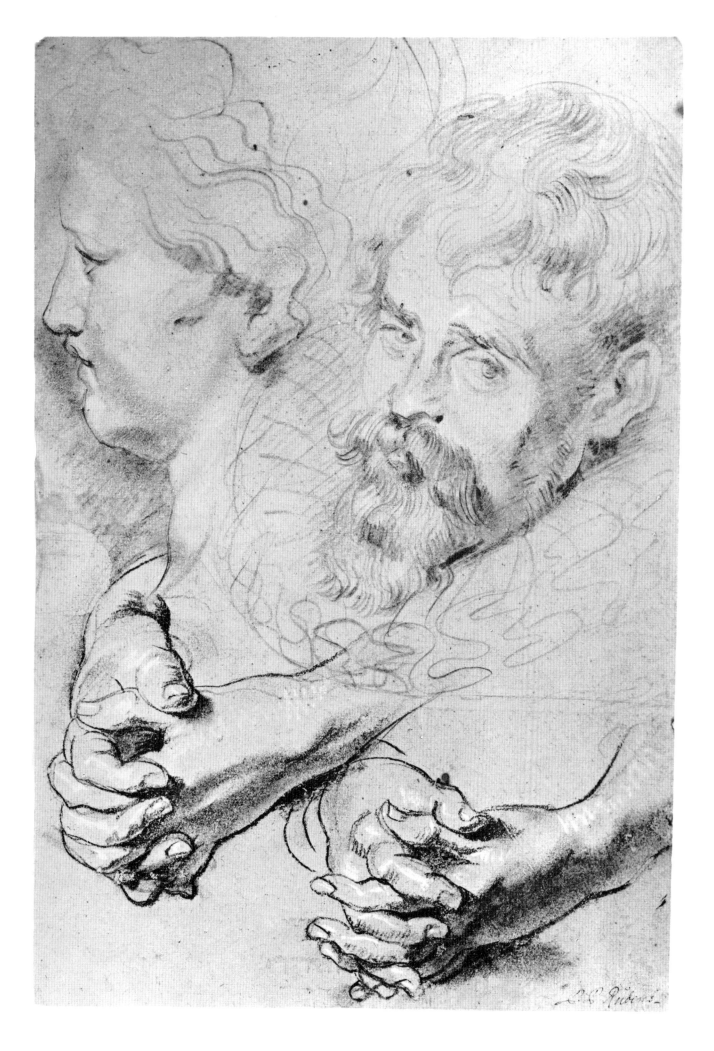

Copy of Albrecht Dürer

STUDY OF HANDS

pen

9⅜" x 9⅞" (23.8 x 25 cm)

Museum of Fine Arts, Budapest

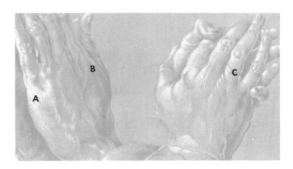

In the hand on the left, the highlight is at A. The front plane is separated from the side plane at the dark edge (B). The principal light is from the left, the reflected light from the right. From the highlight to the dark edge of the hand, the general movement is light to dark.

The veins may be thought of as the flutes of a column. Each separate vein is shaded from light to dark, though the shading on each vein conforms in intensity to the general sweep of light to dark across the back of the hand.

The object of all this is to compel the observer to grasp the mass first and the details second. Hold this picture ten feet away. You will be unable to see the details — the individual veins — but you will clearly grasp the general massing of the hand.

You see how an artist can bring out detail as he moves from the highlight to the dark edge where the planes meet. Study your fluted column and realize how details may be brought out as you move from the dark edge through the area of reflected light.

The ring around the phalange (C) encircles an imagined cylinder, shares the tones of the cylinder, and gives direction to the phalange. The mass of this phalange corresponds very closely to the actual shape; examine this part on your own hand and feel the rounded bone forcing the form on the top plane. See how the ring compresses the bulging flesh on the palm side of the finger; the ring has been worn for many years!

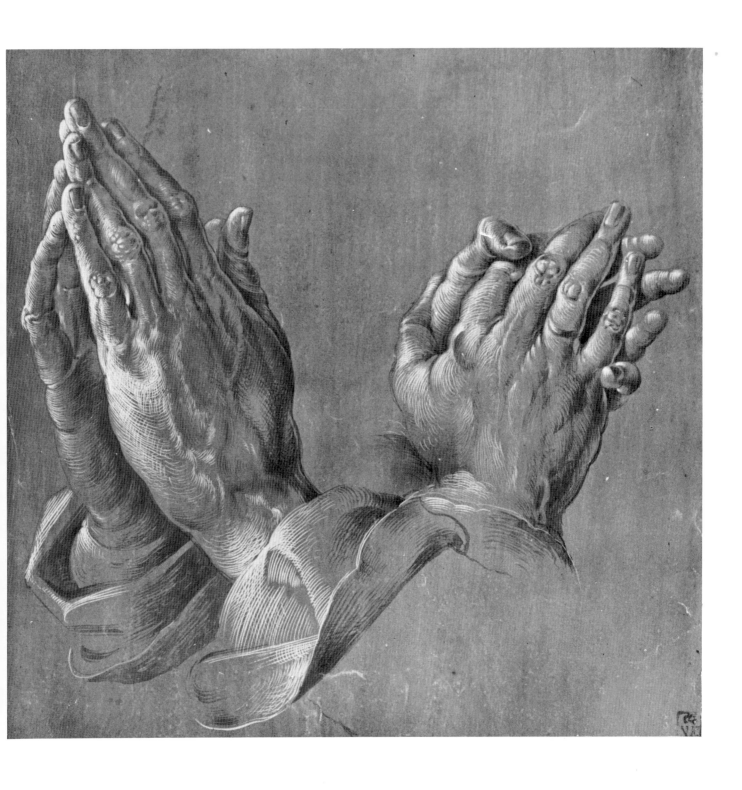

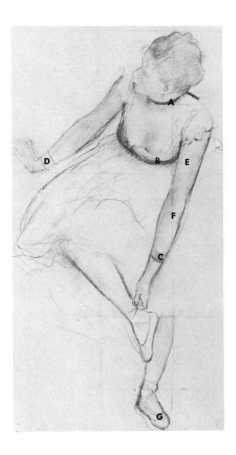

Edgar Degas (1834-1917)

DANCER ADJUSTING HER SLIPPER

pencil and charcoal

12⅞" x 9⅝" (32.7 x 24.4 cm)

H. O. Havemeyer Collection

Metropolitan Museum of Art, New York

In this picture, the directions of head, rib cage, pelvis, arms, and legs have been carefully considered to satisfy the demands of composition, as well as the artist's expressive intent.

The direction of the neck is revealed and reinforced by the black ribbon (A), which is but a line around an imaginary cylinder. But the values on the ribbon have been cast aside to increase the decorative effect. The ribbon around the waist (B) is but a line around the egg-like rib cage, which (for the moment) is thought of as a cylinder. The line of this ribbon wavers slightly to express the bulging flesh of a rectus abdominis beneath. The bracelet at C is given values, while the bracelet at D is given none; they both serve to reinforce the direction of the respective forearms. It is probable that the model wore no bracelets at all; Degas may have created them to express the direction of the wrists and to give them a little more form.

The artist here frequently jumps his light, though not on the individual forms. The light on the upper arm (E) is from the left; on the lower arm (F) it is from the right. The breasts are mere sphere symbols, with the light coming from the right. There is very little reflected light in this drawing, except on the slipper (G) where the direct light comes from the left and the reflected light comes from the right.

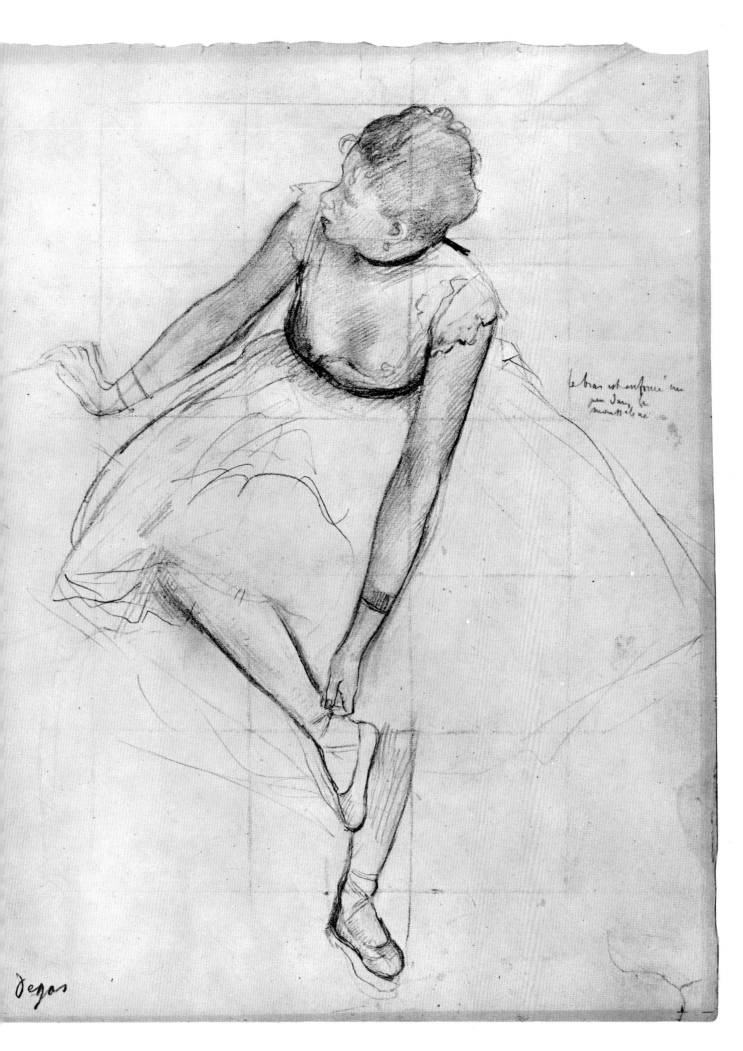

Le bras est enfoncé un
peu dans la
mousseline

Degas

Leonardo da Vinci (1452-1519)

SURFACE ANATOMY OF THE SHOULDER REGION AND HEAD

silverpoint

9⅛″ x 7½″ (23.2 x 19 cm)

*Reproduced by gracious permission of
Her Majesty the Queen*

Royal Library, Windsor

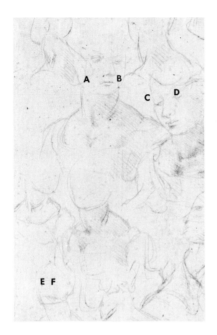

On this work sheet, Leonardo practiced throwing heads into all sorts of difficult positions. It is necessary that an artist be able to draw a head in any position, and be able to do this from his imagination. If he cannot draw a head in a peculiar position from his imagination, he will not be able to draw it at all, even with a model in front of him. There are many reasons for this. One reason is that the direction of *every feature* changes as the head changes position. Since every feature changes position, one must be able to draw each feature in any conceivable position. Also, as the head changes position, the relationships of all the features change.

One difficulty of studying the work of an advanced artist is that his construction lines are usually invisible. An advanced artist does not use construction lines because they mess up the looks of his drawing. But he holds these lines in his mind when he draws. Indeed, I have a struggle to get my students to use construction lines; they too feel that they will ruin their precious drawings. But you will never learn to draw unless you mess up thousands of drawings with construction lines.

The construction lines here are mostly related to the position of the head as a whole. Line A-B, for instance, indicates a level head. Line C-D indicates a down head. And line E-F shows an up head.

128

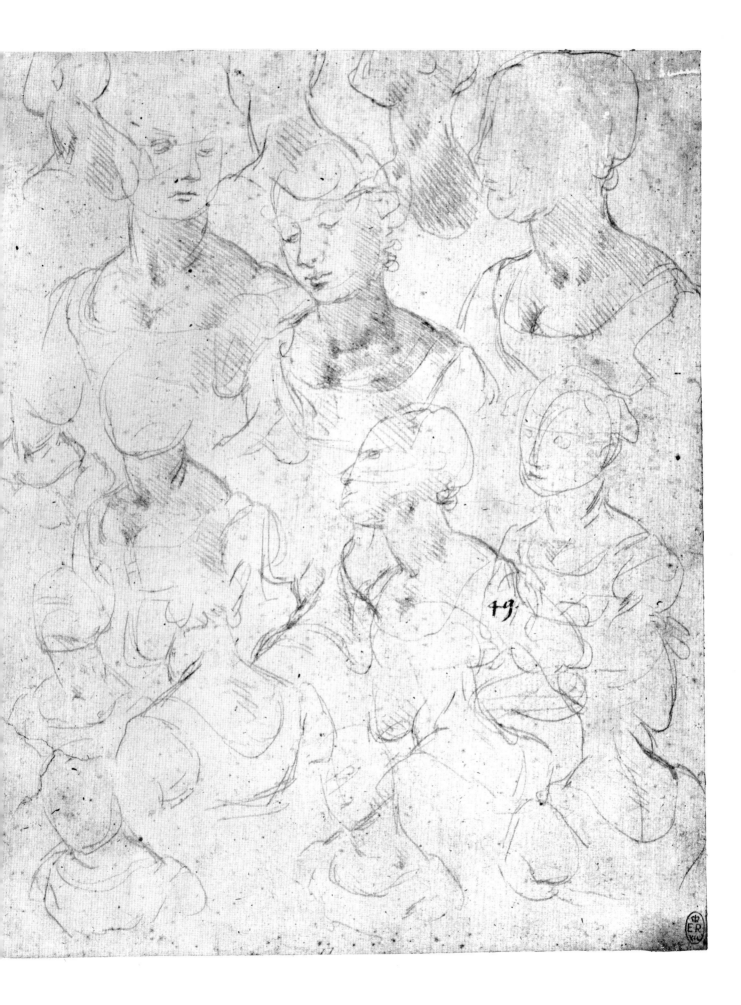

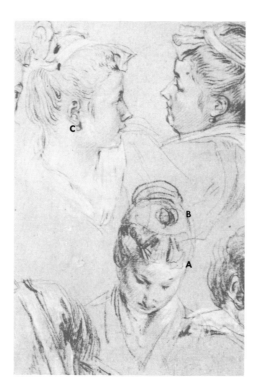

Antoine Watteau (1684-1721)

NINE STUDIES OF HEADS

red, black and white chalk

9⅞" x 15" (25 x 38.1 cm)

Louvre, Paris

In the Leonardo drawing on the previous page, construction lines are frequently used to show the simple massing of the head. At times, he uses the vertical center line of the face. In this more advanced drawing by Watteau, very few construction lines are visible. Perhaps line A-B is a segment of a construction line that indicated the mass of the head. If you watch a practiced artist as he draws, you can tell that he is thinking about his construction lines all the time; his hand moves as if he were drawing them, but he does not let the pencil touch the paper.

To draw a head well, you must first learn by heart the front and side views of the skull, memorizing the relationships of all important details, one to the other. The side view will show you that the base of the nose, the base of the ear, the bottom of the mastoid bone (C), and the bottom of the cheek bone, are all about on the same level.

By studying the side view of a skull, you will develop a feeling for the side plane of the head. Ask yourself all sorts of questions about the side view; what elements lie on a given horizontal construction line; what elements lie on a particular vertical construction line, etc. Memorize the answers by drawing them.

Do the same for the front plane of the skull. Eventually, I hope you will do the same with the back plane, top plane, and bottom plane. Then you will be able to think of your head as a block, and it will not matter what position the block is in; you will feel the relationship of part to part.

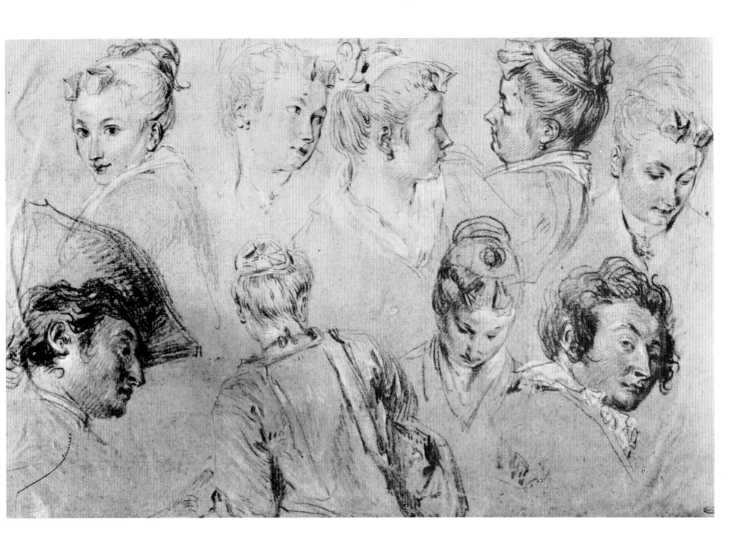

Tintoretto (Jacopo Robusti) (1512-1594)

DRAPED STANDING FIGURE

black chalk

13⅛" x 7¹⁄₁₆" (33.4 x 18 cm)

Uffizi, Florence

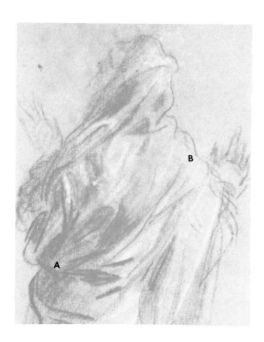

On drapery, the influence of the thrust or direction of bodily forms is very great. The artist often changes the direction of bodily forms to procure a movement of folds that seems more expressive than the movement he actually sees on the model. At the same time, the artist uses the movement of folds to suggest or intensify the thrust or direction of bodily forms beneath the drapery. This, of course, cannot be done unless the artist is able to create figures out of his imagination.

Here the folds move as usual from the waist (A) to the high shoulder (B). The same result occurs on the front view. Furthermore, Tintoretto has given a spiral feeling to the folds to suggest that the rib cage is rotated against the pelvis.

In my classes, if the model poses in a costume that has been packed in a trunk and has become wrinkled, beginners will carefully copy every wrinkle they see. The result is that they produce pictures of a model posing in a costume that really looks as if it had been packed in a trunk. The advanced artist often *creates* the bodily thrusts his expressive intent demands and draws his folds to conform to these imaginary thrusts.

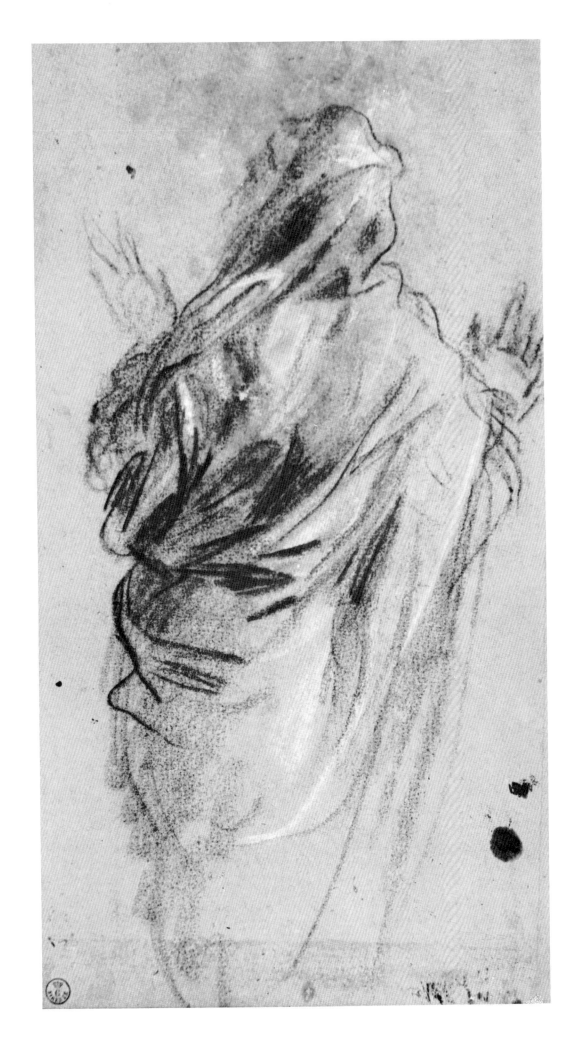

Pieter Bruegel (1525-1569)

SUMMER

pen and brown ink

8⅝″ x 11¼″ (22 x 28.5 cm)

Kunsthalle, Hamburg

On the little figure (A), the folds spiral to show that the rib cage is rotated above the pelvis. Here the twist is so great that the folds cannot go to the high shoulder. The folds on the sleeve (B) are spiralled to suggest that the hand is in pronation, that the lower arm has been rotated in relation to the upper arm.

The folds on the chest (C) are most characteristic. They run from the armpit to the chest and reveal that the upper arm has a backward thrust. Similarly, the folds on the back (D) tell that the upper arm has a forward thrust. The characteristic bunching of the folds at the elbow (E) naturally suggests a bent arm. The folds at F are moving from the armpit to the top plane of the arm to show that the upper arm is raised.

Again and again, this drawing demonstrates that the artist had studied the effect of direct and reflected light on simple form symbols, such as the block, sphere, cylinder, egg, and even the cone. Notice how many planes meet on fields and houses: notice the mass symbols used for the bunched foliage of the trees, and the haycocks.

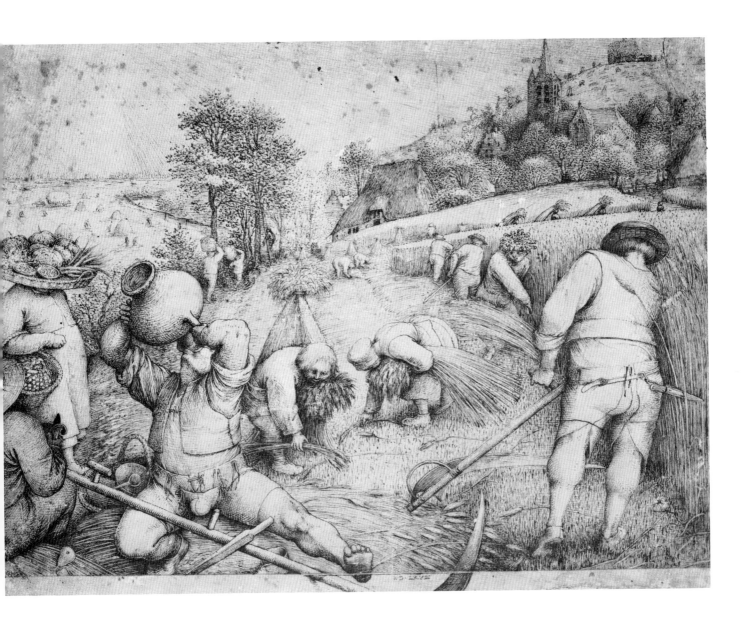

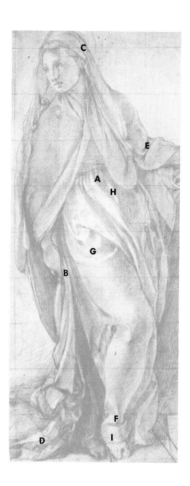

Jacopo da Pontormo (1494–1557)

VIRGIN ANNUNCIATE

red chalk

15½" x 8½" (39.3 x 21.7 cm)

Uffizi, Florence

Drapery likes to fall from points of support (such as A, B, and C) in column-like folds. On the model, these columns have a horrid tendency to be very much the same shape and size. The artist must transform them into varied and interesting forms, as indeed they are here.

At D, the drapery takes on the broken-plane pattern of drapery on the floor. To learn about this, let a piece of cloth half fall to the floor and draw the drapery, transforming the dull shapes you see into interesting forms.

The drapery is bunched at the elbow (E) and at the ankle (F) at the abrupt meeting of interior planes.

Notice how the highlight on the thigh (G) kills the dark tones of the detail of the drapery. To draw drapery well, you must be able to visualize the tones on a spiral rope or a doughnut around a cylinder.

Folds and edges of drapery are often consciously changed to run over the mass conceptions beneath; H suggests the sphere of the abdomen and the shape of the foot is suggested at I.

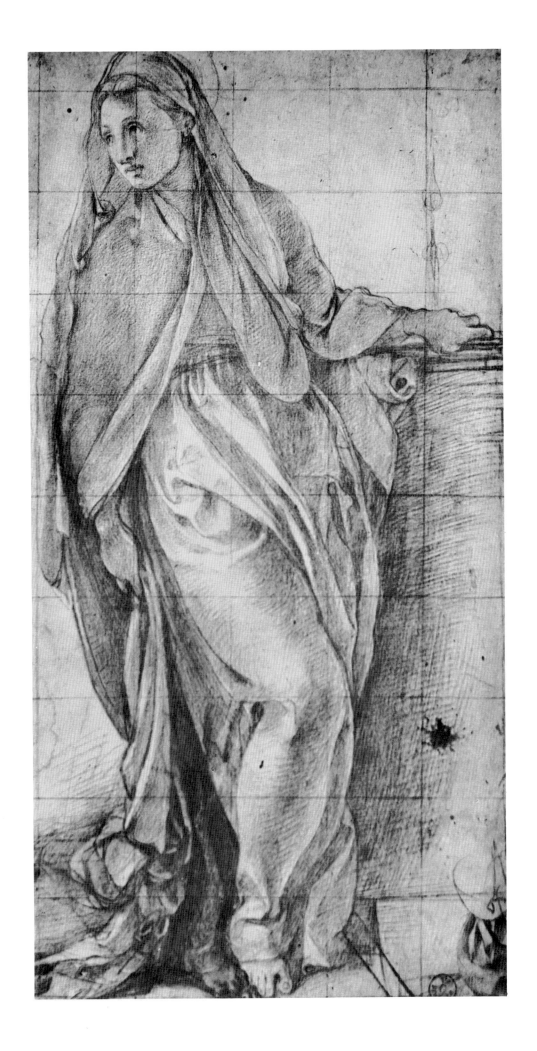

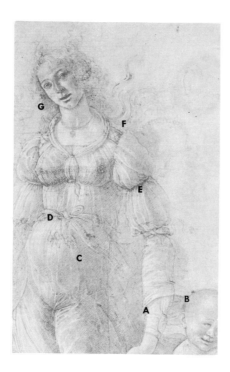

Sandro Botticelli (1444-1510)

STUDY FOR THE ALLEGORICAL FIGURE OF ABUNDANCE

pen

12⅜" x 10" (31.5 x 25.5 cm)

British Museum, London

The underlying mass conceptions of the principal figure are extraordinarily simple in this drawing. The rib cage is an egg, on which are buried the spheres of the breast. The ball of the abdomen is a sphere. The thighs are simple, egg-like columns. At all times, the folds of drapery run over these mass conceptions, just as the necklace runs about the cylindrical mass of the neck. Line A-B, a segment of a circle, shows how a line may be run at a distance from a form to reinforce that form; in this case the form is the egg-cylinder conception of the lower arm. The belt (C) reinforces the mass conception of the abdomen in the same way.

The principal light on this figure comes from the left. There is an abundance of reflected light from the right.

The circular movement of the belt (D) imparts a forward thrust to the pelvis, as the circular movement of the arm band (E) imparts a backward thrust to the upper arm.

This figure is an act of pure creation. Botticelli created the light, the reflected light, the mass conceptions, the bodily thrusts, and the wind itself. The columns of drapery and every bit of windblown hair were completely created and designed by the artist.

The form of the hair (F) is the interior plane of a cylinder, with the direct light causing the highlight. The curl at G is a cylinder, as curls so often are, with the highlight taking its proper place.

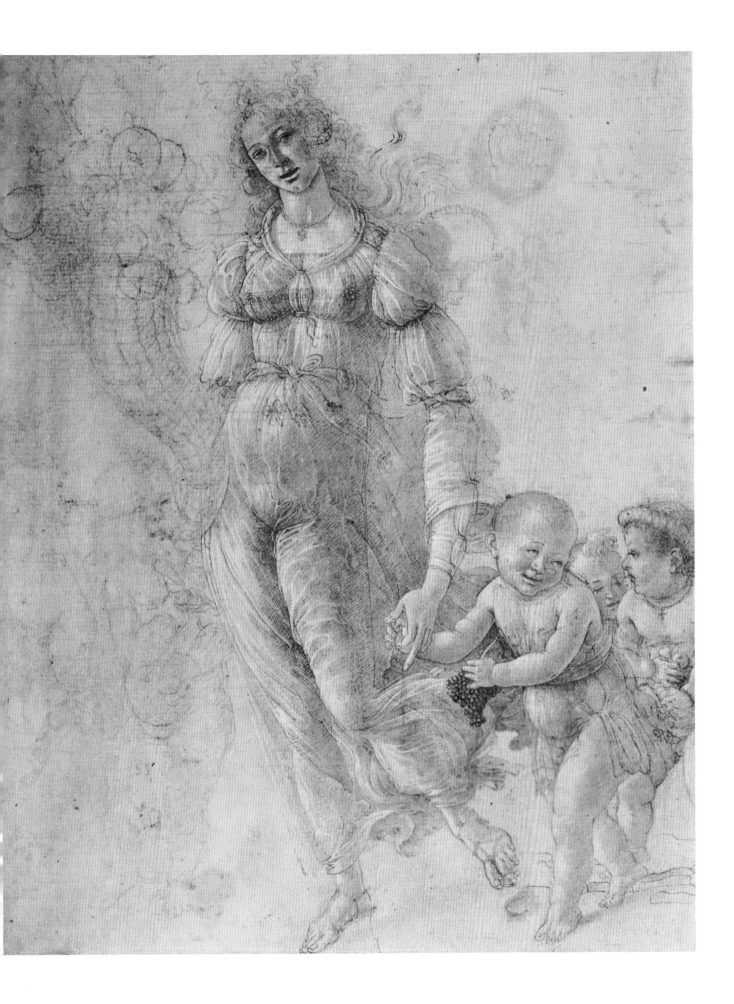

SIX

ARTISTIC

ANATOMY

IF THE ART OF FIGURE DRAWING has fallen into a decline — as it evidently has in the 20th century — certainly one reason is that few contemporary artists have deeply studied artistic anatomy.

DRAWING WITHOUT
THE MODEL

Every artist represented in this book had a staggering knowledge of artistic anatomy compared with today's standards. For no one can draw the figure really well unless he can draw *every part* of the figure, in *any position*, out of his imagination. Every artist reproduced in this book could do this.

Do you think that you can make an adequate drawing of a head well thrown back, or a hand coming directly at you, simply by copying the model? You cannot. You cannot really draw these things unless you can draw them out of your head, before the model takes the pose. And there is no way under the sun to draw the figure *accurately* out of your head without a thorough study of artistic anatomy.

How are you going to discover the important axis line of the hand — the axis which runs from the proximal end of the metacarpal of the

little finger to the proximal end of the metacarpal of the thumb — by squinting at the hand of a model fifteen feet away from you? Especially if you do not know that metacarpals *exist!*

LEARNING ANATOMY

There is so much detail in books on artistic anatomy that the student is often unconscious of a number of the controlling ideas that prove so helpful in the end. I should like to stress a few of these ideas and suggest that you bear them in mind when you study the subject of anatomy.

There is nothing mysterious about artistic anatomy. It is all in the books for anyone to learn. Of course, *medical* anatomy has advanced a great deal since the time of Leonardo, but *artistic* anatomy remains about the same.

One thing that Leonardo had — and every artist in this book had — was a nice collection of bones. And that is the basis of the whole thing.

BONES DETERMINE
BODILY FORMS

It must be understood at once that the form of the body is dictated by the bones. Tap yourself all over. Whatever parts are hard are essentially bone. Your head, your hands, your feet, your joints: the form is primarily influenced by bone.

The influence of bones on the rest of the body is more subtle but just as strong. The base of the column of your neck is founded on the circle of your first ribs. The shape of the important mass of the external oblique is forced by the ribs and the pelvic crest. The inside of the thigh is a reflection of the pelvis, etc.

Essentially, the body is a machine, with the bones in compression and the muscles in tension.

Pull off your muscles, like Hercules in his death throes, and scatter them about. They are so much shapeless meat unless attached to the skeleton. But your skeleton will remain as before, unchanged in form and proportion.

PLEASE BUY
SOME BONES

Therefore, the first thing to do is to get a collection of bones. They may be ordered from any medical supply house. I know that bones are expensive, and that art students are poor; but remember, they will last for a lifetime, and it is possible that you will be giving your lifetime to your art.

You cannot learn the true shape of bones from pictures, however

accurate. You must have the real, three dimensional bone. Even in my classroom, a misguided student will copy *pictures* of bones when the *real skeleton* is hanging right before him.

It is better to buy the separate bones, rather than the whole skeleton (which is often put together by ignorant mechanics). The shape of the important ends of the bones is forced by places where they touch each other; these places cannot be nicely observed in the assembled skeleton. When you have acquired your bones, study them until you can draw them by heart from any position. Then draw them together as a full skeleton.

ORIGIN AND INSERTION
OF MUSCLES

As you learn the bones, memorize the exact origin and insertion of the necessary muscles. The origins and insertions are clearly given in any good medical book on human anatomy: *Gray's Anatomy*, for example. The necessary muscles are listed in any decent book on artistic anatomy.

Artistic anatomy uses but a small part of the data of medical anatomy. Should you be tempted to actually dissect, wait until you are aware of the restrictions of your subject matter. Otherwise, you will be horribly confused.

But if you learn the origins and insertions of the muscles, I assure you that figure drawing becomes quite simple. Half the time, you are simply putting your pencil on the origin of the muscle and moving to the insertion, or vice versa. If you wish to draw the sternomastoid, what could be easier than to put your pencil on the mastoid and spiral gracefully down to the sternum?

THE EVOLUTIONARY
APPROACH

In studying the artistic anatomy of man, it is valuable to keep in mind the artistic anatomy of animals and the place of man in the whole scheme of evolution. You can then see the essential simplicity of the skeleton, head, rib cage, backbone, pelvis, fore and hind limbs. In fact, the wonder is that things have altered so little since our most remote ancestor first stood on four legs. The six basic anatomical elements appear again and again in various but recognizable forms, to the point of monotony, as if the cosmic designers lacked the imagination to think of anything else. And the muscles of animals are all much like our own.

Thus, we can study almost any animal and learn a great deal about ourselves.

Furthermore, elements that are important — but perhaps small or

insignificant on humans — may be of great size on other animals. If we study these animals, we are not likely to forget the existence of these elements. For instance, if you draw a horse's skull a number of times, you will become very conscious of the huge nasal bone. Then, perhaps, when you draw the human skull, you will not forget the little human nasal bone.

In other words, bear in mind constantly that man is but another animal. His forms have been altered and changed by the immense forces of evolution, but essentially he is the same. His lungs are the lungs of the whale; his teeth are the elephant's tusks; his arms are the bird's wings; and his nails are the claws of the tiger.

GRAVITY AND THE
FOUR-FOOTED ANIMAL

Man is the only animal that stands fully erect on his two hind legs. If we consider a four-footed animal as man's remote ancestor, and then consider the forces that would play upon this animal if it attempted to stand erect, we will be greatly helped in understanding the characteristic construction of man.

The four-footed animal, like the Arc de Triomphe, is firmly planted on four legs, an ideal situation for contending with the force of gravity. As for the animal's backbone, the neck is an S curve, and the rest of the backbone is a flat C curve, in the form of a flat arch. The rib cage hangs suspended, in a sense, from the backbone. The pelvis is at the foot of the arch, in the rear. From the pelvis come the supporting rear limbs. The shoulder blades are on each side of the rib cage, the important spines of the shoulder blades pointing downwards. The serratus magnus muscles, coming from the shoulder blades, hold the rib cage in a sort of sling, so that the front legs, which are inserted in the shoulder blades, can support the front of the animal.

GRAVITY AND MAN

Now let us consider the changes that would be forced on such an animal if, through the course of evolution, the animal should stand fully erect.

First of all, we must realize that maintaining balance on two legs alone is difficult; to a large extent, man's body is designed to meet this problem. In other words, the student must at all times be conscious of the force of gravity. Almost the first construction line an artist draws — in creating a standing figure — is the so-called gravity line, which is directed, of course, to the very center of the earth.

The animal, in attempting to stand erect, will of necessity attempt to rotate its pelvis to the upright. The point of rotation is where the rear limbs are inserted. Since the backbone is firmly inserted into the pelvis, the rotating pelvis carries the backbone, rib cage, and skull with it.

In the fully erect position, which is that of man, the typical animal backbone (S curve and C curve) is not the most efficient to carry the weight of the head and rib cage. Therefore, the backbone of man has been developed so that it curves under the head and under the rib cage. This creates the typical curvature of man's backbone, which you should certainly memorize, as this curvature has such a compelling influence on man's shape.

The back profile of man is but a reflection of these curves (though they are inhibited by the protrusion of the dorsal spines). On the front profile, the neck retains the curve of the backbone. Even the abdomen may be thought of as a reflection of the backbone curving under the rib cage.

If man, in his erect position, retained the protruding rib cage of the animal, man would be in danger of falling forward. So, unlike the animals, the greatest width of man's rib cage is from side to side. Man's shoulder blades, instead of being on the sides (as in the animal) are more towards the back. And the important spines of the shoulder blades are almost horizontal.

FURTHER RESULTS OF STANDING ERECT

Practically all of man's muscles engage in the task of holding him erect. If you think of muscles in this relationship, their characteristic form becomes clearer.

It is gluteus maximus — the great buttucks muscle — that has the all-important job of rotating the pelvis and holding it upright. That is why this muscle is more fully developed in man than in any other animal. This is why Aristotle called gluteus maximus the distinguishing muscle of man.

What students call the "strong cords" on each side of the small of the back — the muscles that rise from the pelvis to the rib cage and hold the rib cage erect — are of necessity well developed. So is the opposing muscle (rectus abdominis) in front.

The student should carefully consider which muscles or muscle masses hold man erect, and which muscles lock the joints (so to speak) in the upright position. The student will then not only understand why

the shapes of identical muscles differ so much in man and the animals, but he will come to understand man as the delicately balanced apparatus that man truly is.

THE IMPORTANCE OF
FUNCTION

Function is another aspect of great importance in the study of artistic anatomy. Function has to do with the special kind of activity which the organism (or any part of it) performs. This applies to a muscle, a bone, or the animal itself.

An understanding of function leads at once to a better understanding of form. For instance, certain muscles perform the function of rotation and have the feel of a spiral; such muscles are the sternomastoid, the external oblique, and the sartorius. A greyhound is built for speed; his bones are long and light, and his muscles are slender. A workhorse is built for heavy work and looks it.

FUNCTIONAL GROUPS

But perhaps the conception of function helps the artist most as soon as he can understand the following principle: namely, that if two or more adjacent muscles have approximately the same function, they may be grouped together by the artist.

Let us take an example. Clustered around the bones at the top of the lower arm are so many muscles that when the average student starts to study them, he is tempted to give up art altogether. But a cursory investigation of all these muscles will reveal that they break down into three groups. One group, the so-called supinator group, rotates the hand. Another group — the flexor group — flexes the hand. And another — the extensor group — extends the hand.

If your artistic anatomy book does not stress this point, simply take three colored crayons and color the supinator group red; the flexor group blue; and the extensor group green. Then you will clearly see the three groups on the lower arm; you will not have to draw details of the individual muscles that compose these groups.

Another functional group is the famous hamstring group at the back of the upper leg. There are three muscles in it: semimembranosus and semitendinosus on one side and the biceps of the thigh on the other. The anatomy books present a deep cleft down the middle of this group, although this cleft does not exist in the fleshed figure.

LINES DIVIDE
FUNCTIONAL GROUPS

Further, an understanding of the functional grouping of muscles will help you to solve the difficult problem of where to place lines on the figure. A beginner cannot understand how an artist often creates lines on his figure though these lines are not present on the model. Sometimes these lines are placed at the meeting point of two functional groups of muscles. Artists call these lines "the lines between the functions."

ANATOMICAL SINS

Let me tell you just a few of the terrible things all students do because they have not studied artistic anatomy. They cut off the back of the head on the profile because they are so fascinated by the face that they forget the back of the head entirely. They bring the neck out of some strange part of the shoulder, forgetting that it must rise from the first two ribs (otherwise we could not swallow or breathe). They take enormous bites out of the solid rib cage under the breast. They pull the rib cage far away from the pelvis, or push it right down into the pelvic basin. They run the split of the buttocks right through the impenetrable bone of the sacrum.

This brief catalog of art students' sins (there are thousands of others) is presented simply to persuade you to study artistic anatomy and study it hard.

ILLUSTRATIONS

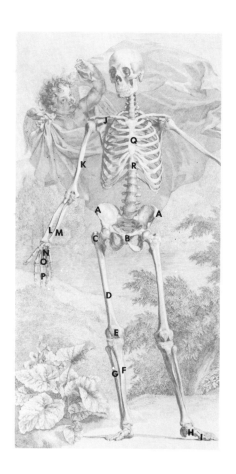

A picture may be worth a thousand words, but there are not enough words in the language to cope with visible reality itself. This is one of the most accurate pictures of a skeleton ever drawn, but we must remember that it is but an illusion of the real thing on a piece of paper. So try to get your full conception of the form of a skeleton from a real skeleton, rather than from pictures.

Note the following bones: pelvic points (anterior superior spinous processes of the ilium) (A); symphysis pubis (B); great trochanter (C); femur (D); patella (E); tibia (F); fibula (G); tarsal bones (H); metatarsal bones (I); clavicle (J); humerus (K); radius (L); ulna (M); carpal bones (N); metacarpal bones (O); phalanges (P); sternum (Q); ensiform cartilage (R).

Bernard Siegfried Albinus

TABULAE SCELETI ET MUSCULORUM

CORPORIS HUMANI, 1747

Plate 2

Metropolitan Museum of Art, New York

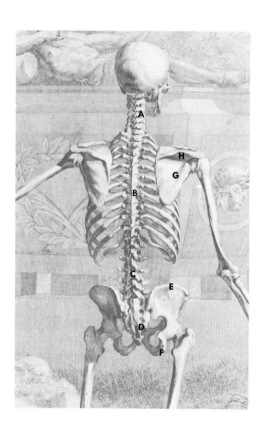

Note the following: cervical vertebrae (A); thoracic vertebrae (B); lumbar vertebrae (C); sacrum (D); iliac crest (E); ischium (F); shoulder blade (G); spine of shoulder blade (H).

The weight is on the right leg. Notice how, because of this, the pelvis falls ever so slightly on the left. Note how delicately the backbone curves upward to the skull. However, since this skeleton is just an illusion, not the real thing, you cannot tell with accuracy how much the backbone curves toward or away from you. And what about the true shape of the twelfth rib? You cannot tell from this picture.

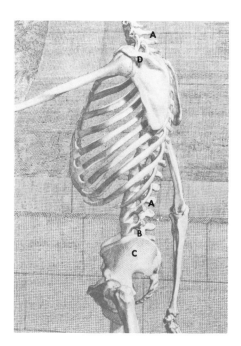

Bernard Siegfried Albinus

TABULAE SCELETI ET MUSCULORUM
CORPORIS HUMANI, 1747

Plate 3

Metropolitan Museum of Art, New York

Here we can see the backbone curving under the skull and curving under the rib cage. This curve is stronger in the front than the back because of the protruding spines (A) of the vertebrae. On certain animals, such as the horse, these spines are so long at certain places that you could never guess just how the backbone curves, merely by observing the fleshed animal.

A most important construction line is that which indicates the pelvic crest (B). The pelvic crest has enormous influence on the form. I fear you will never get it right until you examine a real pelvis. This line has curious concave qualities, which are finally grasped by the student after he has concentrated on the *outer*, rather than the *inner* line of the crest.

The body has two girdles: the pelvic girdle (C), and the shoulder girdle (D). The shoulder girdle is made up of the collar bones and shoulder blades. The pelvis is a fixed form, but the shoulder girdle can be moved in many directions. When you draw the model, try to isolate the shoulder girdle in your mind and accurately place its components.

The left hand is in supination. In the previous picture, it was in pronation. It is difficult to grasp the complex movement of the lower arm bones that cause these differing actions. However, if you have the actual bones before you, pronation and supination may be easily understood. In order to draw the lower arm properly, you must be able to visualize the bones through the flesh.

154

Andreas Vesalius

DE HUMANI CORPORIS FABRICA, 1543

Plate 21

New York Academy of Medicine

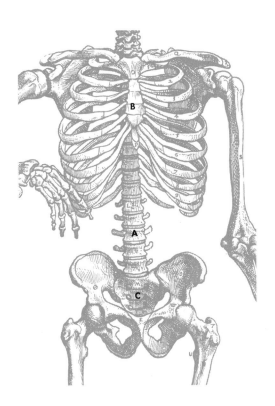

The Albinus plates we have just seen were made in the eighteenth century. This Vesalius skeleton is a product of the mid-sixteenth century. In certain details, it is therefore not so accurate. But the Vesalius plates have such a splendid vigor of style that they have been greatly used by artists through the centuries.

Here the arms seem abnormally long and the curves of the backbone are virtually lacking. Turn to Albinus' front view of the skeleton and notice how strongly these curves are suggested. Compare especially the curve (A) between the rib cage (B) and the pelvis (C). As a result of the suppression of the curves in the Vesalius plate, the ribs are much too horizontal here.

Andreas Vesalius

DE HUMANI CORPORIS FABRICA, 1543

Plate 22

New York Academy of Medicine

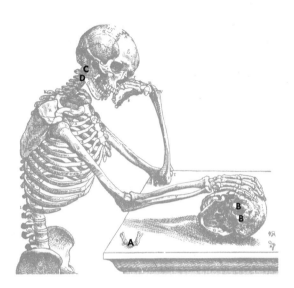

Vesalius' faulty rendering of the curvature of the backbone is again visible here. On the left of the skull on the tomb is the little U-shaped (hyoid) bone (A), which embraces the windpipe; artists are most familiar with this bone because it forms part of the line which separates the planes between the neck and the flesh under the jaw.

We also have here a bottom view of the skull. The two brightly lit bumps are the condyles (B) which articulate with the atlas bone (C). The atlas bone is directly under the skull (remember, Atlas held up the world) and these two condyles fit into two hollows on the top of the atlas bone so that the skull can rock back and forth on the top of the backbone. The atlas, in turn, rotates on the bone beneath — the axis (D) — and thus the skull can turn from side to side. A study of the form and function of the atlas and the axis will enable you to fit the head gracefully on the neck.

In an earlier version of this plate, there was engraved upon the tomb: *Vivitur ingenio, caetera mortis erant*. Genius lives on, all else is mortal.

Andreas Vesalius

DE HUMANI CORPORIS FABRICA, 1543

Plate 23

New York Academy of Medicine

When you study the bones of the arms and legs, do not fail to examine them from the top and bottom views. When you do this, also look down their shafts and you will get a feeling of the slight twist which all these bones have. You will also understand much more clearly the cross-section of the top, shaft, and bottom of each bone.

The tibia (A), for instance, has a platform on the top, which resembles a half cylinder. This merges into the prismatic shaft, which in turn merges into the cube-like bottom of the bone. Once you have discovered how the edge lines on the shaft move to complete these mergers, you should be able to draw the tibia in any position. But can you do this from a picture? You need the bone itself.

At the end of the humerus bone, there are a spool (B) and a ball (C): the capitellum and trochlea. An understanding of these two forms usually enables the student to understand supination and pronation. For the radius is hollowed out on its proximal end and rotates against the ball, while the ulna grasps the spool and moves only with a hinge action.

If you should run a line through the little numbers on the back — from one to twelve — you would get the line that artists call the line of the angles of the ribs. (Actually, I think you would have to draw this line just a touch to the left of number eleven.) When the shoulder blades are at rest, their inner edges like to rest against this line, and artists very often cause the planes of the back to meet upon this line.

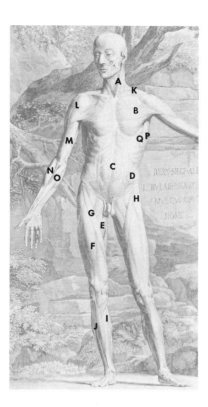

Bernard Siegfried Albinus

TABULAE SCELETI ET MUSCULORUM

CORPORIS HUMANI, 1747

Plate 1

Metropolitan Museum of Art, New York

The muscle groups noted below comprise muscles related through function. In drawing, the group as a whole is stressed; the individual muscles within the group are usually subordinated.

There are other muscles in the flexor and extensor groups of the arm; but since they are not superficial, they are somewhat neglected by artists. To properly study the small muscles of the head, hands, and feet, it is best to consult a medical anatomy.

Note the following muscles: sternomastoid (A); pectoralis group — pectoralis major and minor (B); rectus abdominis (C); external oblique — some artists consider this as a group, combining it with the two muscles beneath, internal oblique and transversalis (D); adductor group of the thigh — adductor longus, adductor brevis, adductor magnus, pectineus, gracilis (E); quadriceps femoris group — vastus externus, vastus internus, rectus femoris, crureus (F); sartorius (G); tensor fasciae femoris (H); calf group — gastrocnemius and soleus (I); peroneal group — tibialis anticus, special extensor of the great toe, long extensors of the toes, peroneus tertius, peroneus brevis, peroneus longus (J); trapezius (K); deltoid (L); biceps group — brachialis anticus and biceps (M); supinator group — supinator longus, extensor carpi radialis longior (N); flexor group — flexor carpi ulnaris, flexor carpi radialis, palmaris longus, flexor sublimis digitorum, pronator radii teres (O); latissimus dorsi (P); serratus major (Q).

Andreas Vesalius

DE HUMANI CORPORIS FABRICA, 1543

Plate 26

New York Academy of Medicine

Here is a front view of the body from Vesalius. The tensor fascia femoris (A), which students often disregard, shows its full importance here. I hope students will carefully compare this picture with the previous plate from Albinus. I suspect the two illustrations could be used as the basis of a psychological test for artistic sensitivity.

Bernard Siegfried Albinus

TABULAE SCELETI ET MUSCULORUM
CORPORIS HUMANI, 1747

Plate 7

Metropolitan Museum of Art, New York

This plate offers an excellent view of the adductor group (A) of the thigh. The basin-like quality of the pelvis is also well expressed. Sculptors like to think of the ball of the abdomen as a ball of clay resting in this basin, and artists often give this feeling to their drawings.

Notice the internal condyle of the humerus (B), which is always prominent in the fleshed figure. Note, too, the large size of the patella (C) in relation to the distal end of the femur. Students always make the patella too small. The egg-like mass of the rib cage is clear; on the front it is widest at the eighth rib.

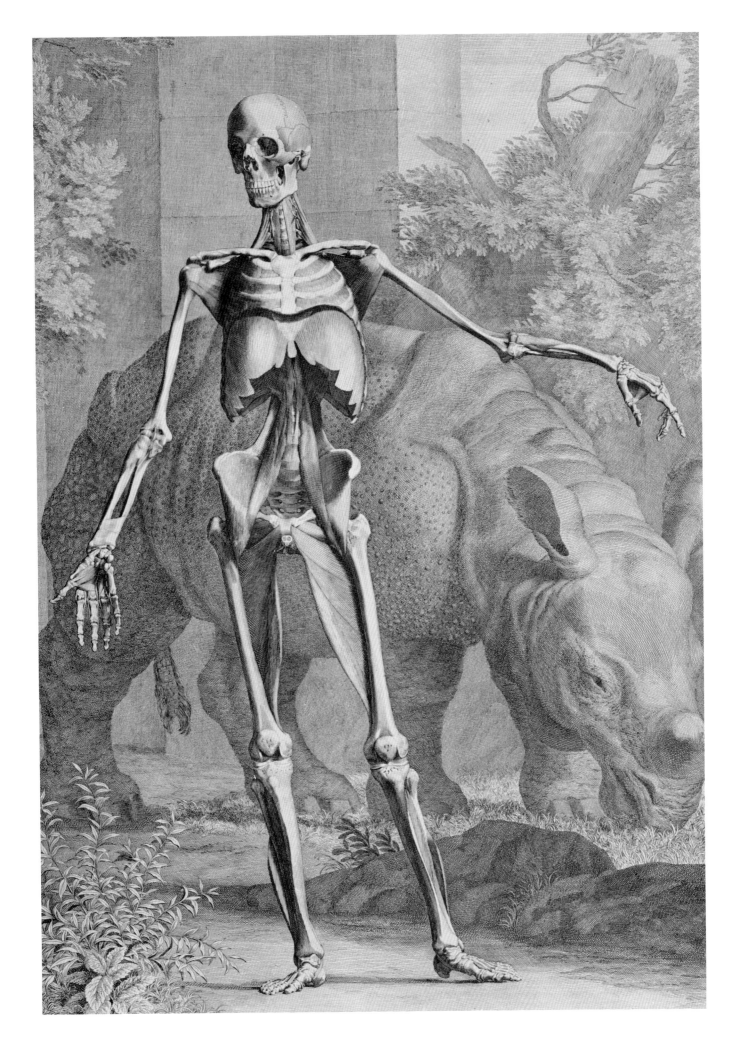

Andreas Vesalius

DE HUMANI CORPORIS FABRICA, 1543

Plate 32

New York Academy of Medicine

Note the following muscles: gluteus medius (A); gluteus maximus (B); hamstring group — biceps of the thigh, semitendinosus, and semimembranosus (C); infraspinatus group — infraspinatus and teres minor (D); teres major (E); triceps group — external, internal, and long heads of the triceps (F); extensor group — extensor carpi radialis brevior, extensor communis digitorum, extensor carpi ulnaris (G).

The following were all noted in the front view: tensor fascia femoris (H); quadriceps femoric group (I); adductor group of the thigh (J); calf group (K); peroneal group (L); trapezius (M); latissimus dorsi (N); deltoid (O); supinator group (P); flexor group (Q).

Vesalius' plates were first published in 1543. At that time, teres minor had not been recognized as an independent muscle. It was evidently thought of as part of infraspinatus; so it is therefore most natural to group teres minor with infraspinatus.

In the region of the back flap of the armpit, artists closely associate latissimus dorsi and teres major, so I suppose these two may be thought of as a sort of group in this region.

A magnificent artists' trick, often employed, is to run the line of the outer edge of the tail of the trapezius in an exaggerated manner over the various muscles beneath as is done here, thus clearly revealing their shapes.

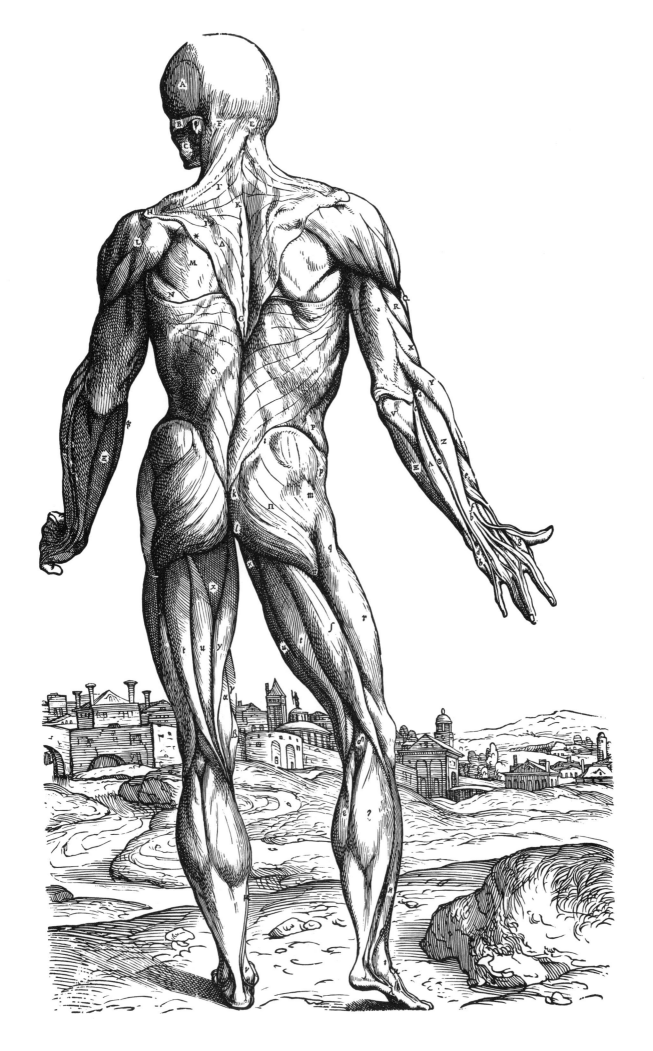

Andreas Vesalius

DE HUMANI CORPORIS FABRICA, 1543

Plate 33

New York Academy of Medicine

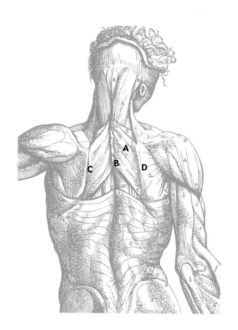

The hardest part of the body to draw is the back. The reason is that students must learn to think in terms of one, two, and at times three layers of muscle.

The rhomboid group (A) has a most active influence on the back. Because the rhomboid group is actually covered by the trapezius, this group is never sufficiently studied. The rhomboids may be thought of as rather heavy rubber sheets that stretch from the center line (B) of the back to the inner edges of the shoulder blades (C and D). When a shoulder blade is moved towards the center line of the back, the rhomboid group naturally creates a remarkable vertical bulge, which usually has a vertical wrinkle or two.

After the time of Vesalius, the rhomboid group was divided into the upper and lower rhomboids. But this division should be forgotten by the artist; as shown here, the two should be treated as one group.

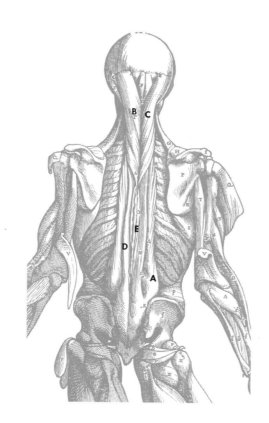

Andreas Vesalius

DE HUMANI CORPORIS FABRICA, 1543

Plate 35

New York Academy of Medicine

The muscles shown here, running up and down on each side of the center line of the back, are of great importance to the artist. They are the muscles that hold the rib cage erect on the pelvis and the neck erect on the rib cage. Thus, these muscles have an essentially human quality. They are seldom sufficiently stressed in books on artistic anatomy because these important muscles of the back are well covered by superficial muscles, and illustrations in such books often present only the superficial muscles.

The group of muscles shown here, moving from the pelvis up the rib cage, is called the erector spinae. One muscle of this group, iliocostalis (A), should be especially stressed when drawing the small of the back, because this muscle is very thinly covered by latissimus dorsi at this point.

A similar situation exists in the back of the neck. Again, the influence of trapezius should be disregarded and the deep muscles should be stressed. Artists like to render these muscles as two strong, rope-like cords (B and C), one on each side of the center line.

You will see certain other subtle forms on each side of the center of the model's back in the region of the rib cage. I fear you will never understand them unless you go to a modern medical anatomy and study longissimus dorsi (D) and spinalis dorsi (E), which also belong to the erector spinae group.

172

Bernard Siegfried Albinus

TABULAE SCELETI ET MUSCULORUM
CORPORIS HUMANI, 1747

Plate 4

Metropolitan Museum of Art, New York

The adductor group (A) is most clearly rendered here. As I have said, it is essentially the bones, rather than the muscles, that determine bodily form. The adductor group creates the form of the inside of the upper thigh. It is evident here how the shape of the upper part of the adductor group is completely forced by the shape of the bottom of the pelvis.

The external oblique is missing; if it were present, it would fill the space at B. If you conceive the external oblique to be something like a sheet of rubber fastened to the rib cage above B, and fastened to the pelvic crest below B, you would arrive at a very close approximation of the form in the area of B.

Artists are acutely aware of the importance of understanding all cross-sections of the body, from the top of the head to the soles of the feet. Without this knowledge, it is impossible to place exactly the meeting of front and side planes under given lights. The cross-sections of many parts of the body are utterly dependent on the shape of bone. The cross-sections of the upper skull, the lower rib cage, the region of the pelvic crest, the knees, the ankles, the elbows, and the wrists are almost entirely cross-sections of bone. Take off your shoe and feel the top of your foot. Feel the back of your hands. You will feel hard bones. Study the bones and you can soon draw the feet and hands.

Raphael Sanzio (1483-1520)

A COMBAT OF NUDE MEN

red chalk over stylus work

14¹⁵⁄₁₆″ x 11″ (37.9 x 28.1 cm)

Ashmolean Museum, Oxford

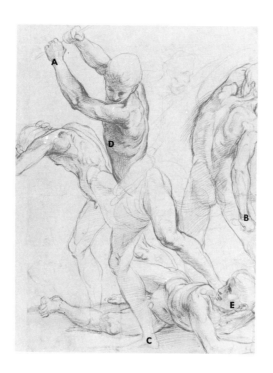

All the artists represented in this book were masters of artistic anatomy. If you want to draw the figure well, you too must study artistic anatomy as much as you can.

No one book will teach it all to you. No one book will exactly answer the manifold questions that should occur to you as you draw the figure. But every anatomy book has something of value to tell you. Actually, just a small number of books have been written on the subject. Try to beg, borrow, or buy as many as you can. What I did was to study one of them until I had practically memorized everything it said. Then I looked through the other books, which largely repeated the first, except that every one, here and there, contained fascinating turns of thought which the first book had omitted.

In this drawing, Raphael demonstrates a complete understanding of the form and proportion of the bones. He could draw them out of his head, in any position, and knew their comparative proportions. See how clearly the distal end of the ulna is indicated (A and B). Note the precise drawing of the distal end of the tibia (C); the movement of each individual lower rib and cartilage (D); the indication of the cheek bone (E). And how well he knew his shoulder blades!

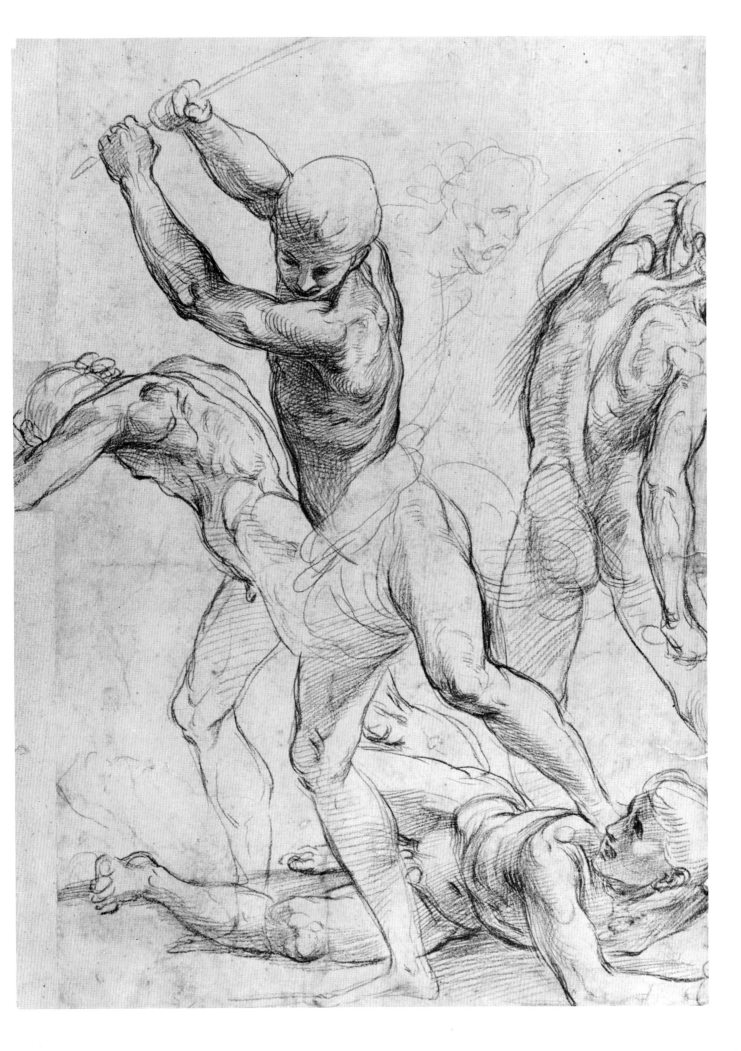

Baccio Bandinelli (1493-1560)

MALE NUDE FROM SISTINE CEILING

pen and bistre wash

15¾″ x 8¼″ (40 x 21 cm)

British Museum, London

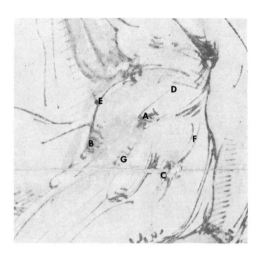

When a beginner starts to draw the figure, his knowledge is sparse. On the torso, for instance, the only landmarks he will place on the body are the nipples and the navel. The practiced artist, however, has thought about bodily landmarks a great deal; on the torso alone, he could probably place hundreds. He can, for instance, place the tips of all the dorsal and lumbar spines of the vertebral column and the tips of all the ribs; here are forty-one landmarks right away.

The artist's landmarks, you will notice, are related to bone rather than to flesh; a good thing, because landmarks of the flesh (the navel in particular) move about a good deal from model to model. Landmarks are valuable because the artist drives construction lines through them, such as the gravity line from the pit of the neck, or the line through the points of the shoulders. The artist establishes his proportions with these landmarks. As he draws down the body, his drawing is preceded by dots, real or imaginary, where the landmarks may be. And finally he drives his lines towards these landmarks.

In the pelvic region of this figure, this last process is very clear. Landmarks visible here are the pelvic point (A), symphysis pubis (B), and great trochanter (C). The line of the external oblique (D) is driven to the pelvic point (A). The line of the abdomen or rectus abdominis (E) is driven downward to the symphysis pubis (B). The line of gluteus medius (F) is driven downward to the great trochanter (C). The front line of the tensor muscle (G) is driven upward to the pelvic point (A).

Leonardo da Vinci (1452-1519)

NUDE ON HORSEBACK

silverpoint

5⅞" x 7¼" (15 x 18.5 cm)

Reproduced by gracious permission of Her Majesty the Queen

Royal Library, Windsor

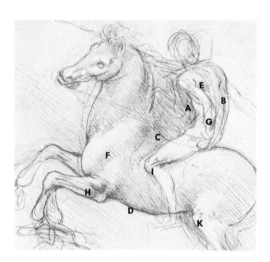

I find that it helps my students when I explain the bodily alterations that took place as man's ancestor changed from a horizontal, four-legged animal to an erect, two-legged animal. By this time, under my constant urging, I hope you have acquired a human skeleton. First draw it in the animal position and then revolve it at the great trochanters and draw it in an upright position. If you let your mind dwell on the muscles that hold this skeleton erect, you will think of many factors that characterize the human body, factors that your drawings may accentuate.

Most of the artists represented in this book may have been unaware of evolution, but almost all of them could draw beautiful horses. In other words, the artists in this book were familiar with comparative anatomy, and it certainly helped them in their figure drawing.

Here Leonardo opposes man's rib cage, shallow from front to back (A-B), to the horse's rib cage, deep from top to bottom (C-D). The shoulder blade on the back of the man's rib cage (E) is compared with the shoulder blade on the side of the horse's rib cage (F). Leonardo is aware of the similarity of muscle groups (G and H) and the similarity of the knees (I and K).

You might take a pencil and trace the movements of the backbones of man and horse in this drawing.

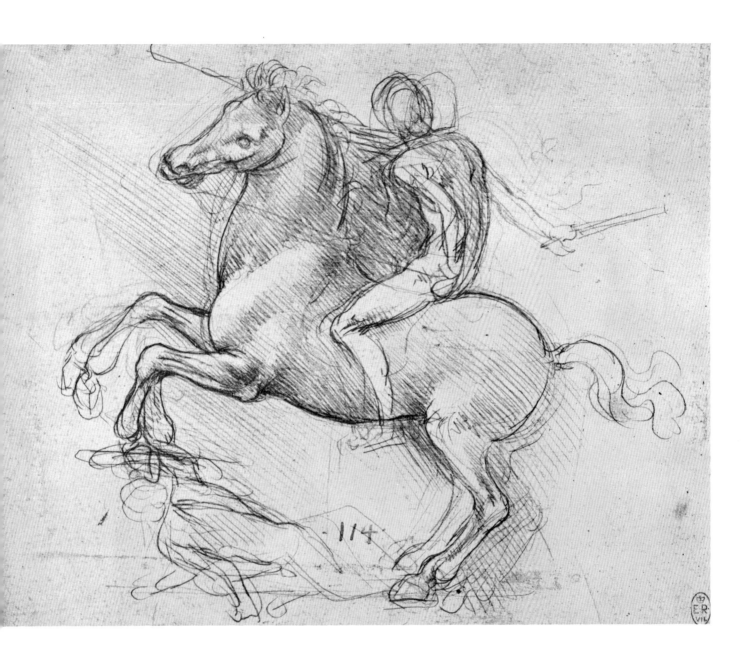

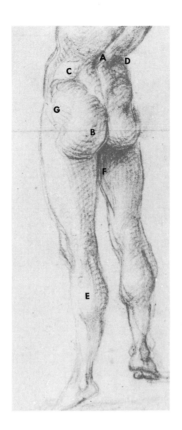

Luca Signorelli (c. 1441-1523)

NUDE MAN FROM REAR

black chalk

16⅛" x 9⅞" (41 x 25 cm)

Louvre, Paris

Draw some front, side, and back views of skeletons. Throw in the muscles or muscle groups that strive to hold the figure upright against gravity. Leave out the arms and the muscles of the shoulder girdle; we have been standing upright so long that they are fairly independent of the struggle against gravity. Concentrate on the erector spinae (A), which holds the rib cage erect; gluteus maximus (B), that most human of muscles, which holds the pelvis erect, and the two masses of the external oblique (C and D), which together prevent side sway of the rib cage.

Certainly, Signorelli was supremely aware of all these matters, or he would not have accentuated these muscles so strongly. Signorelli was also aware of the significance of grouping the muscles into functional masses. He has combined soleus and gastrocnemius to form the calf group (E), since he knew that these two muscles had a similar function. He was aware of the group of all the adductors of the thigh (F), and its antagonistic muscle, gluteus medius (G). He accentuated these last two because he knew that they were playing their part in locking the so-called hip joint against the pull of gravity.

Do not be discouraged. Excluding the hands, head, and feet, there are not many muscles and muscle groups to study. Only about as many as there are letters of the alphabet.

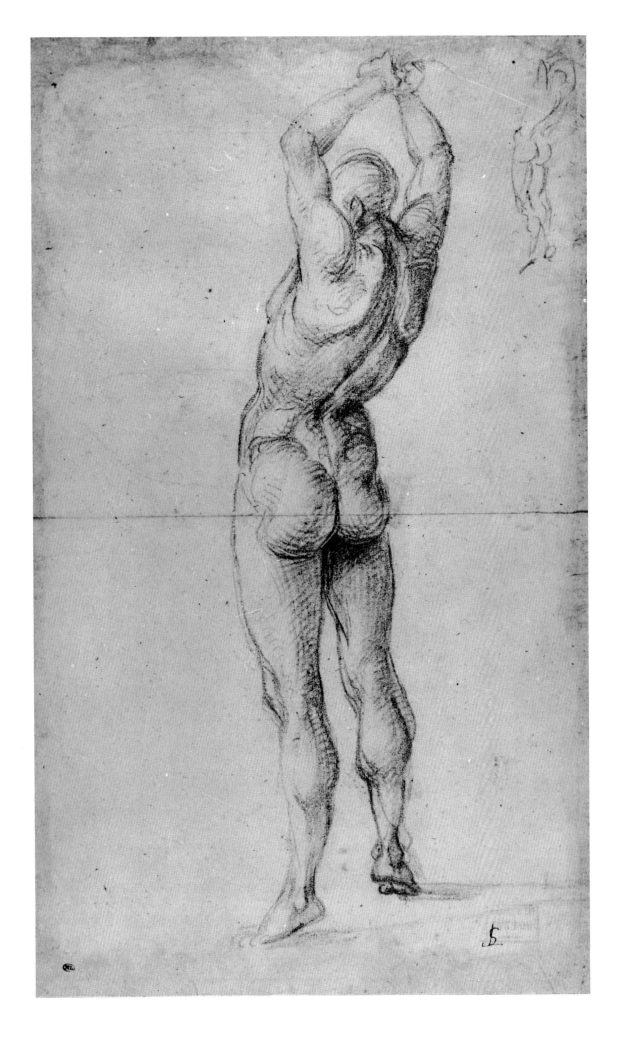

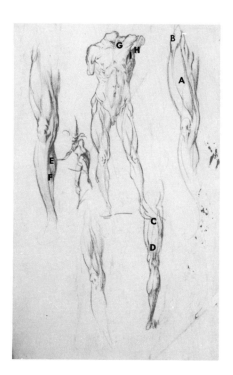

Jacques Callot (1592-1635)

ANATOMY STUDIES

pen

$13^{11}/_{16}$" x $8^{15}/_{16}$" (34.8 x 22.7 cm)

Uffizi, Florence

Here is Callot practicing his anatomy. One can tell, by the extraordinary assurance of this drawing, that he already knew his anatomy very well; but he still thought it worthwhile to keep in practice. Anatomy is something you cannot hold in your mind without constant drawing practice for the rest of your life.

Callot has concentrated on quadriceps femoris (A). He has evidently drawn it so often that he can render it with ease. He is already subconsciously aware of its function and form; the relative proportions of the three visible heads; and their proportions in relation to the surrounding muscles, notably the tensor (B). Were he drawing a less anatomical picture, he would not stress the separateness of the three heads as much, as their function is similar. The same is true of the hamstring group. You will notice that the line C-D is absent from the Callot drawing on the following page. This line separates muscles of similar functions; therefore it will not be stressed on a more advanced drawing.

There are other niceties of anatomy here: the artist's understanding of how gastrocnemius (E) wraps about soleus (F) on the front view; the subtle indication of the one head of pectoralis major (G) which does not adhere to the rib cage; the precise understanding of the insertion of teres major (H) and latissimus dorsi (I) in the humerus and the subsequent course of these muscles.

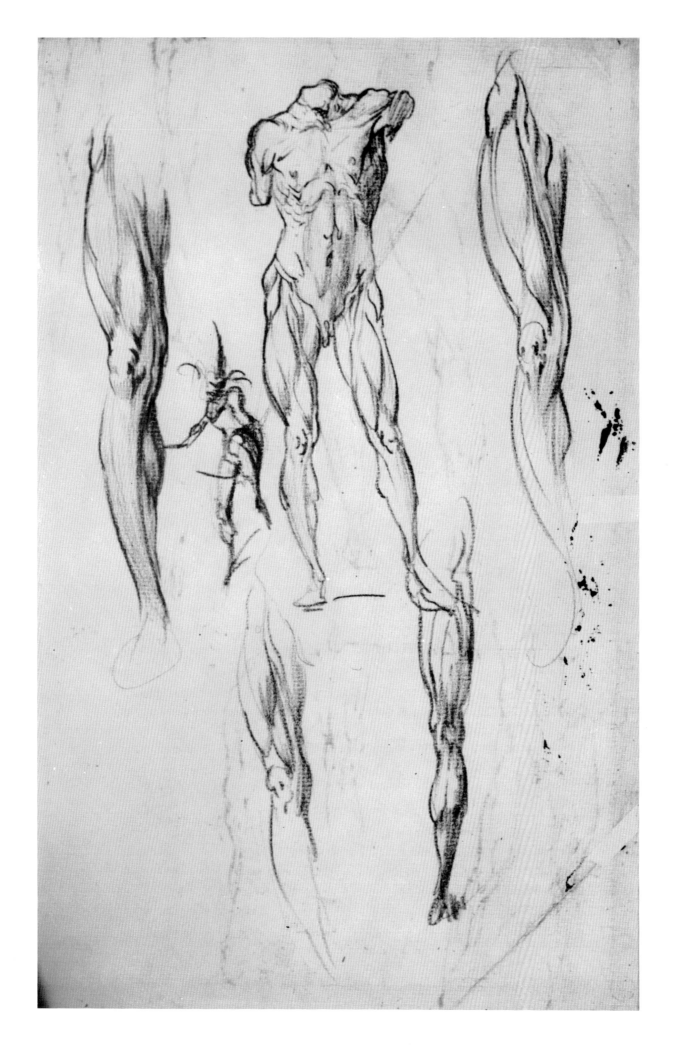

Jacques Callot (1592-1635)

STANDING MALE NUDE

sanguine

12⅛" x 7¼" (30.8 x 18.5 cm)

Uffizi, Florence

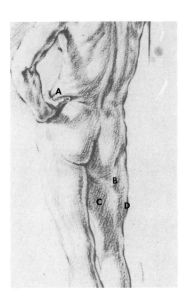

This drawing was made from a model, but Callot brought to it his knowledge of anatomy. Now most beginners seem to have a knowledge of the body drawn mostly from nursery rhymes: they know that people have thumbs (because of little Jack Horner) and a few other evident things, but that is all. And they will sit in a drawing class, sedulously copying the flesh in front of them day after day, making no attempt to identify and analyze each separate part.

Now Callot knew the identity and function of every bump and hollow on this body. And what is more, because of his knowledge of anatomy, comparative anatomy, and function, he was able to characterize every bump and hollow so that they looked more like themselves than they actually did on the model.

Take the external oblique mass (A): Callot knew that it originated on the ribs and flowed to the pelvic crest. Knowing that bone dominates the form of muscle, he had carefully studied the movement of the ribs and the subtle inner and outer curves of the crest. And he knew that, among other functions, the external oblique rotates the rib cage above the pelvis. Like almost all rotators (sartorius and sterno-mastoid, for instance) this imparts to the muscle a spiral quality. Guided by this knowledge, Callot came to a conclusion as to the shape of the external oblique mass. He could then draw this mass with authority and character.

Notice the insertion of gluteus maximus (B) directly between the muscle groups, hamstring (C) and quadriceps (D). The muscle plunges into the line between the functions, intent on its insertion in the femur. This is as it should be, for it hints at how man holds himself erect.

186

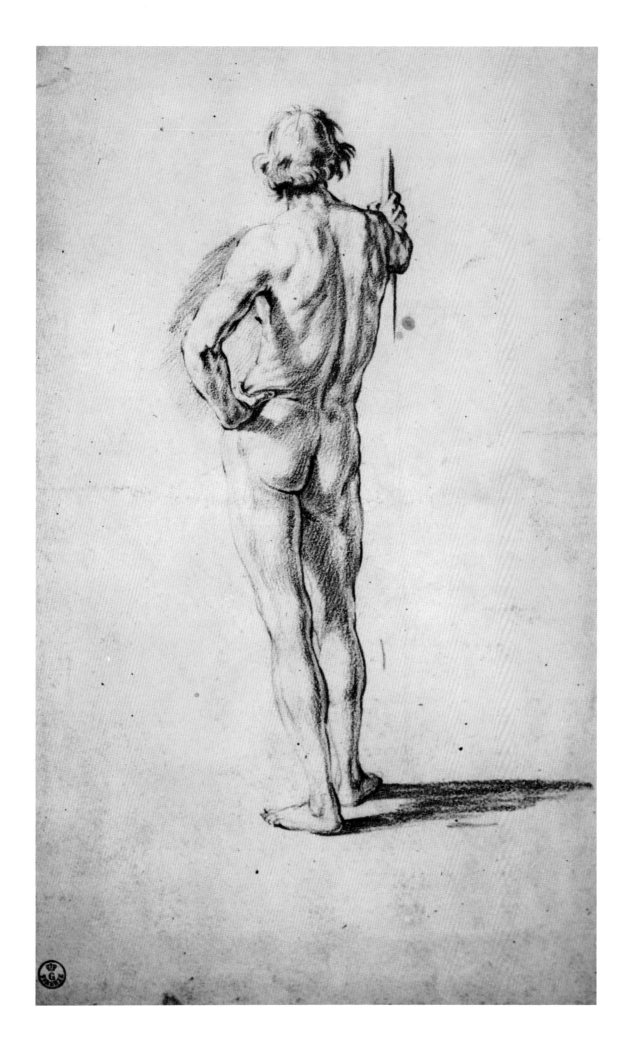

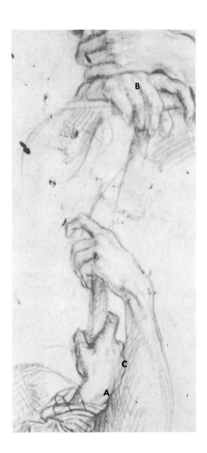

Andrea del Sarto (1486-1531)

STUDIES OF HANDS

red chalk

11¼" x 7⅞" (28.5 x 20 cm)

Uffizi, Florence

Anatomically, the study of the hand may be divided into three steps: studying the bones of the hand; studying the short muscles of the hand; and studying the long muscles and their tendons that arise from the arm.

Studying the bones is most important, because bones, as usual, give the fundamental shape. In studying bones, it is best to think of them as simply as possible, at first, and to draw them that way in the beginning. The femur and the fibula, for instance, may be thought of as a rod with something at one end and something at the other. A rod you can draw, but you cannot draw a *something*. In your mind, you must create a simple form to put on each end of the bone. Take the metacarpals of the four fingers. Initially, each may be thought of as a rod with a cube on one end and a ball on the other. Then you can devote the rest of your life to refining the shape of the cube, the rod, and the ball.

However, you will find these simple, early conceptions used by artists again and again, even in their most sophisticated drawings. The carpus (A) seems to be thought of as a quarter of an apple (skin side on the back) and the ball-like appearance of the knuckles (the distal ends of the metacarpals) is obvious.

Notice how flat the body of the hand is at B — because the metacarpals are pressed against the wood — and observe how rounded the body of the hand is at C.

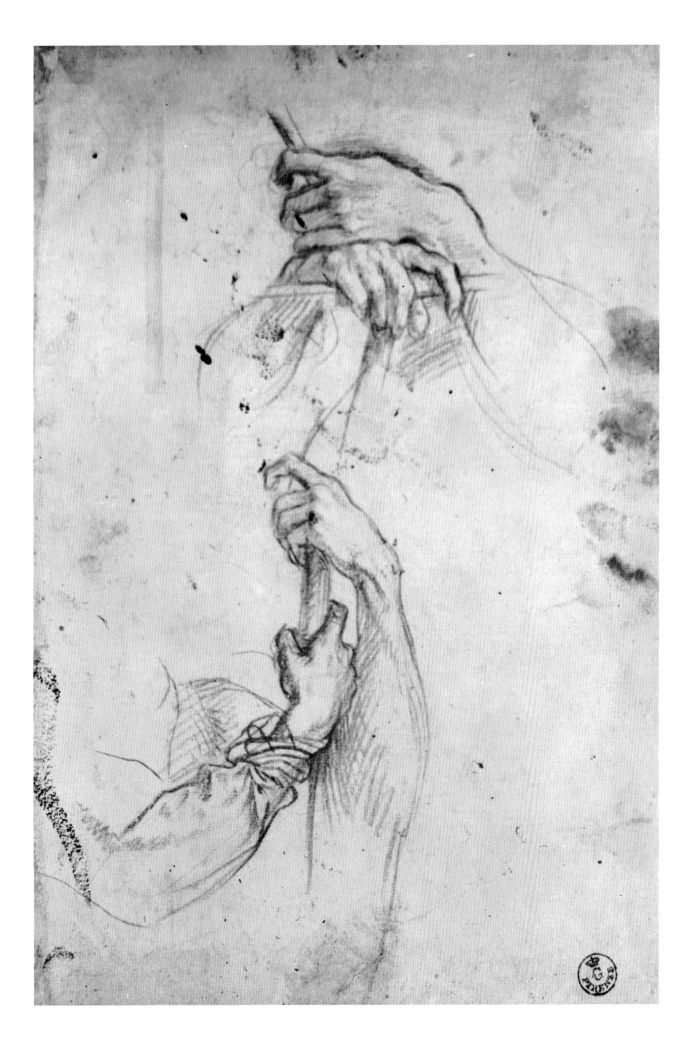

Raphael Sanzio (1483-1520)

STUDY FOR THE TRANSFIGURATION

black chalk and some white

19⅝" x 14⁵⁄₁₆" (49.9 x 36.4 cm)

Ashmolean Museum, Oxford

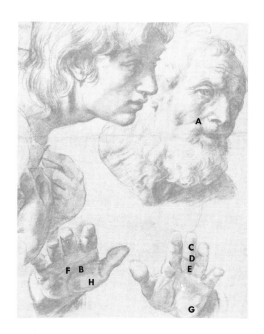

Wrinkles tend to run at right angles to the pull of a muscle. The wrinkles on the forehead of the old man are caused by the vertical fibers of the frontalis muscle. The wrinkle at A is caused largely by the zygomaticus muscle, which runs from the cheek bone to the mouth. The artist calls frontalis the *muscle of attention*, and the zygomaticus the *smiling muscle*. There are many other muscles like these that are responsible for the expression of varied emotions on the face. Study them and you may express any emotion you wish.

The wrinkle at B (the so-called life line) is caused by a small muscle that pulls the thumb towards the center of the hand. Almost all the other wrinkles on the palm side of the hand (such as C, D, E, and F) are caused by tendons of the flexor group of muscles, which originate far away on the internal condyle of the humerus.

The influence of some of the short muscles on the form is clear here. Mound (G) is caused by palmaris brevis; (H) by a little muscle group which arises from the palm and goes largely to the base of the first phalange of the thumb.

Remember, wrinkles are used as lines to express the form over which they run. If you will study your anatomy, you will be able to draw wrinkles even where you do not see them; thus you will get more form in your drawings.

Leonardo da Vinci (1452-1519)

HANDS

silverpoint and white

8¼" x 5¾" (21 x 14.5 cm)

Reproduced by gracious permission of Her Majesty the Queen

Royal Library, Windsor

At A you can sense the ball at the end of the metacarpal of the index and clearly see the tendon of extensor communis digitorum running over this ball, on the tendon's journey to the end of the finger. This tendon appears again at B. H is the same small muscle group labeled H in the previous picture. Mound C represents the abductor of the index; this muscle is so important that it alone will almost make the *skeleton* of a hand look like a *fleshed* hand.

Though you must study the bones of the hand separately, it is also necessary to study the hands (as well as the feet, rib cage, and skull) with the bones all put together. Two arches — the arch (D) where the carpus articulates with the metacarpals, and the half arch (E) at the distal ends of the metacarpals — are the best aids towards the construction of hands. These arches, naturally, are construction lines.

Our upper and lower limbs are much the same. This makes life much easier for the artist. If you learn all about the human upper limb, you already know a great deal about the lower limb, and vice versa. It's true that our elbows look forward and our knees look back, but that is because they got twisted about in the course of evolution. But taking this into consideration, study the remarkable analogies between the muscles and bones of the upper arm and the thigh; the lower arm and the lower leg; and particularly the analogies in the hands and feet.

210.

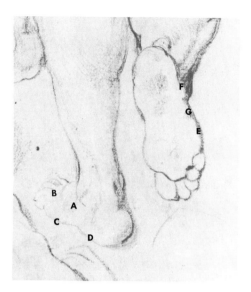

Peter Paul Rubens (1577-1640)

STUDIES OF ARMS AND LEGS

black chalk and some white

13¾" x 9⁷⁄₁₆" (35 x 24 cm)

Boymans Museum, Rotterdam

In studying feet, remember again that the bones force the form. The arch (A) where the tarsus meets the metatarsals is most valuable. Pretend the foot is on the lawn, and put up a croquet wicket to represent this arch. Then draw a line *on the lawn itself*, where the distal ends of all the metatarsals reach the ground (B). Then draw lines to represent the movement of the metatarsals. This will give you a nice sense of the dorsum of the foot.

Artists like to think of the foot in terms of its two bone systems: the ankle system that starts with the astragalus and ends with the big toe and its two adjacent toes; and the heel system, that starts with the os calsis and ends with the little toe and its adjacent toe. Walk about on the floor with wet feet and see how the imprint of these two systems varies as you apply more weight to the foot.

Then look at your foot from the inside and sense the great arch on which the weight of the body rests.

Learn to draw footprints out of your imagination. Remember, many difficult views of the foot are but footprints in an odd perspective.

The short muscles of the foot are as influential as they are on the hand. The forms at C and D are caused by abductor minimi policis. They reappear at E and F. Notice the little bump at G: the proximal end of the metatarsal of the little toe.

Study the long muscles. Exclusive of the calf, most of them may be grouped on the side of the leg. I know that the names of none of them appeared in your nursery rhymes, but the tendon of tibialis anticus, when the foot is flexed, makes a form as big as your nose! And you wouldn't think of leaving out the nose, would you?

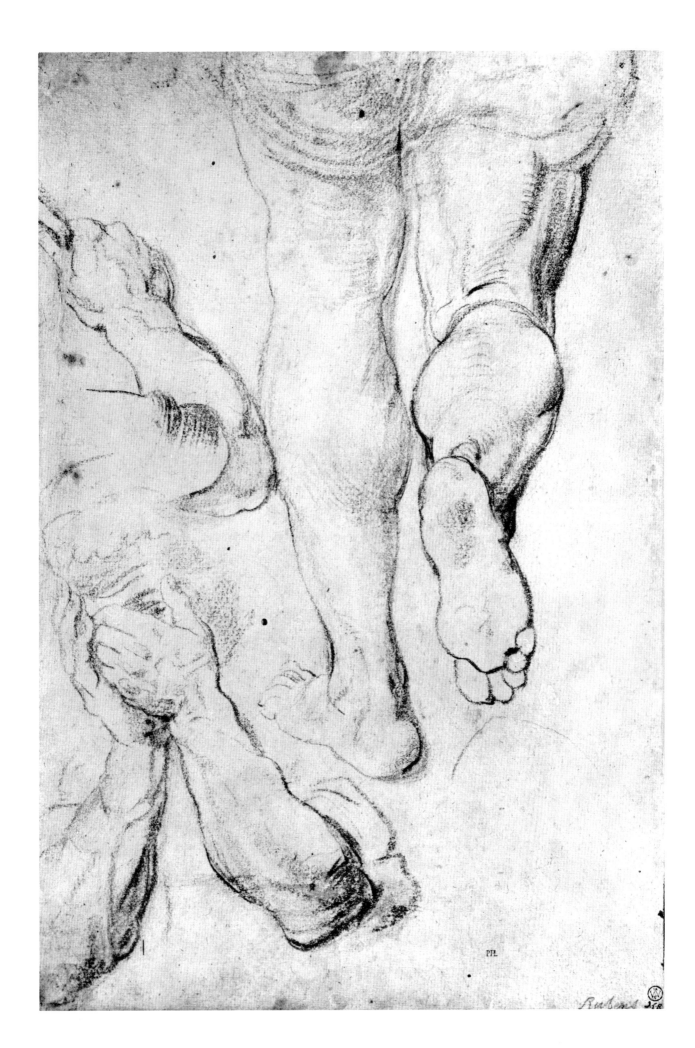

Rubens

Michelangelo Buonarroti (1475-1564)

STUDY FOR CHRIST

black chalk

12⁹⁄₁₆″ x 8¼″ (32 x 21 cm)

Teyler Museum, Haarlem

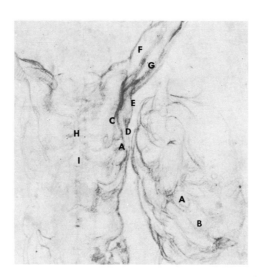

Here is a superb front and side view of the body. The great mass of the rib cage is conceived as an egg, somewhat flattened from front to back. This is the controlling mass; all details upon it are drawn with an awareness of its presence.

The little bumps of serratus magnus (A) are admirably shown on both front and side views. Realize that the lower four digitations of this muscle are not parallel; they fan from the lower angle of the shoulder blade. The bumps marked B are the fleshy origin of the external oblique; they fan out even more and are invariably mistaken by students for ribs.

The pectoralis (C) is moving under the deltoid to its insertion. Together, these two muscles make up the front flap of the armpit. The back flap of the armpit is composed of latissimus dorsi (D) and teres major (E) seeking its insertion in the humerus. Notice that the back flap of the arm is inserted between the biceps (F) and the triceps (G).

Notice the hollow made by the sternum bone (H) as the pectoralis piles up on each side of it. This may suggest why so many things that are prominent on the skeleton become depressions on the fleshed figure. The ensiform cartilage (I), a famous landmark, is at the bottom of the sternum.

Why is the ensiform a famous landmark? The distance from the pit of the neck to the top of the ensiform cartilage, if doubled, will give you the bottom of the rib cage. Since artists have a hard time deciding where the bottom of the rib cage is, this is a convenient bit of information.

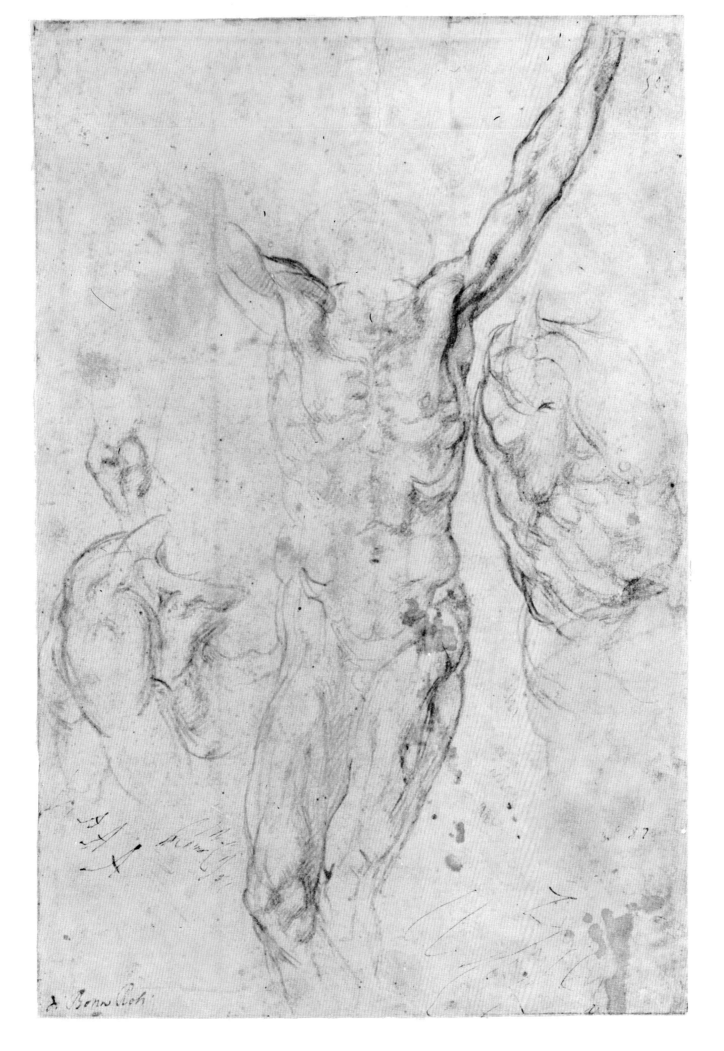

Filippino Lippi (1457-1504)

ATHLETIC YOUTH

pen

6⅞" x 3¹⁵⁄₁₆" (17.5 x 10 cm)

Royal Library, Turin

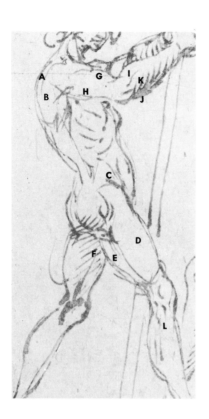

For centuries, artists have combined muscles of similar function into groups. Thus, the artist does not bother much with the individual muscles in the group, but presents a symbol of the group as a whole. Here are some of these muscle groups.

Rhomboid group (A): upper and lower rhomboid. Infraspinatus group (B): infraspinatus and teres minor. External oblique group (C): the external oblique is usually thought of in relation to the muscles beneath it. Quadriceps of the thigh (D): vastus internus, vastus externus, rectus femoris, and crureus. Hamstring group (E): biceps femoris, semitendinosus, semimembranosus. Adductor group of the thigh (F): all the adductors of the thigh that move from the pelvis to the femur, plus the gracilis. Biceps group (G): biceps of the arm and the so-called pillow muscle, brachialis anticus. Triceps group (H): the three heads of the triceps. Supinator group (I): brachioradialis and extensor carpi radialis longus. Flexor group of the lower arm (J): all the flexor muscles that go to the hand from the internal condyle of the humerus. Extensor group of the lower arm (K): all the extensor muscles that go to the hand from the vicinity of the external condyle.

Although I have never seen it mentioned, I think you might combine the six muscles at (L) that go down to the foot and call them the peroneal group.

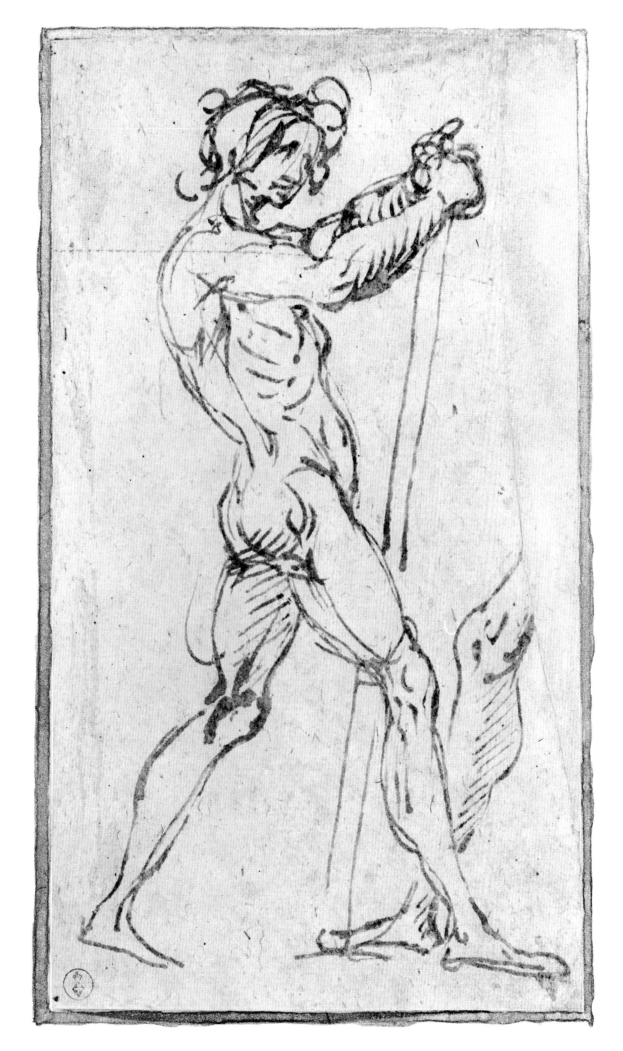

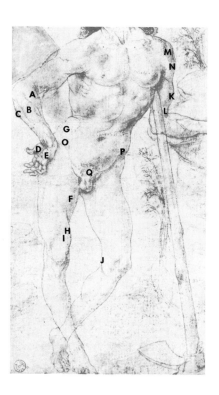

Antonio Pollaiuolo (1432-1498)

FIGURE OF ADAM

pen and ink, with black chalk

11¹⁄₁₆″ x 7¹⁄₁₆″ (28.1 x 17.9 cm)

Uffizi, Florence

Here Pollaiuolo clearly defines the three muscle groups of the lower arm: the supinator group (A); the extensor group (B); and the flexor group (C). Also evident is the group of muscles (D) that cluster about and include flexor brevis pollicis. The opposite mound (E) is caused by palmaris brevis. The adductor group of the thigh is presented as a simple egg shape (F), with no individual muscle showing. The form of the external oblique (G) is well thought out and in a state of mild compression.

There are many small but important details. Line (H) is drawn up over the mass of the adductor group (F) to show that the flesh of vastus internus (I) is in front of the adductor group. Line (J) moves forward on the leg to show that the inner hamstring (which this line represents) is in front of the calf. Notice how many times this device is repeated in this figure, down to the smallest details.

Notice the swelling of the biceps (K) and its sudden turn into tendon (L). Notice the two swellings of the deltoid, upper and lower (M and N). Remember, the greatest width of the upper body is through the lower swelling of the deltoid. The points of the pelvis (O and P), together with the symphysis pubis (Q) form the famous imaginary triangle at the front of the pelvis. There is a triangle in back: the sacrum. As these triangles are fixed in position, one to the other, a pelvis may always be constructed from them. Try it.

200

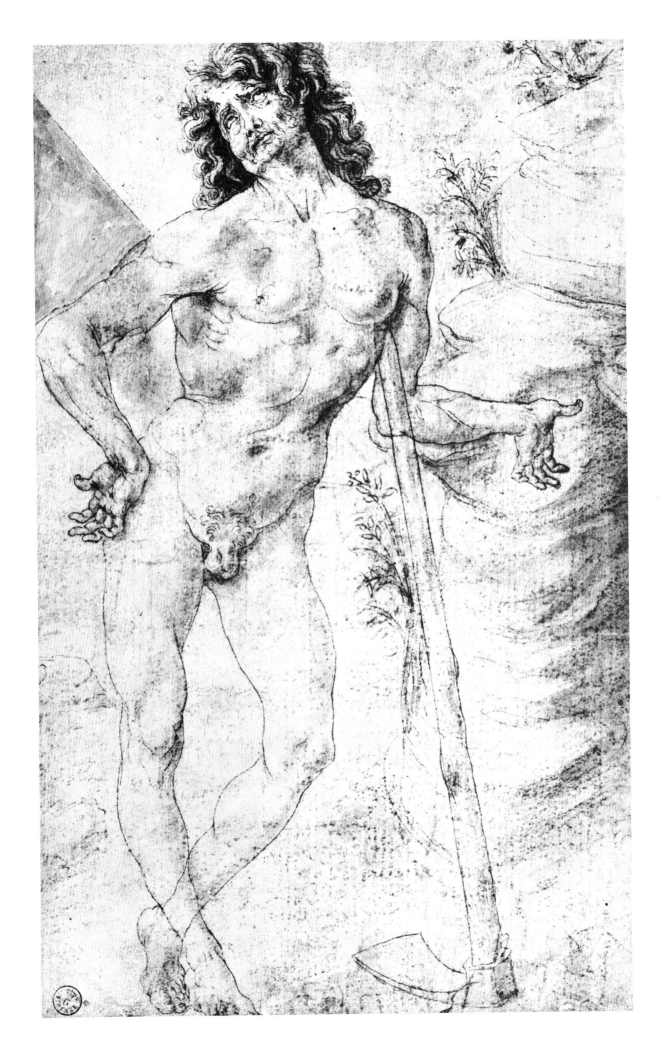

Andrea del Sarto (1486-1531)

STUDY OF FEET AND HANDS

red chalk

10⅝" x 14⁹⁄₁₆" (27 x 37 cm)

Louvre, Paris

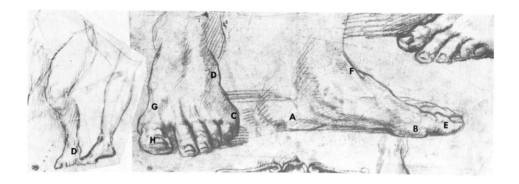

In these sketches, we have an excellent opportunity to study the five masses of the foot: the heel (A), which, on the outside view of the foot, is thought of as the first convexity of the abductor of the little toe; the distal end (B) of the metatarsal of the big toe; the second convexity (C) of the abductor of the little toe; the egg-like form (D and D) of the group of short extensors of the toes; and the great toe itself (E).

At F is a superb view of the tendon of tibialis anticus. This is a most important tendon because it carries "the flow of the form" (as artists say) from the lower leg to the foot. This is the way the deltoid carries the flow from the shoulder to the arm, or the external oblique from the rib cage to the pelvis. Think of how the side view of the front ankle would look if the tendon of tibialis anticus were not there. The outline would then be carried by the bones, and would offer a most jagged appearance.

The very obvious tendon at G is the tendon of the special extensor of the great toe. The similar tendons that go to the other toes are the tendons of the common extensor of the toes. Notice that the big toe (H) points its own way, the other toes to a point beneath the picture.

202

ANDREA DEL SARTO PIT.

Michelangelo Buonarroti (1475-1564)

STUDY OF THE BACK AND LEGS OF A MAN

black chalk

9½" x 7⁹⁄₁₆" (24.2 x 18.3 cm)

Teyler Museum, Haarlem

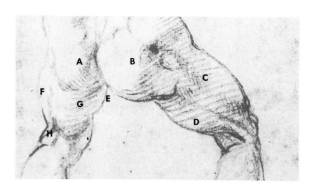

This picture and the more developed drawing on the following page are interesting because they present many identical forms, with the bodily thrusts just slightly altered. In both, the direct light is from the left, and the reflected light is from the right.

You will notice that I mention light sources and their direction a great deal. This is because beginners always think of shade as a sort of dye on the body. They think of shade as something independent of the light source. The advanced artist never observes shade on the figure without subconsciously considering the light that causes this shade.

Here the two great gluteal muscles (A and B) are slightly altered sphere symbols, as usual. B is driving to the femur bone, between the quadriceps group (C) and the hamstring group (D), thus giving evidence of the primary function of the gluteal muscles. On the left leg, all the important masses of the thigh are strongly characterized: the adductor group (E); the quadriceps group (F); and the hamstring group (G). The inner and outer hamstrings (H and I) are accentuated on both legs.

There is no doubt that the artist was strongly conscious of the functions of all the forms he dealt with. You have a great advantage over Michelangelo. By simply studying a modern medical anatomy book for a month, you can learn twice as much about the function of bodily forms as poor Michelangelo gathered in his whole lifetime.

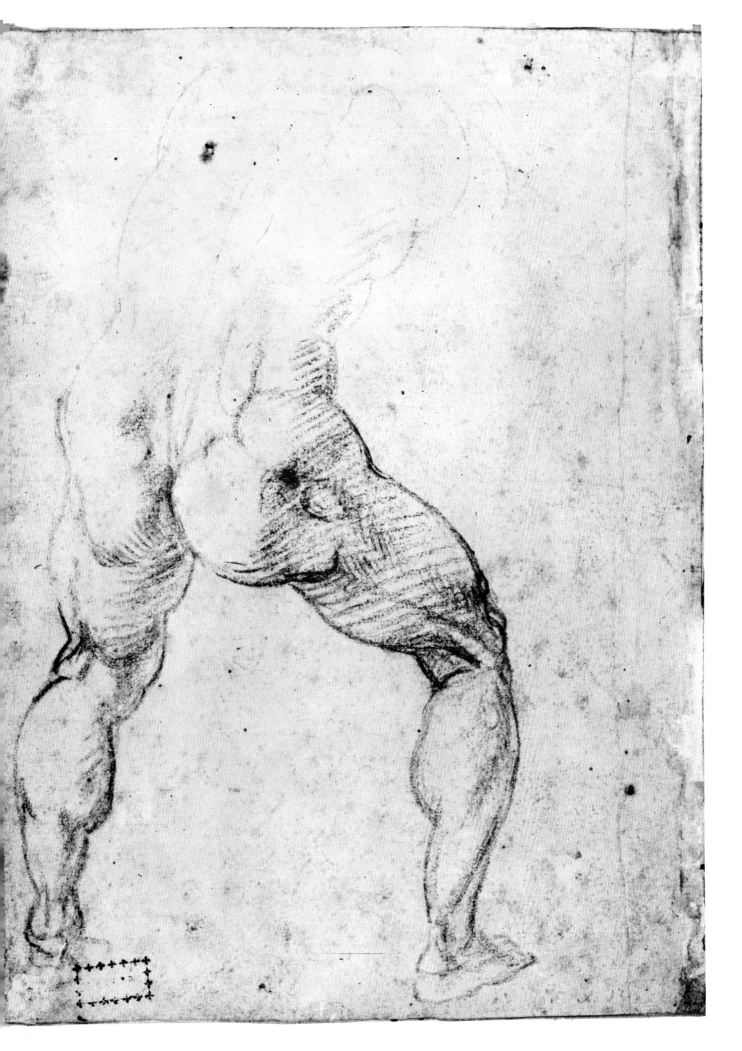

Michelangelo Buonarroti (1475-1564)

FIGURE OF MALE NUDE

black chalk

10¹⁄₁₆" x 6⅛" (25.5 x 15.5 cm)

Casa Buonarroti, Florence

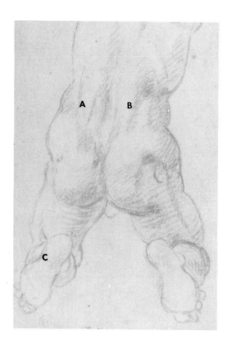

We have here an excellent opportunity to observe what students call "the strong cords" (A and B) in the small of the back. These cords hold the rib cage erect on the pelvis. Because this is such a typically human function, these cords are always accentuated.

In actuality, they are the fibers of the iliocostalis, a part of the erector spinae. In artistic anatomy books, they are often omitted because they are really covered by latissimus dorsi. Latissimus is only a thin film here and not worth much attention. If your artistic anatomy book does not show the details of erector spinae, you must go to a medical anatomy book. The other components of erector spinae —longissimus dorsi and spinalis dorsi — are frequently used by artists.

The feet in this drawing are but footsteps in perspective. Notice the prominent little bump at C. Have you ever noticed it on your wet footprint? It is the proximal end of the metatarsal of the little toe. Put your finger down and feel it on your own foot.

Never forget that *you* have all the same bones and muscles as your model. Become familiar with your own body. Why not get down on your knees and take the same pose as this figure? Then you can feel your muscles in function, a .d observe the precise thrust of your bodily forms.

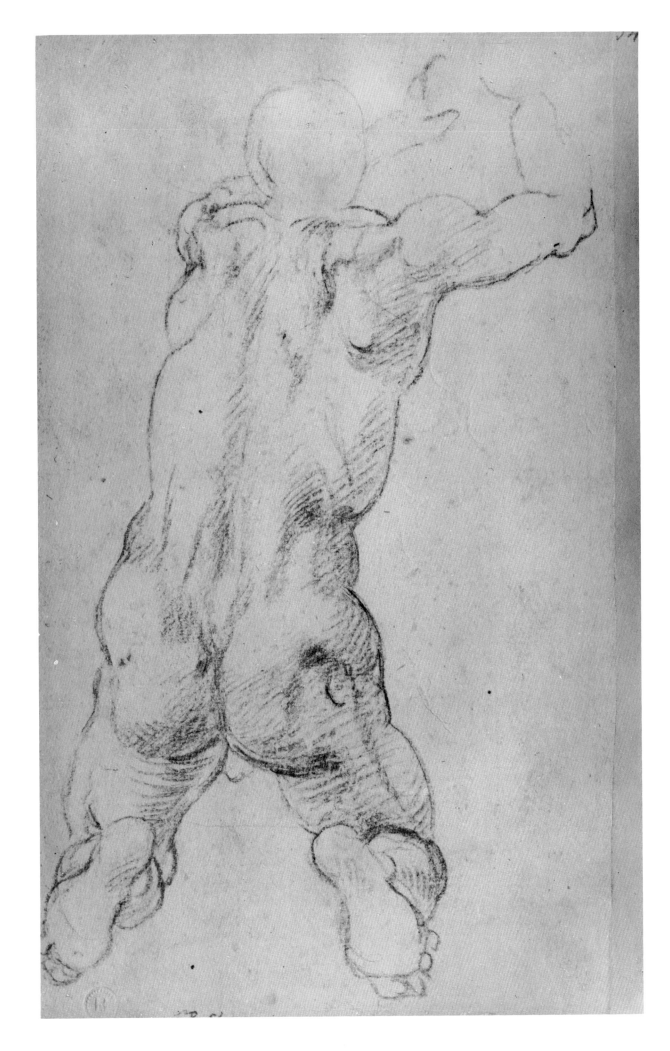

SEVEN

DRIVING ALL
THE HORSES
AT ONCE

THE REALLY HARD THING about drawing is that you have to think of so many things at once. But this is true of many skills, such as playing a musical instrument, speaking a language, or designing a building. It is evident that we humans are so organized that we *can* cope with these tasks, provided that we take the time and trouble.

THE ELEMENTS OF
DRAWING ARE
INTERRELATED

In the previous chapters, I have dealt separately with the subjects of line, light, planes, mass, direction, and anatomy. These are but six of the elements that form the basis of good draftsmanship. There is not an artist in this book who had not thought deeply about all of these elements and mastered all of them. There is not a picture in this book in which any one of these elements is missing.

You must understand, too, that these elements are interrelated and dependent upon one another. You cannot make a drawing in line without understanding all the other elements. You cannot express your anatomical knowledge without understanding line, lighting, planes, mass, etc. In fact, anatomy as a science did not exist until these elements were

mastered by artists. In other words, good drawing is something like driving a big team of horses, controlling them all simultaneously.




COMPOSITION AND
PERSPECTIVE




There are, of course, other elements besides those I have mentioned. Composition is one of them; perspective is another; rendering texture is still another. And then there are certain ghost horses, hard to define and therefore hard to control, whose presence the artist senses as he develops.

Beware of neat theories of composition. The artist's feeling for composition, like the artist's feeling for proportion, is a highly personal thing. However, certain principles of composition may be learned by studying the masters. Goya's mastery of the balance of blacks, grays, and whites is a case in point.

And related to the artist's style, there is a kind of personal geometry that each artist develops and uses. As you study the masters, look for vertical, horizontal, and oblique lines that dominate the forms, appearing and disappearing (Veronese). Look for simple, geometric forms like triangles and circles that contain an assemblage of forms (Raphael). Look for lines that converge at a given point which is either inside or *outside* the picture (Degas). Sometimes these lines touch the outsides of forms or run through the axes of forms. Look for spirals. Look for related and controlling curved lines.

It is difficult to study composition from drawings alone. The larger works of the masters — paintings and sculpture — must be consulted. I shall, however, point out a variety of compositional devices in the gallery of drawings that concludes this volume.

As for perspective, all the artists in this book have mastered it. You can do the same if you wish. You can find a book on perspective in your nearest library and in most art supply stores. There will be short articles on perspective in your encyclopedia. Like the other elements of drawing, the influence of perspective is apparent in every line of every drawing in this book.

Perspective and composition, of course, are closely associated. It takes great skill to control the perspective so that it does not overwhelm the composition.

There is a matter, related to composition and perspective, that has not been sufficiently noticed. To master perspective, an artist must form the habit of driving lines to a perspective point, either inside or outside




the picture. Through the tradition of Western art, this habit became so automatic that it entered into composition. By this, I mean that artists frequently drive lines, relating to their composition, to points inside and outside the picture, to points which are not perspective points at all.

STUDY THE HISTORY OF ART

If you have decided to be an artist, you should make a great effort to learn all you can about the history of art. Not just the history of Western European art, but the history of all art, from prehistoric times to the present.

All this is easy to learn nowadays; technological developments in art reproduction have made great works of art — from every culture that ever existed — yours for the asking.

I also believe that you should become supremely aware of the art tradition of your own country, and strive for your proper place within this tradition. Due to the rapidity of mass communications, it is true that art is becoming international in style. But the flavor of the country of an artist's origin seems always to persist, and adds strength to his work.

Ignorance of the past history of art has led many artists into disaster, for they persist in outworn styles, or waste their strength on problems that have been fully solved. You should strive, too, to learn all you can about contemporary art, the art of your own time, and strive to understand, in full, the forces that have brought this art about. Otherwise, like almost all students, you will grasp at some shopworn cliché and persuade yourself that this fragment is the creation of your own imagination.

YOUR FUTURE GROWTH AS AN ARTIST

Remember that no book can take the place of study under an accomplished artist. In drawing and painting there are many things that can only be communicated by a turn of your teacher's pencil or a flourish of his brush. Western artists partake of a long tradition, well formed before the time of Leonardo. In an unbroken line, studio techniques have been handed down from master to pupil. Many of these numerous techniques and devices are so subtle that they have never appeared in print and never will.

Your style will develop through the decisions you make as you draw or paint from day to day. These decisions will all be influenced by the qualities of your mind; by your selflessness or selfishness; by your

curiosity or lethargy; by your dignity or vulgarity; by your honesty or insincerity. Never forget that the really good critics — and there are quite a few — can look right through a canvas into the eyes of the artist beyond.

And finally remember that you are forsaking the world of words and entering a world of visions.

The best of luck to you all!

ILLUSTRATIONS

DRIVING ALL THE HORSES AT ONCE

Jean Auguste Dominique Ingres (1780-1867)

PORTRAIT OF PAGANINI

black lead and chalk

11⅝" x 8½" (29.5 x 21.6 cm)

Louvre, Paris

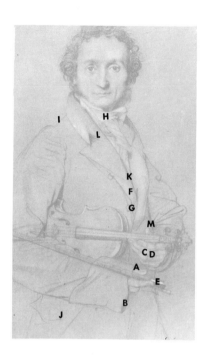

Notice how the line of the sleeve (A-B) runs over the thumb to give it form and direction. The line is then depressed by the bow, giving direction to the bow, and then runs over the index finger to give form and direction to *this* finger.

As the phalanges of the fingers change direction, notice how values change (C and D). Ingres is very conscious of the rules: up plane light, down plane dark; front plane light, side plane dark. See how the up plane on the block at the end of the bow (E) contrasts violently with the down plane. Notice how the up plane of the lapel (F) contrasts with the down plane (G). It is very probable that the planes of the lapel were *not* breaking at this place; but artists love to put a plane break in the lapel here, indicating that beneath this break the great front plane of the chest meets the down plane of the body.

At H, the folds of the cravat indicate the thrust of the cylindrical neck.

Ingres uses an interesting compositional device: lines, no matter how short, are forced to point at the pupil of the dominating eye. Put a straight edge on the pupil of the eye on your right and note how accurately Ingres has done this with the line on the coat (I); the line on the pocket (J); the line where the cravat meets the lapel (K); the line on the collar (L); and the right hand side of the coat line above the hand (M). This last line, if extended, would just touch the tip of the bow.

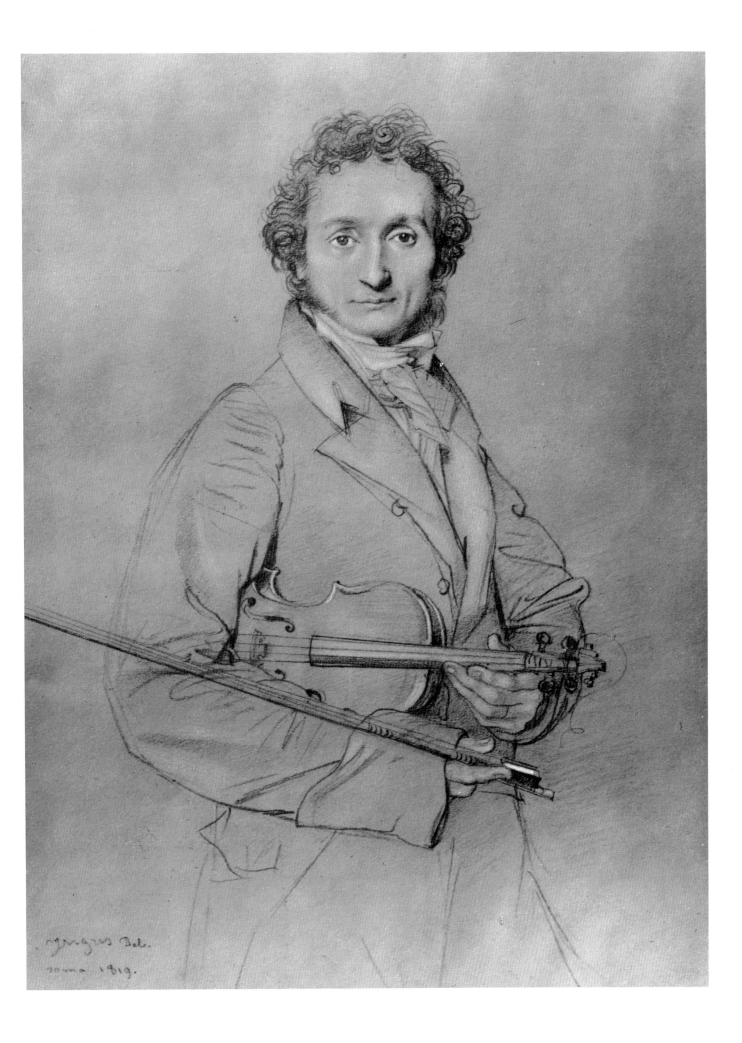

Giovanni Battista Tiepolo (1698-1770)

ANGEL

pen with wash

7½" x 11⅝" (19 x 29.5 cm)

British Museum, London

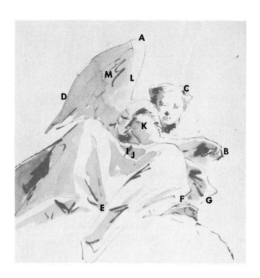

Tiepolo often liked to enclose compositional masses in triangles. One line of the triangle runs from the top of the wing (A) through the little finger (B). He must have worried about the fact that the head dress breaks through this line to the right, so he added a strong little shade accent (C) to intensify the existence of the line.

Note how lines D, E, F, and G all meet at a point in the lower left of the picture, giving direction to the two random strokes I and J.

Naturally, this is an imaginary picture; angels do not pose for artists. Tiepolo's knowledge of perspective was staggering, as you must know if you have seen his great compositions. He completely solved the difficult problem of creating figures well above the horizon, as he has done here.

The light is the artist's favorite light, from the right. Reflected light comes from the left. The foot and hand are broken into clear planes. The upper arm is more or less a cylindrical conception, and the little lines of the sleeve (K) run over this conception to give it form and direction. Naturally, these lines are light in value on the top plane, and dark on the side plane. The wing is planed: the front plane is L and the side plane is M. This side plane is curved. Tiepolo thoroughly understood the movement of reflected light on a curved side plane. I hope you will study this carefully. All you need is the interior of a round hat box.

Rembrandt van Rijn (1607-1666)

GIRL SLEEPING

brush and wash

9⅝" x 8" (24.5 x 20.3 cm)

British Museum, London

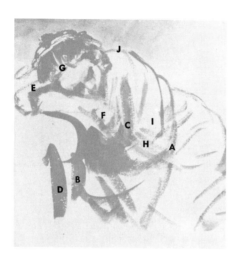

This is another triangular composition; but the triangle is so big that you will have to imagine it running off the page to left and right. Rembrandt uses curved brush strokes (A, B, C, and D) coming from a point outside the picture below and to the left.

The light is again the artist's favorite light, from the right. The severe blocking of the sleeve (E) is interesting because it was not that way on the model, and this picture is drawn from life. The clarity of the three planes of the hand (F) is Rembrandt's, not the model's. The highlight on the hair (G) was supplied by Rembrandt to indicate the curving plane of the hair at this point. Rapid strokes indicate that H was the down plane of the arm and I the up plane. Line J on the shoulder disappears behind the head and turns up again on the sleeve. Dropping a line this way and picking it up again is a familiar compositional device. Notice it in line A.

This drawing was done very quickly. Students always feel that they can make a good drawing if they have enough time. But these marvelously rapid sketches of Rembrandt may teach you that it is not time that makes a good drawing, but understanding.

Andrea Mantegna (1431-1506)

JUDITH AND HER SERVANT

pen

14³⁄₁₆″ x 9¹³⁄₁₆″ (36 x 25 cm)

Uffizi, Florence

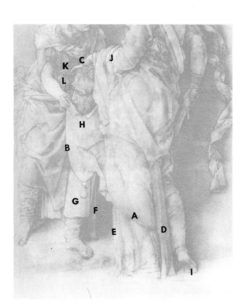

In this drawing, the composition has been thought out very carefully. The place-ment of the two figures is controlled by an arched line; the top of the arch is Salome's head, and the right side follows the ribbon that falls from her hair. Lines appear, disappear, and reappear again and again, as on the bottom of the drapery (A), the side of the bag (B), and the top of Salome's hand (C). The lines of the folds (D, E, F, and G) emanate from a point above the picture, a little to the left of center. Deliberate vertical lines (such as H) are played against deliberate horizontals, such as the foot (I) and the horizontal axis of the lower arm (J). The oblique thrust of the sword is stopped by the counter oblique of fold A. Many lines are arranged to point at the eye on the right of the severed head.

Mantegna's understanding of the mechanics of drapery is remarkable. But this knowledge would be of no avail unless he was able to draw figures out of his head, as indeed he was. The drapery at all times suggests the form of the body over which it passes. As it moves, the drapery constantly reveals the artist's con-ceptions of the mass and direction of various parts of the body. At K, for in-stance, he suggests the forward thrust of the rib cage; at L, he reveals the ball-like form of the abdomen beneath.

It is wonderful practice to draw ribbons out of your head — like the ones here — and to shade them under direct and reflected light: If you can draw ribbons, you can imagine the ribbons wrapped tightly about a model, both horizontally and vertically. Then, if you know how to shade the ribbons, you can shade the body.

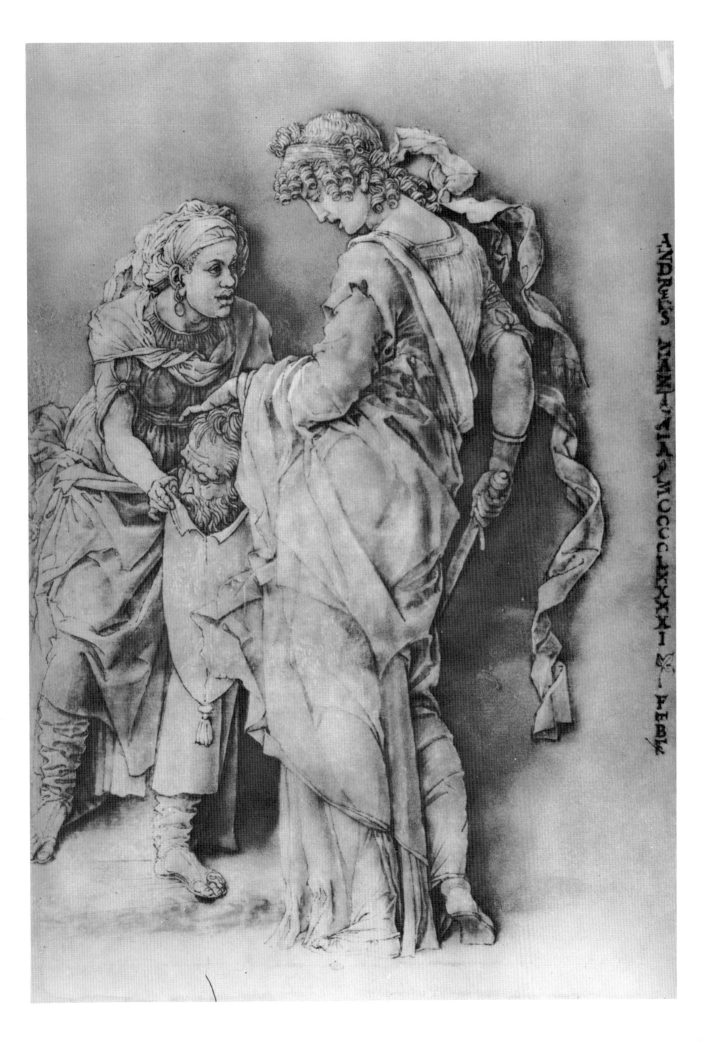

ANDREAS MANTINIA M·CCCC·LXXXI · FEBR·

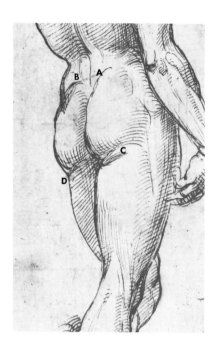

Raphael Sanzio (1483-1520)

STUDY OF DAVID AFTER MICHELANGELO

pen with some black chalk

15½" x 8⅝" (39.3 x 21.9 cm)

British Museum, London

It is difficult for a beginner to realize that perspective is operating in every line of a figure like this. But it is. The horizon line runs through the knees; everything above the knees is drawn as if seen from below, and everything below the knees is drawn as if seen from above.

Perspective, like anatomy, is complicated. That is why I keep asking you to study these subjects with a teacher who knows about them. And you should go to the books. For those who are particularly curious and ambitious, I would also recommend a study of descriptive geometry.

Mass conceptions and perspective are closely related. The masses used by the artist are largely blocks and cylinders. If the body is thought of in terms of blocks, and the model is standing at attention like a soldier — that is, with the shoulders parallel to the pelvic points — then it is easy to put each of these blocks in the proper perspective.

But since models hardly ever stand at attention like soldiers, the problem is always more complex, as it is in this drawing. Here the pelvis drops to the left, and the rib cage drops to the right. The artist was therefore forced to accommodate his perspective to the differing thrusts of rib cage and pelvis.

Notice that the construction line A-B through the top of the sacrum — which Raphael has actually lightly traced — does not fall so much as it moves to the left as the construction line C-D. This is always true when the weight of the model is on one side.

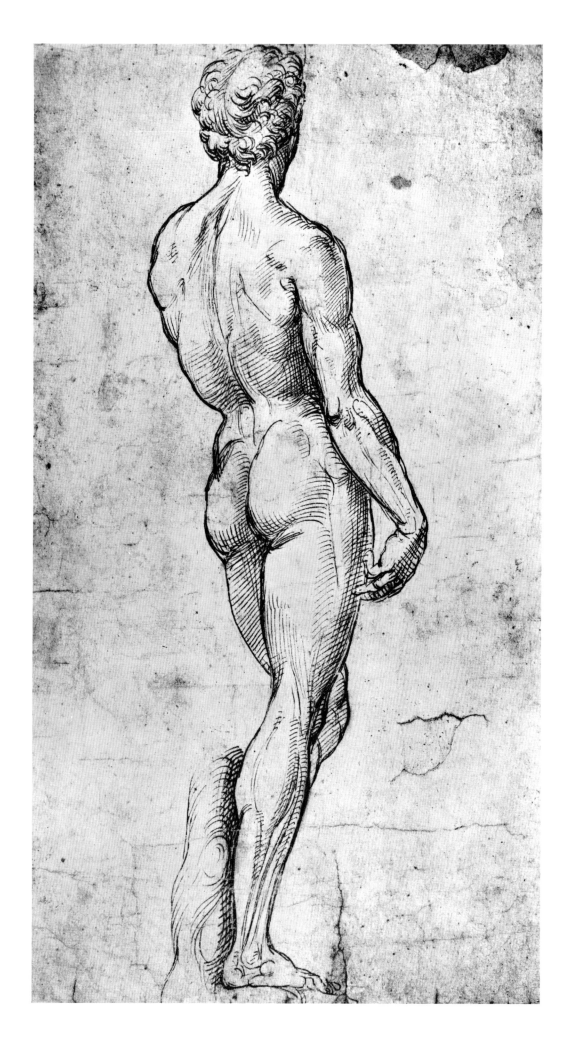

Peter Paul Rubens (1577-1640)

NUDE WOMAN

black chalk

20¹⁵⁄₁₆″ x 9¹⁵⁄₁₆″ (53.2 x 25.2 cm)

Louvre, Paris

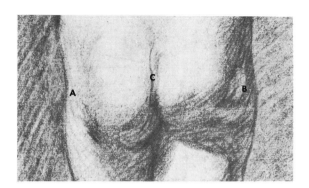

Let me suggest one way to get a feeling of perspective for figure drawing. Sketch a number of great cylindrical towers in the desert, at varying distances from you. Then imagine the towers to have steel bands going around them at varying levels. You will find that the bands you draw at the horizon level will be horizontal and continuous with the line of the horizon. The bands above the horizon on the fronts of the towers will curve up. Those below the horizon will curve down.

Then substitute a human figure — standing like a soldier at attention — for your tower. Run circles around this figure. Try not only the front view but other views. You will then get a sense of how perspective works on the figure.

Artists have thought a lot about these circles, and through their study of the body, artists know exactly where to put them. They run these circles through landmarks on the body that are on the same horizontal level. You may wonder whether artists must have X-ray eyes; I assure you that is just what all good artists have.

For the mass of the head, they will run a circle through the eyebrows, and through the tops of the ears, because these landmarks are on the same level. A more sophisticated artist might run his circle through the base of the nose, the bottoms of the cheek bones, the bottoms of the ears, and the bottoms of the mastoid processes.

For the mass of the pelvis, they may well run their circle through the tops of the great trochanters (A and B), the bottom of the sacrum (C), and the symphysis pubis. If you have X-ray eyes, you can see the symphysis pubis right through the body, opposite C.

For the mass of the rib cage, the circle is often run through the nipples and the bottoms of the shoulder blades. As models seldom stand at attention, the circles must vary with the differing thrusts of the body.

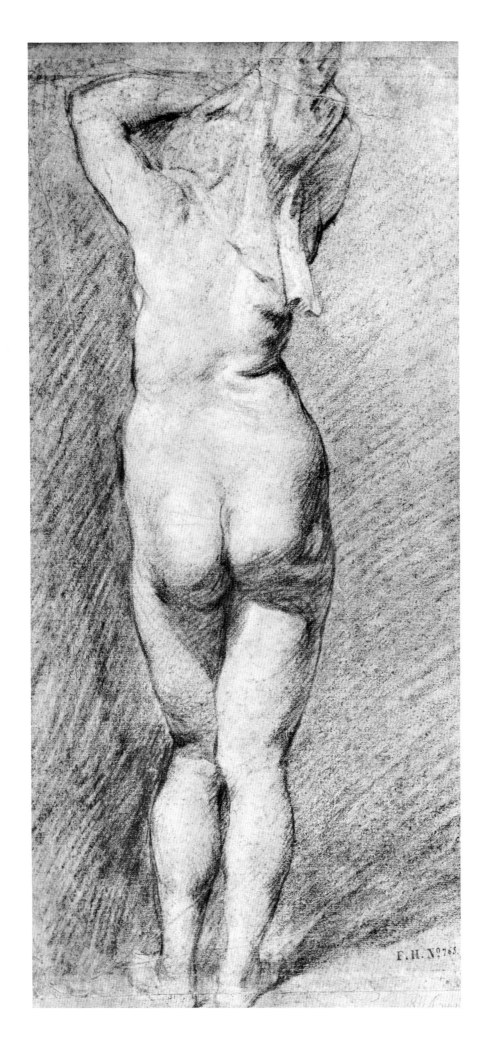

Andrea del Sarto (1486-1531)

HEAD OF AN ELDERLY MAN

black chalk

8¹¹⁄₁₆" x 7¹⁄₁₆" (22 x 18 cm)

Uffizi, Florence

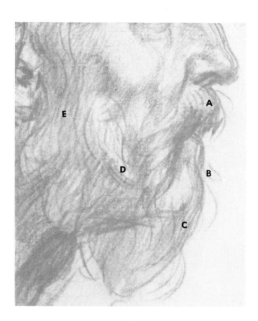

Here is a level profile. The head is tipped neither towards you nor away from you. This type of head is by far the easiest to draw, as perspective problems are held down to a minimum. Skillful artists love to tip the profile a little this way or that way, for the same reason that a skillful pianist loves to play a difficult passage. Actually, the form may be better brought out in a tipped profile for various subtle reasons. One of them is that in a tipped profile you can show the curve of the line where the lips meet, as this line curves around the teeth. In a level profile, this line becomes straight and a straight line can scarcely reveal curving form.

Most students feel that a beard is just a mass of hair on the face. But actually, the beard has very definite forms and grows from definite places. These are the mustache (A), the goatee (B), the beard of the center of the chin (C), the beard of the cheek (D), and the sideburn (E). The model here must have shaved his neck, for the great beard of the neck is missing.

The ear is beautifully drawn. On this type of profile, beginners will draw the ear as if it lay flat on the side of the head. But here you can feel the ear coming out of the head at a strong angle. Notice too that the ear is not vertical, but rotated slightly backwards.

226

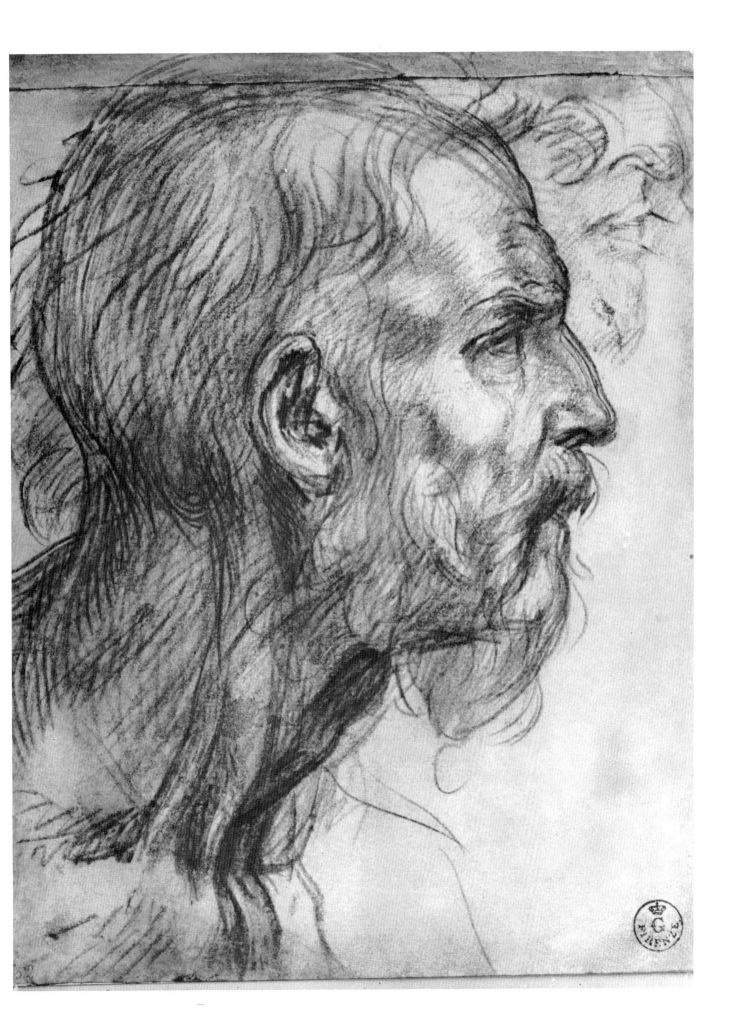

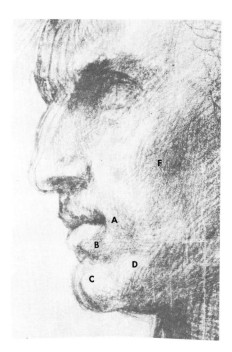

Andrea del Sarto (1486-1531)

HEAD OF AN APOSTLE

black chalk

14⅜" x 9⁷⁄₁₆" (36 x 24 cm)

Uffizi, Florence

The profile is turned very slightly towards us and the top of the head leans very slightly to the left. You can never draw a head like this from the model, unless you have absorbed all the principles of turning and tipping heads, and you can draw a head in this precise position from your imagination. There are too many problems involved here that cannot be resolved by mere copying while you are drawing the model; they must all have been solved well in advance.

Here are some of the conditions the artist faced. In the first place, all models' heads move slightly while they are being drawn; thus, the artist had to decide on the exact position of the head he wished to portray. The artist then had to force all features to conform to the position he had chosen for the head. He then had to invent the mass conception of the head suitable for the character of the model and for the lighting conditions. He then chose lighting conditions suitable for his mass; here he decided upon a brilliant direct light from the left and a subdued reflected light from the right.

He then had to come to a conclusion as to the exact shape of all the small forms (such as A, B, C and D) he wished to indicate on the head. And he had to be able to render them in the lights he had chosen, so that these small forms looked like the shapes he had in mind.

In fact, he even had to be able to draw a skull out of his imagination, in the same position as the head. Otherwise, he could not have indicated with such exactitude the edge of the temporal fossa (E), the turn of the cheek bone (F), and many other bony details.

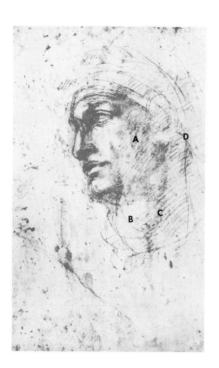

Michelangelo Buonarroti (1475-1564)

HEAD IN PROFILE

black chalk with pen and bistre

14¹⁵⁄₁₆″ x 8¹⁄₁₆″ (38 x 20.5 cm)

British Museum, London

Here is another head somewhat similar to the previous one, though it is turned a little more and tipped a little more. The mass conception of the head is much the same; a block-like conception, with the nose a smaller block protruding from the front plane. Here, however, the side plane (A) is unfinished; otherwise, it would have been brought into tonal relationship with the darks of the side plane of the nose.

It is interesting to see Michelangelo change his mass conceptions as he moves from head to head dress. The head is certainly block-like, but the circular lines of the head dress clearly run over a more cylindrical conception.

The neck is also block-like, with a front plane (B) and a side plane (C). Michelangelo has refused to mar the front plane with the cast shadow used in the previous picture. Note how the curved lines on the front plane give cylindrical overtones to the block-like mass conception of the neck.

I hope all students will study the expanse of form behind the ear (D) where the mastoid is. Beginners, who are unaware that the mastoid exists, leave this whole expanse out, and always bring the back outline of the neck down from directly behind the ear. Michelangelo was so aware of the mastoid that he curved the bottom line of his head dress sharply over the bone at D.

Antonio Pisanello (1380-1456)

MULE

pen

7¼" x 9¾" (18.4 x 24.8 cm)

Louvre, Paris

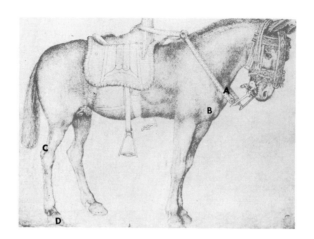

All the artists in this book could draw animals, and some could draw them very well indeed, like Pisanello. It is clear that all of them assiduously studied the anatomy of animals and this study helped them to draw the human figure. If you want to draw animals, get some animal bones and study them. Get some books on animal anatomy. If you know your human anatomy well, you will find that the analogies are so many that you will be drawing very nice animals in no time at all.

Almost all drawings of animals must be created out of the imagination. Animals can seldom be simply copied; they are always moving. (Just try to persuade a mouse to take a static pose on the model stand.) Analogies between animals are so numerous that you only have to know one animal well to know them all. Most artists start their study with the horse because there has been quite a lot written on the artistic anatomy of horses.

As you learn to draw animals, try to place on them all the landmarks that you have learnt on humans. A is the pit of the neck. B is the point of the shoulder. C is the equivalent of the Achilles tendon. D is the equivalent of the fingernail. For artists learning animal anatomy, it is perhaps best to disregard the veterinarian's terms and use the terms of *human* anatomy.

This picture shows that Pisanello had made a deep study of hair tracts and hair direction. Notice his interest in the differing textures of hair, leather, metal, and braid.

If you live in a city where there are both an art museum and a museum of natural history, do not neglect the museum of natural history, for there you can see things not as they appeared to the eyes of other men, but as they really are.

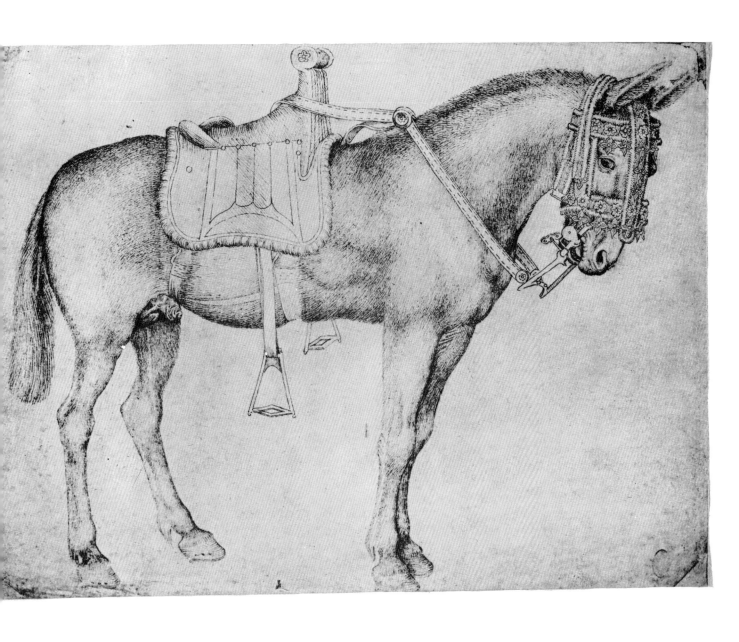

233

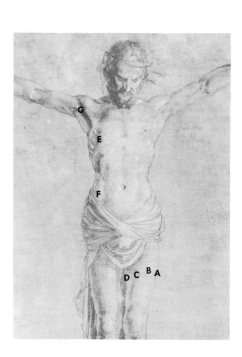

Albrecht Dürer (1471-1528)

CHRIST ON A CROSS

lead heightened with white chalk

16¼" x 11¹³⁄₁₆" (41.3 x 30 cm)

Louvre, Paris

Anyone who has practiced drawing the tonal movements on a column should understand the shade movements on the torso and legs of this figure. These parts of the figure are lit by an imagined light coming from some distance outside the picture, on the right, in front of the figure, and placed at about waist height. The torso and legs are also lit by an imagined reflected light, again outside the picture, behind the figure at about shoulder level.

The basic movement is clearly seen on the thigh on the right. From the outline (A) to the highlight (B), there is a dark to light movement; from highlight (B) to the meeting of the planes (C), a light to dark movement; from C through the reflected light to the outline (D), a dark to light movement. Students should become so thoroughly familiar with these movements that tonal movements become second nature.

On the torso the dark edge where the planes meet runs down the body from E to F. This edge is, of course, not a straight vertical line, but moves according to the requirements of the form. This movement is controlled by the artist's knowledge of the changing cross sections of the body.

The anatomy of the joining of the arms to the body is very well rendered, and is worthy of study. Dürer knew that in this position the muscle coracobrachialis comes into full prominence and he has so rendered this muscle at G.

234

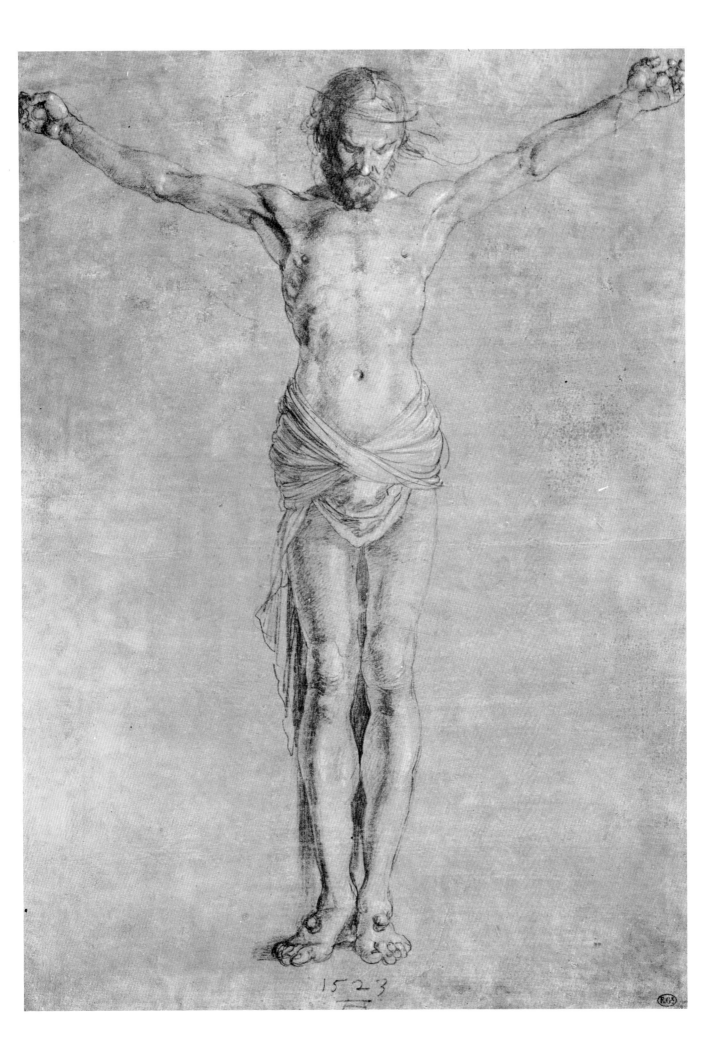

1523

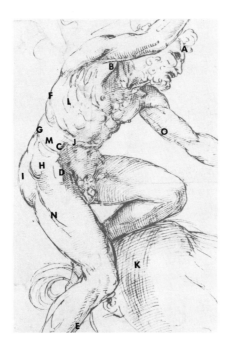

Raphael Sanzio (1483-1520)

HERCULES AND THE CENTAUR

pen and brown ink

15¾" x 9⅝" (40 x 24.4 cm)

British Museum, London

It is not easy to convince a beginner that in order to make a good line drawing, he must have a knowledge of such things as light, planes, mass, direction, and anatomy. Yet I assure you that hardly any of the lines that Raphael used in this drawing were visible on the model; that is, if he had used a model, which I do not think he did here. Whether he used a model or not, however, he would have put in virtually the same lines, based on his knowledge, not merely on what he *saw*.

In this picture, Raphael conceived the direct light from the left and the reflected light from the right. He moved the source of reflected light up and down at will; sometimes it came from above, as on the forehead (A) and sometimes from below. The edge where the two planes meet may be more or less followed down the body; it is very strong on the front flap of the arm (B), on the front of the external oblique (C), on the front of the tensor muscle (D), and down the lower leg (E).

He uses line to outline the forms of latissimus dorsi (F), external oblique (G), gluteus medius (H), and gluteus maximus (I). He runs lines over form to explain the underlying shape, as in the two wrinkle lines (J) at the waist. He runs lines over his mass conceptions (K), to suggest the great column-like form of the horse, and to suggest the egg-like form of the rib cage (L) of the man. These last lines also describe the serrations of the external oblique (M). He runs lines between the muscle groups of different functions on the lower leg (N) and on the far upper arm (O). These last lines also speak of the meeting of interior planes, as do almost all his lines on the body, except those added for tone.

236

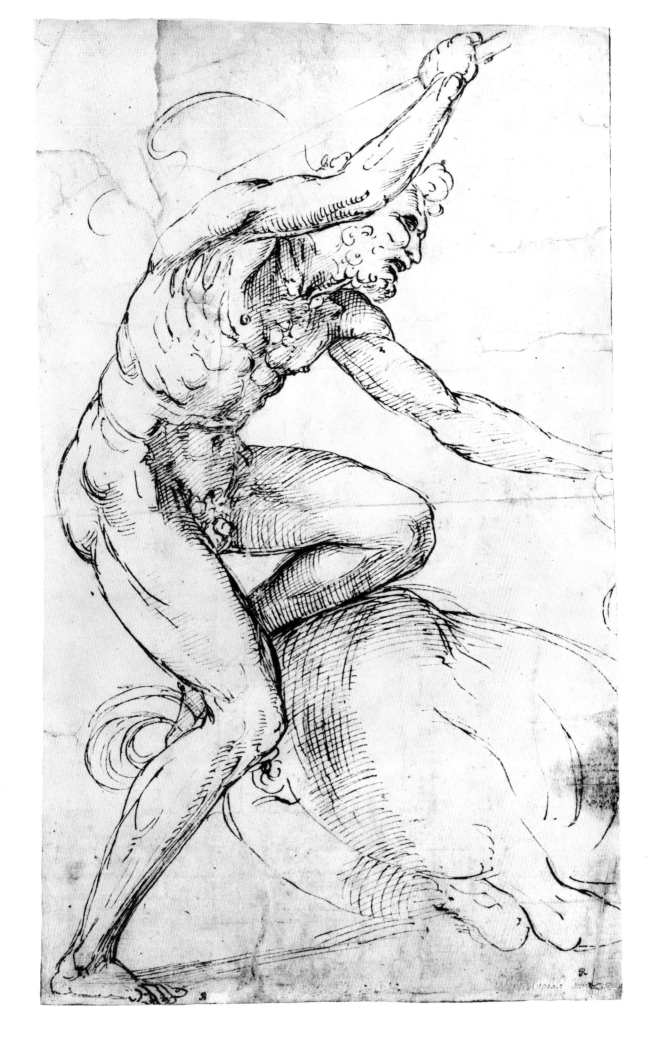

Michelangelo Buonarroti (1475-1564)

STUDY OF A NUDE

pen

15¾" x 7⅞" (40 x 20 cm)

Louvre, Paris

Let us see how Michelangelo Buonarroti handles some of the forms I have been mentioning. The inner hamstring (A) clearly spirals from behind and around the bones of the knee. At a little below the level of the patella, the hamstring breaks into a darker down plane as it moves towards its insertion. Gastrocnemius displays itself vividly (B and C). The line which separates this muscle from the bone now becomes a series of lines at D. And the inner surface of the shaft of the tibia bone may be clearly seen as a ribbon of light, immediately to the right of these lines. As the direct light is constant (from the left on the entire figure), the inner surface of the shaft of the left tibia becomes a ribbon of dark (E). The external oblique (F) is in compression; to indicate this, Michelangelo has given it two bulges.

The lower legs of the larger figure are going in different directions. The one on the right is straight; the other is going backwards. When directions change, tones change. Therefore, the artist has darkened the whole lower leg on the left by means of a series of lines. If you can visualize this figure from the side view, perhaps you can feel the down plane on the front of this lower leg.

The directions or thrusts of the bodily forms are graciously felt here. Note the turn of the head on the neck; the backward thrust of the neck; the turn of the rib cage on the pelvis; the fall of the pelvis to the left. Note how the front edge of the tibia (on the right) follows the axis line of the thigh above. This is a good rule for all legs that are not bent at the knee, but held straight.

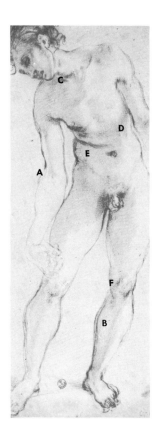

Jacopo da Pontormo (1494-1577)

MALE NUDE

black chalk

15¼" x 8⁹⁄₁₆" (38.8 x 21.8 cm)

Uffizi, Florence

Here the direct light is from the right and the reflected light is from the left. The reflected light is very active. Sometimes it seems as if the artist had used it like an imaginary flashlight: at times from above, as on the elbow (A); at times horizontally, as on the lower leg (B); at times from below, as at the neck (C). The artist has used a cast shadow (D), and though it obviously makes a hole in the rib cage, he decided to let the shadow remain because it curves around the rib cage, thus aiding the illusion of form.

The line at E speaks of the meeting of interior planes and the shape of the forms over which the line moves: external oblique and rectus abdominis. The line (F) of the inner hamstring is carried well down into the leg to show that the inner hamstring is in front of the calf.

On the lower leg, notice the clarity of the front and side planes, breaking, as they often do, along the sharp edge of the front of the tibia. Again, the inner surfaces of the tibia present the familiar ribbon of light and ribbon of dark.

Pontormo's incredible grasp of anatomy is demonstrated throughout. It is especially apparent in the lines that comprise the outline of the figure. These lines identify and at times even characterize one anatomical form after another as they travel. How many of these forms can you name?

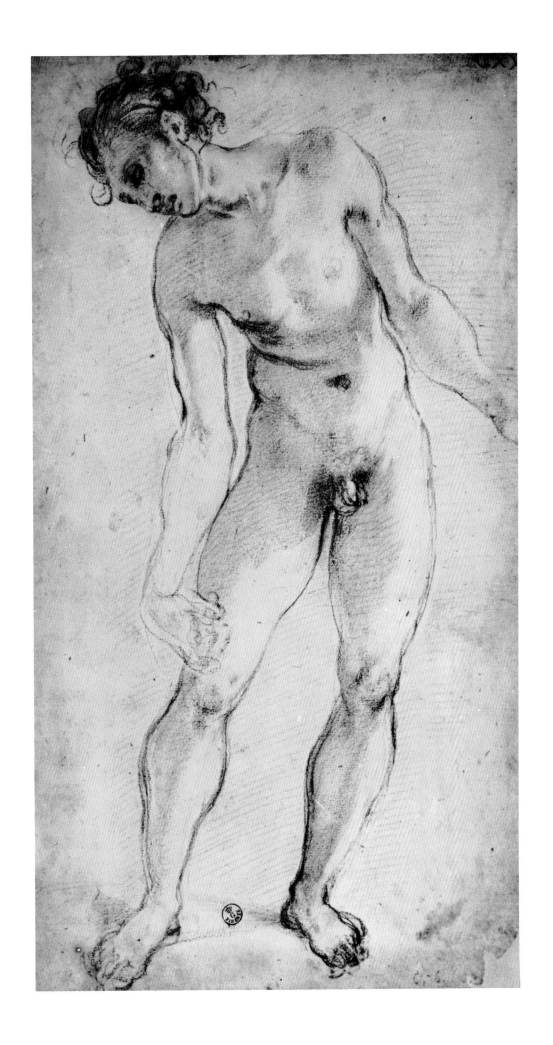

Peter Paul Rubens (1577-1640)

STUDY FOR ABRAHAM AND MELCHIZEDEK

black chalk

16⅞" x 21⅛" (42.8 x 53.7 cm)

Louvre, Paris

The highlight here runs down the body through A. The dark edge, where the two planes meet, runs through B. Having established his front and side planes — the front plane generally light and pointing to the left, the side plane generally dark and pointing to the right — Rubens could be assured that anything he made reasonably light would give the illusion of pointing to the left, and anything he made reasonably dark would give the illusion of pointing towards the right. That is why the patches of extreme light (C and D), even though they are in the side plane, give the illusion that the flesh they cover is pointing towards the left. They are much lighter, you will notice, than any reflected light the artist has used.

Can you get the feeling that this figure could be put inside a cylinder, that the back (from neck to buttocks) would fit up against the inside of a horizontal cylinder? If so, you can feel the curve of the side plane. And if you are familiar with the movement of tones on the outside of a horizontal cylinder, you will better understand the tones on the side plane of this figure.

Rubens has used the cast shadow from the arm on the thigh (E), but look how strongly he has curved the shadow around the thigh and thus promoted the illusion of his cylindrical mass conception. Note, too, how this cast shadow reinforces the direction of the thigh.

Edgar Degas (1834-1917)

STUDY FOR LES MALHEURS

black chalk

9¹⁄₁₆″ x 14″ (23 x 35.5 cm)

Louvre, Paris

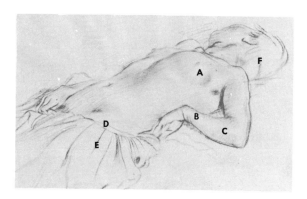

Degas was an impressionist, but all the great impressionists were thoroughly familiar with the studio techniques discussed in this book. If they shifted the directions of their light sources, or reversed their tones, or violated a highlight, they knew what they were up to. They were still fascinated with the presentation of the illusion of three dimensional form on a two dimensional surface. However, in certain parts of their pictures, they occasionally considered the decorative or accidental effect more important than the preservation of this illusion.

Here the direct light is from the right and the reflected from the left. The planes are evident throughout. The breast (A) is a partially buried sphere symbol; the wrist (B) is a block form and beyond it (C) is the familiar egg symbol. The up and down planes on the index finger of the far hand are evident. The drapery line about the thigh (D) fades as it crosses the great highlight of the body. Theoretically, line E should have faded too, but perhaps Degas feared that it would lose its force as a directional line pointing to the head. Line F gives direction to the head, it is a segment of a circle that might be thrown about the head, and it is a reflection of a line familiar to artists: a line drawn where the trapezius arises from the skull.

Degas' marvelous knowledge of anatomy, which he kept under most gracious control, is evident throughout. Notice how the far outline travels over the collarbone and over the breast, sinks between the tips of the eighth and ninth ribs, moves down the arm to the distal end of the ulna, dwells for an instant on the carpus, and then reflects the slight concavity of the forth metacarpal which would be evident in this position of the hand.

244

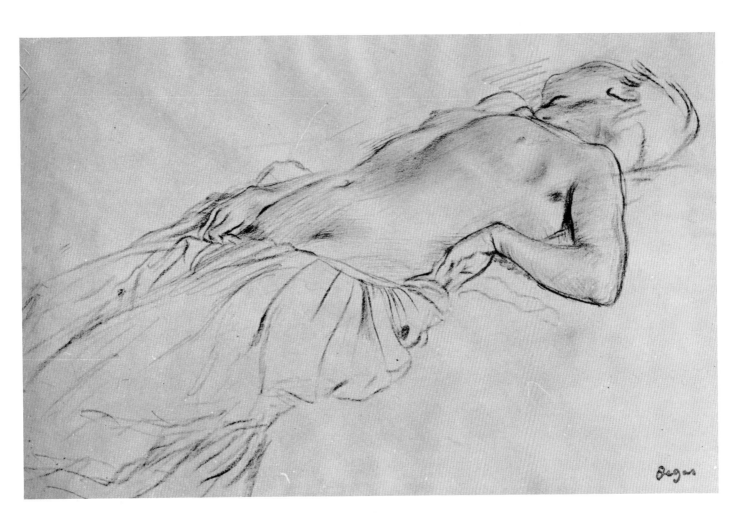

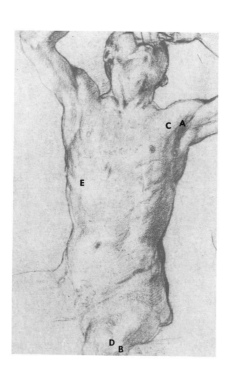

Correggio (1494-1534)

BOY WITH A FLUTE

red chalk

10" x 7⅛" (25.4 x 18.2 cm)

Louvre, Paris

This is another example of simple front and side planes. The dark edge, where the planes meet, starts on the deltoid (A) and ends at the knee (B). The general highlight is very near the dark edge and flows all the way down the body from C to D.

It usually is a good rule to keep your highlight *near* your dark, as the resulting contrast accentuates the planes and reinforces the form. Beginners, sedulously copying the tones they see on the model, invariably try to get the highlight as far away from the dark edge as they can. On this figure a beginner might well have put his highlight next to the left outline of the figure and his dark next to the right outline of the figure.

Correggio could have placed his highlight anywhere left of the dark edge, but I doubt that he would have placed it much left of E. Similarly, he could have shifted his dark edge either to the right or left. It is not until you can visualize the result of these actions in advance that you can determine the best placement of the highlight and the edge. This drawing offers a fairly normal placement of highlight and dark.

The tones on the lower arm on the left are interesting. When a form points in the direction of the direct light source, it is always necessary to alter the direction of that source.

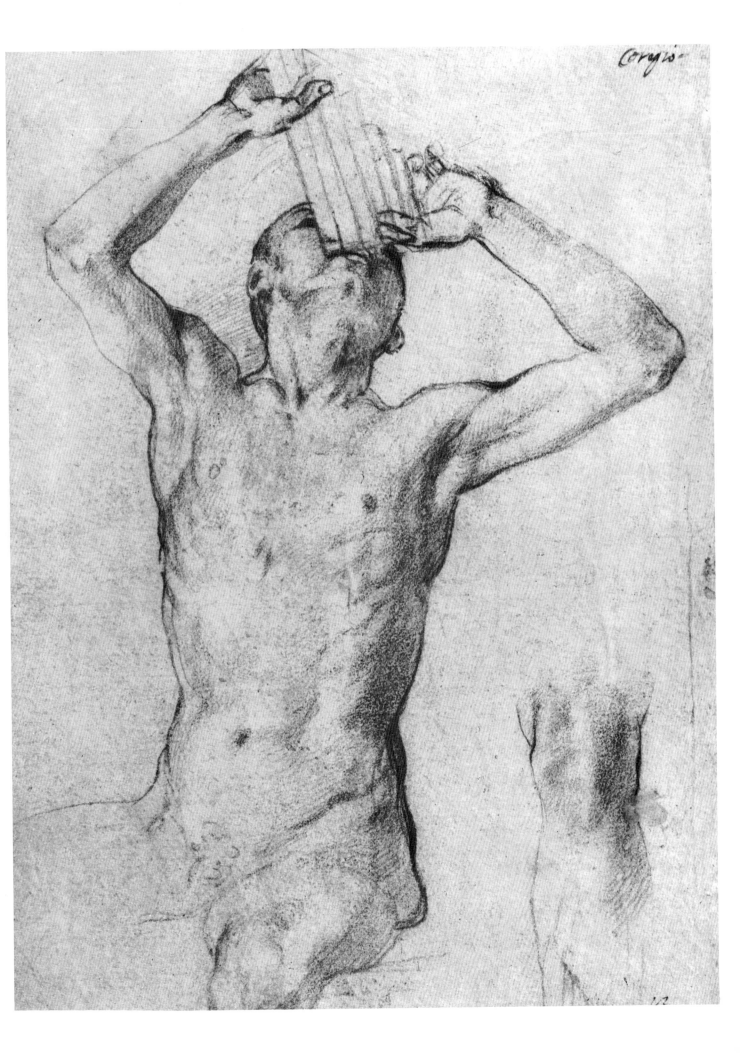

Andrea del Sarto (1486-1531)

TWO JOINED HANDS

red chalk

3¾" x 6⅛" (9.5 x 15.5 cm)

Louvre, Paris

Throw your own hand into the position of the top hand, wiggle your thumb a bit, and you can easily see the tendons that Andrea del Sarto has accentuated. They are the tendons of the extensors of the thumb: two at A and one at B. The space between the two tendons is called the "snuff box" because it will hold just a pinch of snuff.

It is curious that we all cannot draw hands well — after all, our own hands are constantly in view. This simply proves the point again: we cannot draw anything well unless we have thought about it a great deal. Very often, when I am lecturing on hands, I notice the students carefully examining their own hands as if they were seeing them for the first time. Actually, I suppose the forms we draw are just thoughts with lines around them.

Hold your left hand up in front of you and look at the palm side carefully. Feel the outside line of the wrist on the left; it will sweep up along the outside of your index finger. Notice that the line on the right hand side of your wrist will sweep up along the outside of your fourth finger. These lines are two important construction lines. How many other construction lines can you think of that will help you to draw the hand? Among my students, I have noticed that there is a clear correlation between good draftsmanship and originality in creating construction lines.

248

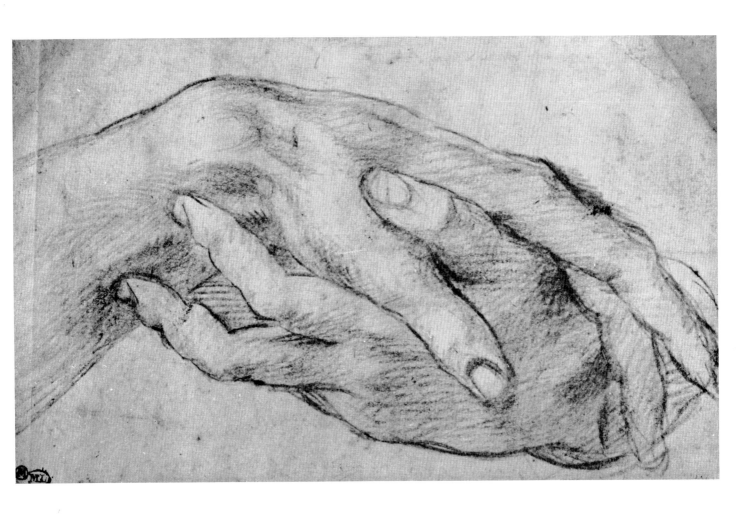

249

Peter Paul Rubens (1577-1640)

PORTRAIT OF A LITTLE BOY

red and black chalk

9¹⁵⁄₁₆″ x 7¹⁵⁄₁₆″ (25.2 x 20.2 cm)

Albertina, Vienna

Proportions reside in bones. If you wish to draw children, try to get some conception of how our bones vary in proportion, one to the other, from birth to adulthood.

Notice how line A of the shoulder continues into line B of the shoulder. When the shoulders are at rest, this is a construction line greatly used by artists. Be sure to run it behind the column of the neck because this line actually designates the trapezius muscle, which comes from the back of the skull.

Examine the bead at C. It is a perfect sphere symbol with its highlights, dark, and reflected light. Notice that the nostril (D) is shaded exactly the same way. Notice how the cast shadow under the nostril has been handled; it is very dark and very small, just large enough to accentuate the form above. On the actual model, it may have been ten times as big. If Rubens had copied the shadow as he saw it, what a splotch it would have made on the delicately modeled flesh above the baby's lips!

If you examine the shade lines very carefully, you will find that they are almost all contour lines that carefully follow the form beneath. Rubens could not have drawn them with such sureness and ease unless he had practiced drawing hundreds of thousands of contour lines when he was a student.

To draw children well, one must have a sure knowledge of their proportions at different ages. The best plates I know on the proportions of children are in Rimmer's anatomy.

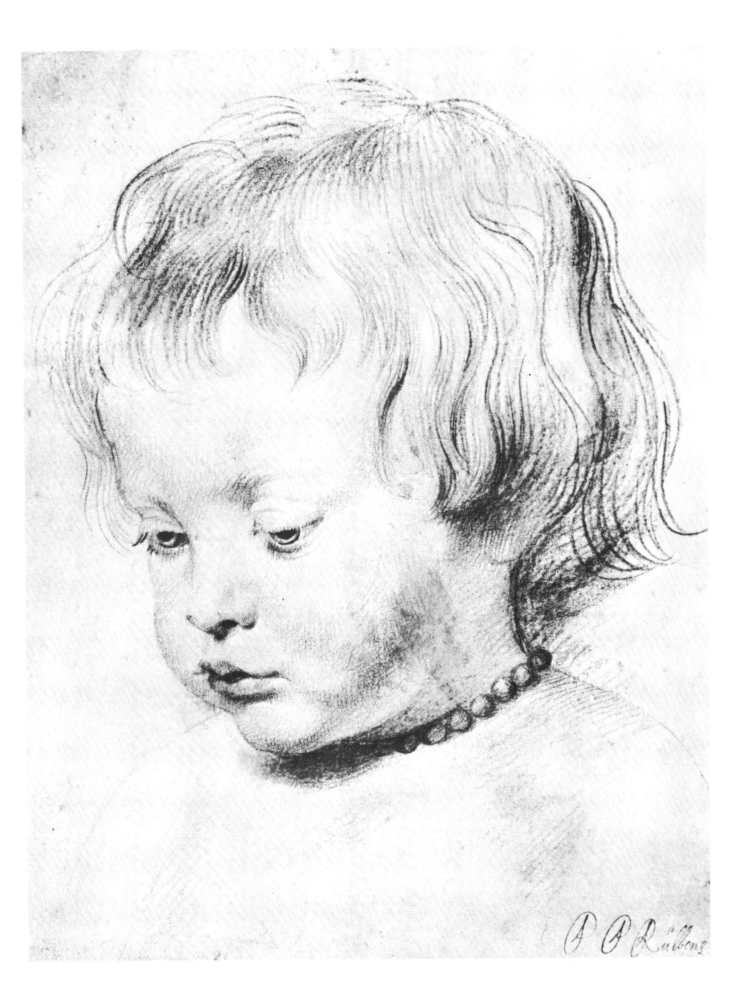

Rembrandt van Rijn (1607-1669)

SASKIA CARRYING RUMBARTUS DOWNSTAIRS

pen and bistre wash

7¼″ x 5¼″ (18.5 x 13.3 cm)

Pierpont Morgan Library, New York

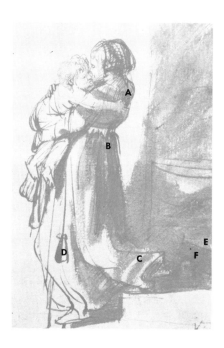

It is interesting to speculate about whether Saskia was wearing a white dress or a black dress. The direct light is coming from the left, the reflected light from the right and above. The reflected light is very feeble, though we can see its influence on the shoulders (A), on the flare of the skirt at the waist (B), and on the drapery above the step (C). The reflected light is used to remind us that all these surfaces are up planes. Just as an artist can control the direction of his light, he can control the intensity of his light. Rembrandt has conceived his direct light as extremely brilliant here. When a really bright light falls on an absolutely black surface, that surface may well be drawn as white.

Another indication that Rembrandt is deliberately creating the direction and intensity of his light is the form at D. A bright light has been suddenly thrown on this form from the right, though the cast shadow remains on the right. Thus he achieves a brilliant decorative effect. Those of you who insist that you must draw exactly what you see, take careful note.

When the light source comes from above, the rule is: up planes light, down planes dark. The up and down planes of the step are E and F.

Giulio Romano (1492-1546)

TWO FIGURES

red chalk

13⁷⁄₁₆" x 8¹¹⁄₁₆" (34.1 x 22.1 cm)

Louvre, Paris

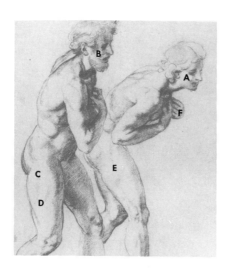

Here the direct light is from the left, the reflected light from the right. The head (A) is massed as the usual block with the nose — another block — attached to the front.

Now under these lighting circumstances, the side of the nose would, of course, have a cast shadow on it. But naturally, the artist eliminated this cast shadow because he wanted the side of the nose to have the same tone as the side of the cheek. Then everyone would know that the side of the nose and the side of the cheek were pointing in the same direction.

The artist massed the other head (B) the same way. However, since he probably thought it would be boring to have the two heads with the same tones, he ran a tone over the face of head B. But you will notice that the tones of the side of the nose and the side of the cheek remain the same.

The line between the functions — between the hamstring group and the quadriceps group of the thigh — is indicated by a number of small, short lines running from C to D. These lines also appear for the same reason at E.

Notice the simple, quarter-cylinder conception of the body of the hand at F.

254

Francisco Goya (1746-1828)

THREE MEN DIGGING

brush and brown wash

8⅛" x 5⅝" (20.6 x 14.3 cm)

Dick Fund, Metropolitan Museum of Art, New York

The two men with the adzes are engaged in repetitive action. Goya accordingly shows one man at the beginning of the action and one at the end of the action.

Goya undoubtedly drew this picture out of his imagination, and I suspect that he got up from his chair, while he was drawing, and went through the actions involved. Artists naturally do this to decide, say, on the exact rotation of an arm; to determine the precise thrust of a hand; or perhaps to catch a fold or fall of drapery that might not have occurred to them.

Here the direct light is from the left, as can be seen by the cast shadows from the feet on the ground. The lines at A are not folds; they represent the dark edge of a sphere symbol. Even though the lower leg (B) is heavily wrapped, Goya uses the ribbon of shade that runs down the inner surface of the shaft of the tibia.

The lower line of the sleeve at C forces the sleeve into planes, thus intensifying the form as well as indicating the direction of the arm. These planes also reveal the prismatic cross section of the upper arm. And meeting as they do on the front edge of the biceps, these planes reveal the exact rotation of the upper arm.

256

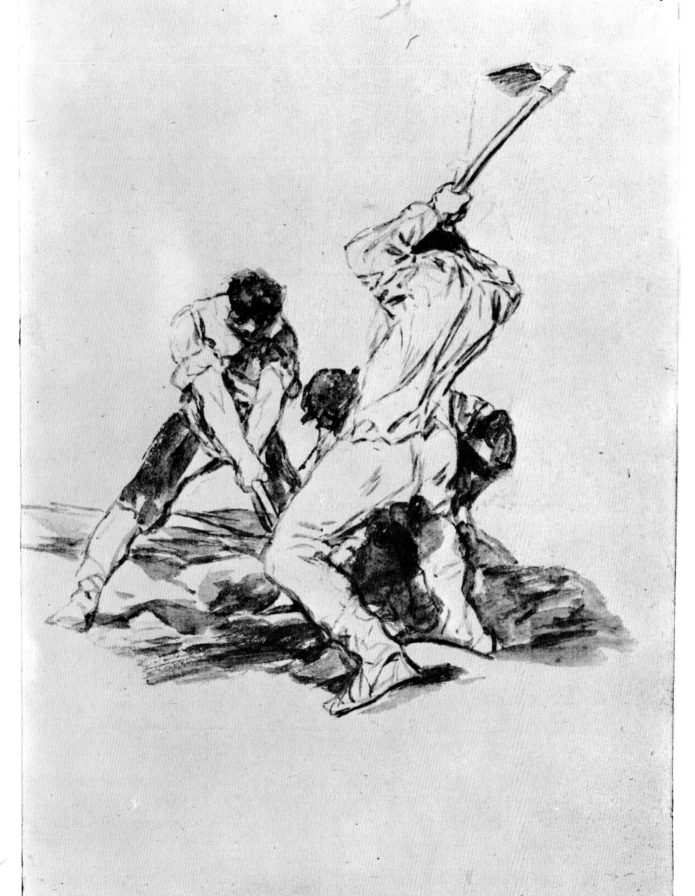

Rembrandt van Rijn (1607-1669)

FEMALE NUDE

pen and brush in bistre

8¾" x 7¼" (22.2 x 18.5 cm)

Graphische Sammlung, Munich

This back is shaded somewhat like a flight of steps on its side. The direct light comes from the right, so we get front plane (A), side plane (B), front plane (C), side plane (D). This gives an excellent impression of the form.

Now the trick is this. If the model had posed in the light chosen here, there would be a black splotch of cast shadow on plane C. But Rembrandt wisely deleted this shadow to give the impression that the flesh at C was pointing towards the direct light on the right. He has done the same thing at E; but he has not left the flesh as bright at E, to show that it is not looking as much towards the right as the flesh at C.

Rembrandt's knowledge of anatomy was massive and accurate; at first, it is difficult to realize that a staggering amount of this knowledge is on restrained display in this somewhat simple figure. For example, the line at F represents the right outline of teres minor; the little break below it indicates how latissimus dorsi is curving about the body to embrace teres major and the shoulder blade. (He has done the same thing on the other side of the body.) At the wrist (G), there is a little line which represents extensor carpi ulnaris, seeking its insertion in the metacarpal of the little finger. It is interesting to note that you really would not see this tendon in this position; it would actually be covered by a series of wrinkles. The point is that anatomical indication often gives a stronger illusion of reality than the mere copying of what you see.

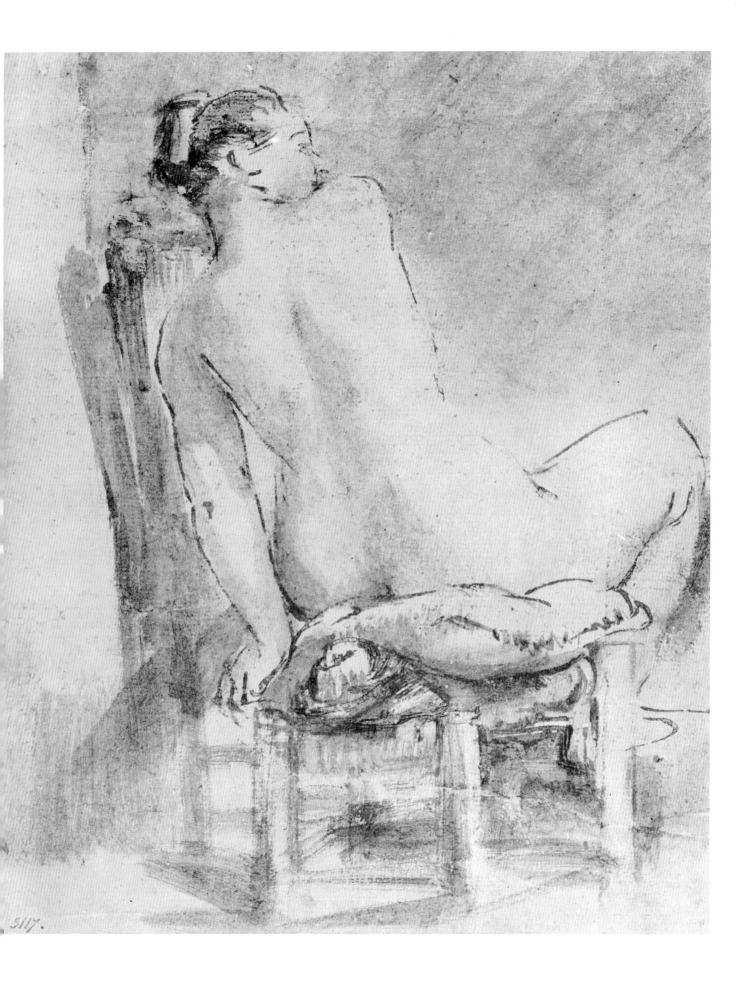

Francisco Goya (1746-1828)

WAKING FROM SLEEP IN THE OPEN

brush and brown wash

7¹⁄₁₆" x 5¾" (17.9 x 14.6 cm)

*Dick Fund, Metropolitan Museum
of Art, New York*

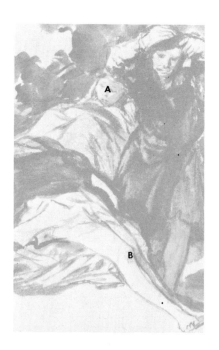

In many of his compositions, Goya seems to have used a rule familiar to artists: one quarter black, one quarter white, and one half gray. And of course Goya knew that if an artist places a part of one figure in front of another figure, the rear forms become unusual and more interesting. The legs in the foreground cut off part of the man in black; and the man in black cuts off part of the recumbent figure behind him. Figures can also be used to cut off full shapes in the background, as indeed they do here.

Beginners seldom do this; their compositions usually consist of isolated figures.

Here the imagined direct light is from the left; the reflected light is from the right. Cast shadows are sparingly used. There *should* be one on the right of the nose on head A; but if Goya had used a cast shadow, he would have destroyed the front plane of the face. Nor is there a cast shadow below the nose; the shade used here designates the plane break at the right hand side of the philtrum.

Plane breaks always occur at knees and elbows, except in a totally straight arm. Artists are always on the lookout for plane breaks at these places. That is why Goya put the little patch of shade at B, even though the leg is straight.

Auguste Rodin (1840-1917)

FIGURE DISROBING

pencil

12³⁄₁₆″ x 7⅞″ (31 x 20 cm)

Kennedy Fund, Metropolitan Museum of Art, New York

In this rapid sketch, Rodin is concerned with mass and the direction of mass, though many of the delicate movements of the outline are controlled by his extraordinary understanding of anatomy.

The line of the sleeve (A) reveals the cylindrical mass conception of the arm and its direction. A number of the drapery lines in front of the rib cage reveal the egg-like conception of the rib cage and its direction. The small vertical curve designating the navel (B), not only suggests the surface of the ball of the abdomen, but reveals the direction of the pelvis.

Lines C and D designate the inner and outer hamstrings respectively. More subtle is the short line E; it reflects the tendon of tibialis anticus. There are, of course, a great many other indications of exact anatomical understanding in this picture.

Line F, though it encircles the mass, picks up the lower edge of the twelfth rib at F. On a profile view of the figure, the lower edge line of the twelfth rib is automatically stressed by many artists to place the mass of the rib cage in front of the erector spinae group.

4.

10-66 1

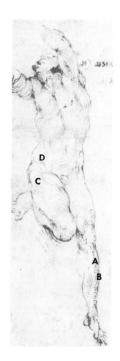

Michelangelo Buonarroti (1475-1564)

NUDE YOUTH

pen

12¹³⁄₁₆″ x 6¹¹⁄₁₆″ (32.5 x 17 cm)

Louvre, Paris

In making a line drawing, students always forget that the light sources are playing their parts as usual. The lower leg (A) is clearly divided into two planes; these planes are meeting as usual on the front edge of the tibia, though as usual on the upper part of the lower leg (A) this edge is troubled by tibialis anticus.

On this leg – as indeed for the whole body, except, perhaps, for the upper thigh on the right – the direct light comes from the left and the reflected light from the right. Look at the little lines to the right of the edge of the tibia (B). Notice that most of them begin with a little hook. This is to give the effect of a value movement from dark to reflected light on the side plane which they cover.

The cylindrical mass conception of the arms is clear. The shade lines upon them betray this and also give direction to the form.

The lines of the tensor (C) go in the same direction as the fibers of the tensor muscle. So do the lines on the external oblique (D) above. Shade lines often do this, and that is one of the reasons why the directions of muscle fibers have to be learnt. Another reason is that muscles have a tendency to bulge and wrinkle at right angles to the direction of their fibers.

Deciding what direction to run a shade line over the body is indeed most complex. Not only the direction of muscle fibers, but factors of light, plane, mass, direction, rhythm, and contour are all important. The artist must select from among all these factors those that help to clarify the problems of the moment. For instance, the foreshortened arms were a problem here, even for Michelangelo; so he used his shade lines to clarify their direction.

264

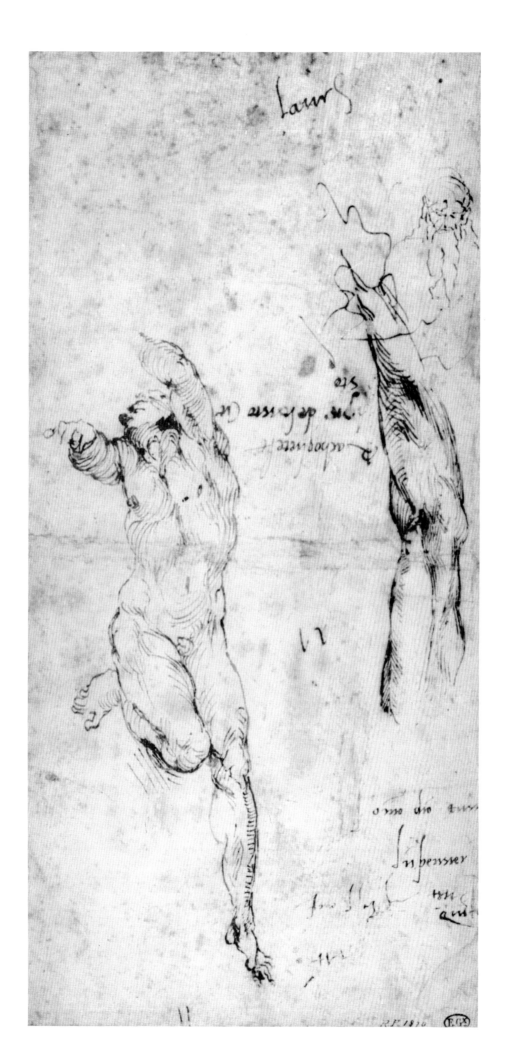

Winslow Homer (1836-1910)

A FISHER GIRL ON THE BEACH

pencil

14¾" x 11⅜" (37.5 x 28.9 cm)

Rogers Fund, Metropolitan Museum of Art, New York

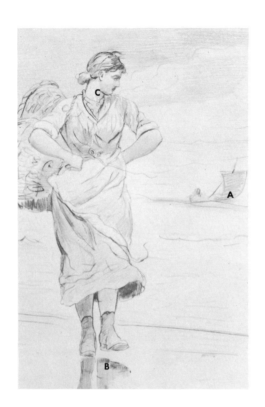

By now, I hope you can understand quite a number of the technical devices that Homer used to achieve the effects he has produced here. Try to analyze the light, the lines and their many meanings, the directions of form, the planes, the massing, and the tones. Notice the ghost of a highlight on the curving up plane of the sail (A); the planes of shoe (B), even in the reflected foot; the faint hint of the sternomastoid (C).

You must realize that in the years to come your style will reflect not only your own thoughts and feelings, but those of your whole generation. The terms of expression which the future will require are unknown. Learn the techniques of your trade and learn them well. For I assure you that the full development of your style will depend on your ability to meet the manifold demands the future will impose.

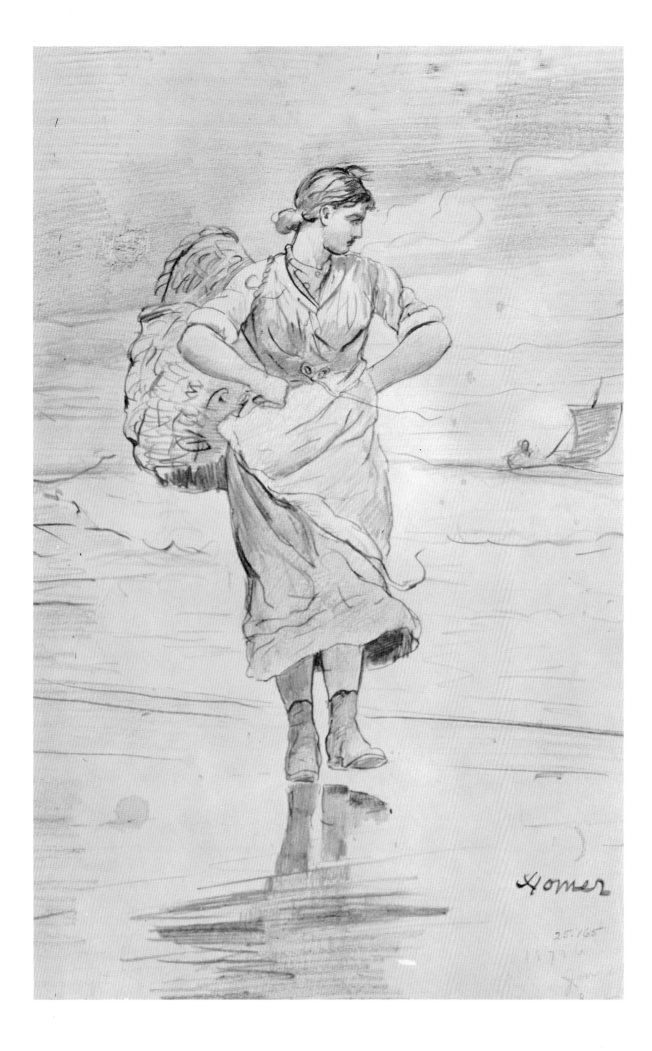

Homer

25.165

INDEX

Abductor minimi policis, 194
Achilles tendon, 232
Adductor brevis, 162
Adductor group, 174, 200, 204
Adductor longus, 162
Adductor magnus, 162
Albinus, Bernard Siegfried, *Tabulae Sceleti et Musculorum Corporis Humani,* plate 1, 150; plate 1, 162; plate 2, 152; plate 3, 154; plate 4, 174; plate 7, 166
Anatomy, artistic, 35, 42, 141-207, 236; and evolution, 143; and function, 146-147; learning, 142; medical, 142; of horses, 232
Antihelix, 44
Antitragus, 44
Art, history of, 211
Astragalus, 194
Atlas bone, 158

Bandinelli, Baccio, Male nude from Sistine ceiling, 178
Bellini, Gentile, 72; Portrait of a youth, 70
Biceps, 146, 162, 196, 200
Biceps femoris, 198
Biceps group, 162, 198
Blake, William, 48
Bones, buying, 142-143; determine form, 142
Botticelli, Sandro, Study for the allegorical figure of Abundance, 138
Boucher, François, 80; Study for the Judgment of Paris, 78
Brachialis anticus, 162, 198
Brachioradialis, 198
Bruegel, Pieter, Summer, 134; The painter and the connoisseur, 52
Buonarroti, Michelangelo, *see* Michelangelo

Buttocks, 68, 88
Calf, 38
Calf group, 162, 168, 182
Callot, Jacques, Anatomy studies, 184; Standing male nude, 186
Cambiaso, Luca, 26, 28; Christ leading the calvary, 24; Group of figures, 22
Capitellum, 160
Carracci, Annibale, Polifemo, 102; Polifemo, 104; Standing figure of a nude woman, 20
Carpals, 150
Carpus, 188, 192, 244
Cartilage, 176
Cast shadow, 61-62, 68, 82, 104, 122, 230, 240, 242, 252, 254, 256, 258, 260
Cervical vertebrae, 152
Cheek bone, 76, 98, 130, 176, 190, 224, 228, 230
Clavicle, 150; *see also* Collar bone
Collar bone, 154, 244
Composition, 210-211, 216, 218, 220, 260
Condyles, 158; external, 198
Construction line, *see* Line
Context, *see* Juxtaposition
Copying, 258; *see also* Model
Coracobrachialis, 234
Correggio, Boy with a flute, 246
Crureus, 162, 198
Cube, *see* Form
Curved planes, 30, 34, 59
Cylinder, *see* Form

Da Pontormo, Jacopo, Head of a woman, 76; Male nude, 240; Nude boy seated, 38; Virgin annunciate, 136
Daumier, Honoré, Don Quixote and Sancho Panza, 28

Da Vinci, Leonardo, 24, 96, 98, 211; Canon of proportions, 94; Cartoon for the Virgin with Saint Anne, 106; Hands, 192; Head of an old man, 98; Madonna and child and other studies, 30; Nude on horseback, 180; Pupil of, Head, 40; Surface Anatomy of the shoulder region and head, 128

Degas, Edgar, 210; Dancer adjusting her slipper, 126; Study for Les Malheurs, 244

Del Sarto, Andrea, Head of an Apostle, 228; Head of an elderly man, 226; Studies of Hands, 188; Study of feet and hands, 202; Two joined hands, 248

Deltoid, 82, 162, 168, 196, 200, 202, 246

Details, selecting, 91-92, 124

Direction, see Thrust

Dorsum, 194

Drapery, 48, 54, 64, 111, 118, 220, 244, 252, 256, 262; and thrust, 113, 132, 134, 136

Drawing, learning, 13-31

Dürer, Albrecht, 72; Christ on a cross, 234; Female nude, 68; Five nudes, study for a resurrection, 82; Head of a man, 44; Head of a Negro, 72; Standing female nude, 96

Dürer, copy of, Study of hands, 124

Ear, 44, 98, 130, 224, 226, 230; see also Mastoid

Ensiform cartilage, 150

Erector spinae, 172, 182, 206, 262

Extensor carpi radialis brevior, 42, 168

Extensor carpi radialis longus, 162, 198

Extensor carpi ulnaris, 42, 168, 258

Extensor communis digitorum, 168, 192

Extensor group, 146, 168, 200

External oblique, 20, 146, 162, 174, 178, 182, 186, 196, 200, 202, 236, 238, 246, 264

External oblique group, 198

Eye, 76, 91; ball, 40, 44, 98; lashes, 40

Fascia lata, 14; tensor of, 20

Femur, 150, 188, 198, 204

Fibula, 150, 188

Fingers, 44; see also Phalanges

Flexor brevis pollicis, 200

Flexor carpi radialis, 162

Flexor carpi ulnaris, 162

Flexor group, 20, 146, 162, 168, 190, 198, 200

Flexor sublimis digitorum, 162

Foreshortening, 50

Form, determined by bones, 142; geometric, 15, 16, 18, 20, 22, 24, 26, 35, 46, 48, 50, 52, 87, 210; in motion, 111, 120, 256; shape, lighting, and position, 14

Frontalis, 190

Fuseli, John Henry, 42; Man embracing a woman, 48; The dead Achilles mourned by Thetis, 18

Gastrocnemius, 162, 182, 184, 238

Geometric form, see Form

Gluteal muscles, 204

Gluteus maximus, 145, 168, 182, 186, 236

Gluteus medius, 168, 178, 236

Goya. Francisco, 210; Three men digging, 256; Waking from sleep in the open, 260

Gracilis, 162, 198

Gravity, and man, 144-145; and the four-footed animal, 144

Gray's Anatomy, 143

Great trochanter, 94, 150, 178, 224

Hamstring, 186; group, 146, 168, 184, 198, 204, 254; inner, 24, 168, 200, 238, 240, 262; outer, 24, 262

Hands, 44, 82, 122; see also Phalanges; Carpals; Metacarpals

Heel, 202

Helix, 44

Highlight, violating, 64, 244

Hips, 88; see also Pelvis

Homer, Winslow, A fisher girl on the beach, 266

Horses, 28, 42, 116, 154, 180, 232

Humerus, 150, 160, 166, 184, 190, 196, 198

Iliac crest, 152

Iliocostalis, 172, 206

Index, abductor of the, 18

Infraspinatus group, 168, 198

Ingres, Jean Auguste Dominique, Portrait of Paganini, 214

Internal oblique, 162

Ischium, 152

Jawbone, 30, 48

Juxtaposition, 15

Latissimus dorsi, 162, 168, 172, 184, 196, 206, 236, 258

Light, and planes, 57-85; and shade, 14, 22, 44, 64; and three dimensional form, 62-64; changing on plane, 44; destroying form, 62-64, inventing, 63, 66, 74, 90, 102, 138, 250; jumping, 63, 126; selecting, 228; sources of, 24, 28, 46, 54, 59, 246, 264; see also Tone

Line, 33-55; and functional groups, 147; and thrust, 112; as color meets color, 34, 40, 44, 46; as outer edges, 33, 46; as plane meets plane, 34, 38, 40, 46, 48, 50; as tone meets tone, 34, 46, 104; concave, 78, 80; construction, 128, 130, 248, 250; convex, 78, 80; explaining shape, 34-35, 40, 54; made with dots, 52; practicing, 14-15; suggesting changing tones, 36; to indicate direction, 50

Lippi, Filippino, Athletic youth, 198

Lips, 52

Longissimus dorsi, 172, 206

Lumbar vertebrae, 152

Mantegna, Andrea, Judith and her servant, 220

Mass, 87-107, 236; and detail, 91-92; and general shape, 87; and perspective, 222; and proportion, 88-89; as symbols, 100

Mastoid, 230; processes, 224

Metacarpals, 122, 141-142, 150, 188, 192, 244, 258

Metatarsals, 150, 194, 202, 206

Michelangelo, 89, 102; Figure of male nude, 206; Head in profile, 230; Nude youth, 264; Studies for the Libyan Sibyl, 100; Study for Christ, 196; Study of the back and legs of a man, 204; Study of a nude, 238

Models, copying from, 42, 46, 80, 116, 118, 186, 228, 236; drawing without, 141-142

Moore, Henry, 89

Muscles, and function, 146-147; origin and insertion of, 143; see also Anatomy

Nose, 44, 52, 74, 98, 100, 130, 254, 260

Nostril, 250

Os calsis, 194

Palmaris brevis, 190, 200

Palmaris longus, 162

Patella, 150, 166, 238

Pectineus, 162

Pectoralis major, 50, 52, 162, 184, 196

Pelvic crest, 154, 186
Pelvic girdle, 154
Pelvis, 89, 94, 96, 142, 150, 152, 166, 172, 178, 182, 198, 200, 202, 206, 222, 224, 238, 262
Peroneal group, 162, 168, 198
Peroneus longus, 162
Peroneus tertius, 162
Perspective, 46, 84, 116, 210-211, 216, 222, 224, 226
Philtrum, 260
Phalanges, 122, 150, 214
Pillow muscle, 198
Pisanello, Antonio, Mule, 232
Plane, meeting plane, 46; *see also* Light; Line
Pollaiuolo, Antonio, Figure of Adam, 200
Position, *see* Thrust
Poussin, Nicolas, Holy Family, 26
Pronator radii teres, 162
Proportion, 96, 97, 98, 116; and bones, 250; of the head, 98

Quadriceps femoris group, 162, 168, 184, 186, 204, 254

Radius, 150
Raphael, 210; Combat of naked men, 80; Combat of nude men, 176; Fight between man on a horse and two nude soldiers, 42; Hercules and the centaur, 236; Study for the transfiguration, 190; Study of David after Michelangelo, 222
Rectus femoris, 162, 198
Rectus abdominis, 102, 126, 145, 162, 178, 240
Rembrandt, 48; Female nude, 258; Girl sleeping, 218; Saskia carrying Rumbartus downstairs, 252; Two butchers at work, 120; Woman with clasped hands, 46
Rhomboid group, 170, 198
Rib cage, 14, 44, 50, 72, 80, 88, 89, 91, 110, 180, 196, 202, 206, 222, 224, 236, 238, 262
Rimmer's anatomy, 250
Robusti, Jacopo, *see* Tintoretto
Rodin, Auguste, Figure disrobing, 262
Romano, Giulio, Two figures, 254
Rubens, Peter Paul, 89; Nude woman, 224; Portrait of a little boy, 250; Portrait of Isabella Brant, 74; Studies of arms and legs, 194; Studies of heads and hands, 122; Study for Abraham and Melchizedek, 242; Study for Mercury descending, 118

Sacrum, 22, 94, 147, 152, 200, 222, 224
Sanzio, Raphael, *see* Raphael
Sartorius, 146, 162, 186
Semimembranosus, 146, 168, 198
Semitendinosus, 146, 168, 198
Serratus magnus, 144, 162, 196
Shade, 57, 58; *see also* Cast shadow; Light; Shading

Shading, the rear form, 65
Shadow, *see* Cast shadow; Shading
Shoulder blade, 152, 154, 170, 176, 224, 258
Shoulder girdle, 154, 184
Signorelli, Luca, Nude man from rear, 182
Soleus, 162, 182, 184
Sphere, *see* Form
Spinalis dorsi, 192, 206
Sternomastoid, 143, 146, 162, 186, 266
Sternum, 143, 150, 196
Supinator group, 146, 162, 168, 198, 200
Supinator longus, 162
Symphysis pubis, 89, 94, 96, 150, 178, 200, 224

Tarsal bones, 150
Tarsus, 194
Temporal fossa, 228
Tensor, 178, 184, 236, 264
Tensor fascia femoris, 162, 164, 168
Teres, major, 168, 184, 196, 258; minor, 168, 198, 258
Texture, 210-211
Thrust, 118, 122, 224, 236, 238, 256, 262; and drapery, 113, 132, 134, 136; and light, 65; and line, 112; and tones, 112; and true shape, 112-113; determining, 109-111
Tibia, 150, 160, 176, 238, 240, 256, 264
Tibialis anticus, 42, 194, 202, 262, 264
Tiepolo, Giovanni Battista, Angel, 216
Tintoretto, Design for archer, 50; Design for Venus and Vulcan, 84; Draped standing figure, 132
Titian, Rider and fallen foe, 116
Tones, and color, 58; and direction of form, 112; and interior planes, 60; meeting tone, 46; movement of, 13, 74, 84, 234, 264; reversing, 64, 244; *see also* Light; Shade
Tragus, 44
Transversalis, 162
Trapezius, 80, 162, 168, 170, 172, 244, 250
Triceps, 168, 196, 198
Trochlea, 160

Ulna, 42, 150, 176, 244

Van Rijn, Rembrandt, *see* Rembrandt
Vastus externus, 162, 198
Vastus internus, 168, 198, 200
Vecelli, Tiziano, *see* Titian
Veronese, Paolo, 210
Vesalius, Andreas, *De Humani Corporis Fabrica*, plate 21, 156; plate 22, 158; plate 23, 160; plate 26, 164; plate 32, 168; plate 33, 170; plate 35, 172

Watteau, Antoine, Nine studies of heads, 130; Woman seated on the ground, 54
Whistler, James, 61
Wrinkles, 190

Zygomaticus, 190

Edited by Donald Holden
Designed by Betty Binns